Craigie The Art of Craigie Aitchison

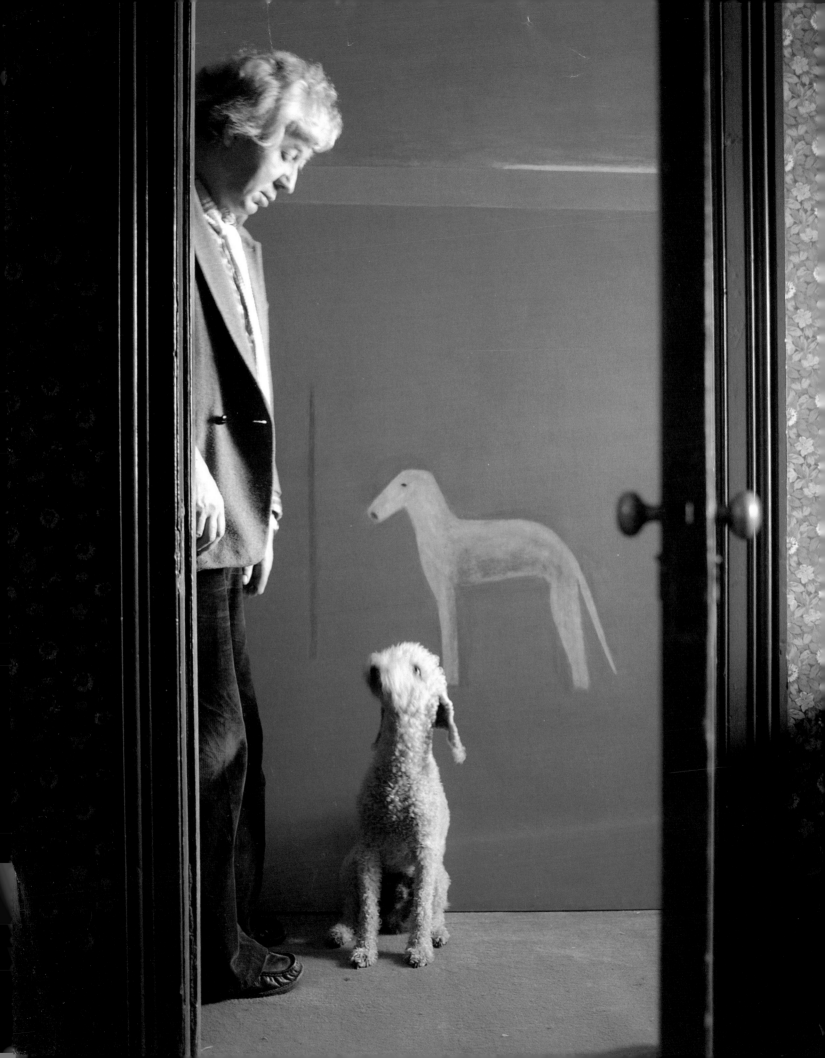

ANDREW GIBBON WILLIAMS

Craigie The Art of Craigie Aitchison

CANONGATE

First published 1996
by Canongate Books Limited
14 High Street, Edinburgh EH1 1TE
Paintings © Craigie Aitchison
Text © Andrew Gibbon Williams

ISBN 0 86241 610 8 *hardback*
ISBN 0 86241 577 2 *paperback*

Designed and typeset by Dalrymple
Colour reproduction by Toppan
Printed and bound in Italy by Manfrini R.
Arti Grafiche Vallagarin S.p.A.

FRONT COVER
Boy in a Thames T-shirt, 1975
76 × 63.5cm, (Nigel Gee)

BACK COVER
Cruxifixion, 1993
51.1 × 45.7cm, (Robert Fleming Holdings Ltd)

FRONTISPIECE
Craigie with Wayney in the hallway of
32 St Mary's Gardens in 1987 (Derry Moore
© Vogue, Condé Nast Publications Ltd)

Introduction

criticism I see I have regularly commented on Craigie Aitchison's painting and always I am glad to say favourably. Nevertheless, there were always things that puzzled me about Craigie Aitchison, not least the 'Scottishness' of his name. How was it that such a highly regarded and clearly important artist – obviously Scottish – never, or at least rarely, cropped up in exhibitions north of the Border? Where did he live? Why did he paint Crucifixions? What was a 'Bedlington'?

Some of these questions were answered for me in conversation with a London art dealer in the spring of 1994. The dealer's eye twinkled as he gossiped about 'Craigie', and he recounted amusing anecdotes most of which to his credit were benign and reflected badly on him. Over lunch the artistic personality that had intrigued me took on social flesh, and I inquired about the book that would tell me more. But there was no such study available.

The next few months are fuzzy. I met up with Craigie and was seduced (as I now know many others to have been) by his honesty, lack of pretentiousness, and sense of humour. It helped that we had had friends in common; not least the writer Elizabeth Smart, who, it transpired, had transcribed an illuminating interview with Craigie. We seemed to hit it off.

The possibility of a book about Craigie, however, I hardly dared mention. I could see immediately that here was a man who did not court publicity. In fact, here was the best sort of artist: someone who got on with it, and did not give a damn about what people said of his work. On the other hand, he was gregarious, and endowed with a fair share of that curiousness about others vital in an artist. He enjoyed his celebrity, albeit in a self-effacing way.

It took a while to summon up the courage to put to him the proposition that he might subject himself to the 'microscope treatment', and when I did I got the response I expected: doubtful, bordering on defensive. No doubt he was thinking: What might be written? What forgotten

corners of my life might be illumined? 'Perhaps it should wait until I'm dead', he suggested.

Fortunately from my point of view, Craigie was finally won over to my opinion that posthumous accounts of artists' careers leave a lot to be desired, and that there is much to be said for being allowed to put one's own view of things. I think Craigie sensed that there was nothing new to me about the lonely studio, and that a 'hatchet job' was unlikely. Ultimately, he acquiesced.

Biographies, of course, have their place, and anecdotes their value. But in the case of the artist, there is more likelihood of personal information being 'beside the point' than in that of any other creative discipline; painters invent their own worlds much as children do. Coloured though these worlds must be by their circumstances, they demand objective assessment above all.

I therefore make no apology for not having revealed more of Craigie's life than I have. The point of this book is to try and explain how he came to paint his extraordinary pictures, and – this is more important – to try and help those who enjoy them to enjoy them on a deeper level. In this it has been a help that Craigie is not someone who enjoys disguising meaning or perplexing his public; and this virtue informs his life as thoroughly as it does his art.

But when one likes one's subject there is the danger of pulling punches, of natural sympathy blunting the critical edge. If I have fallen victim to this fault too often here then it is I who must take the blame. Craigie is critical of his work to the point of neurosis; when 'the pictures' work, they work, when they don't they are 'rubbish'. A much thinner book would have resulted had Craigie been allowed to 'veto' certain illustrations.

Craigie is fond of recounting how his first important black model, Georgeous Macaulay, would comment, 'I suppose this must be good practice for you.' 'He seemed to think I was preparing to win Wimbledon or something,' Craigie reflects with a smile. But Georgeous had hit on a truth. Craigie's approach to painting is like that of the professional athlete: each canvas is a performance which may

or may not come off, and such an approach precludes traditional notions of stylistic 'development'.

Finally, I am keenly aware of telling an unfinished story. After nearly half a century of work, Craigie is at the height of his powers, at least in the sense that he is now more likely to paint a significant picture than ever before. This is not because some climax of achievement has been reached, but because practice has made perfection more easily obtainable. As his friend, artist Euan Uglow, puts it, 'Craigie just gets better and better.'

In the annals of British art there is nothing unusual about an artist ploughing a lonely furrow. William Blake, working in an age when stylistic individualism was shunned not courted, is an obvious example. Nearer our time, Stanley Spencer and L. S. Lowry convincingly asserted the artist's right to be idiosyncratic. But it was not until the 1960s when Francis Bacon's distinctive individualism first began to be appreciated that a British artist's peculiar vision achieved legitimacy as an essential element of the contemporary *zeitgeist*.

Craigie Aitchison's world could not be further removed from the angst-ridden one explored by Bacon, although it is significant that the same art dealer, Helen Lessore, perceived in both artists original talents. In terms of the conviction with which he has investigated his chosen territory, however, Craigie's single-minded dedication has been just as marked.

Certainly Craigie was lucky in discovering his highly distinctive 'self' almost as soon as he began taking painting seriously. Unlike so many of his generation who, trying to 'find themselves' amidst the hurly-burly of postwar London, found themselves destabilised by seductive muses both from across the English Channel and the Atlantic, Craigie Aitchison was his own man from the outset. At the Slade School of Art he took what he needed and ignored what he did not, both from teachers and peers. As the sixties swung, he disdained Pop Art (except

occasionally in spirit) along with everything else that was thrown at him. He knew that such movements had little to offer him. Moreover, for an artist devoid of 'facility' to a degree which might have dissuaded less rounded personalities from even trying to be an artist, stylistic borrowing was never an option.

Nevertheless, all artists require corroboration of their natural bent, and with Craigie this came in his late twenties with his first experience of Italy and Italian Renaissance painting. Helen Lessore even implied that Craigie attempted to take up where the quattrocento left off, and there is something in this; Craigie recognised in Masaccio, Piero della Francesca and Fra Angelico kindred spirits. But it was the clarity of the Italian landscape as much as that in the country's art that confirmed Craigie's belief in his own direction, that spurred him on to pursue his own method of recording a likeness or a landscape, or of interpreting a Crucifixion.

Now that Craigie's near half-century of consistent creativity can be viewed objectively, it would seem that his early decision to leave his native Scotland was a wise one. One wonders how an artist of such febrile temperament would have coped in one of the Scottish art colleges, characterised as they were by a more oppressive approach to inculcating drawing and painterly skills. And yet Craigie's fondness for Scotland has played an increasing role in dictating his subject-matter as the years have passed. And it is not too far-fetched to detect in his basic approach to picture-making a candour which is essentially Scottish. Wit and humour are also inherited qualities.

Finally, I must tackle with the brevity it deserves the misleading impression created over the years by some commentators who have regularly and thoughtlessly described Craigie as 'naïve' or 'primitive'. That such a sophisticated intelligence could engage in any activity which might be described as 'primitive' is ludicrous. When it comes to 'doing the pictures' (as Craigie quaintly refers to his daily activity), few artists are as cerebral and calculating. Each picture depends for its impact on a precise arranging of shapes, tones and colours, and this synthesis is arrived at painstakingly. Superficial simplicity results from the paring away of inessential elements much as a fine poet might hone a verse. There is nothing 'naïve' or 'primitive' about it.

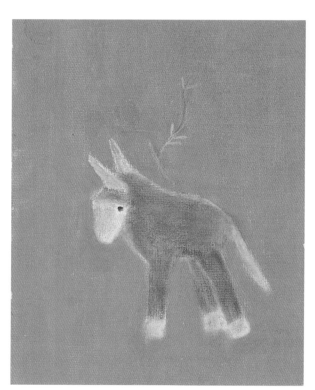

Acknowledgements

Craigie Aitchison is fortunate in having a dedicated band of admirers and my prime thanks must go to the most generous of them; without Robert and Maureen Forsyth and Miles Donnelly this book would not have been published. The Jerwood Foundation, which in 1994 made Craigie the first recipient of the Jerwood Painting Prize, has contributed financial help and support, as has the Milton Grundy Foundation.

Several of Craigie's friends and colleagues have given up their time. I would especially like to mention Myles Murphy and Euan Uglow who transported me back to the 1950s when they, Craigie and several other Slade School of Art students were on the thresholds of exciting careers. One of their number, Susan Campbell, has allowed me to publish an entertaining and perceptive diary she kept while Craigie was making a fine 'portrait' of her dog. Kenneth Lambert and Martin Sherry were invaluable when it came to archive material. Francis Fry has become a friend.

Fortunately, those dealers who over the years have been privileged to show Craigie's work, were conscientious in their archive-keeping, and, in this respect I would like to mention Mark Glazebrook and Rodney Capstick-Dale, formerly of the Albemarle Gallery, and David Grob. Without their co-operation my task would have been much more irksome.

In addition I must thank all those collectors, galleries and other organizations whose 'Craigies' are reproduced here, the photographer Geoffrey Allen for facilitating this in superb fashion, and Maureen Forsyth for locating the majority of the pictures in the first place. The latter was no easy task. For this, for diary-arranging and for her unflagging enthusiasm Maureen deserves special praise.

Finally, of course, the contribution of the artist to a book such as this is more than desirable: it is essential. For Craigie's kindness and patience, I thank him.

ANDREW GIBBON WILLIAMS
Broughton, January 1996

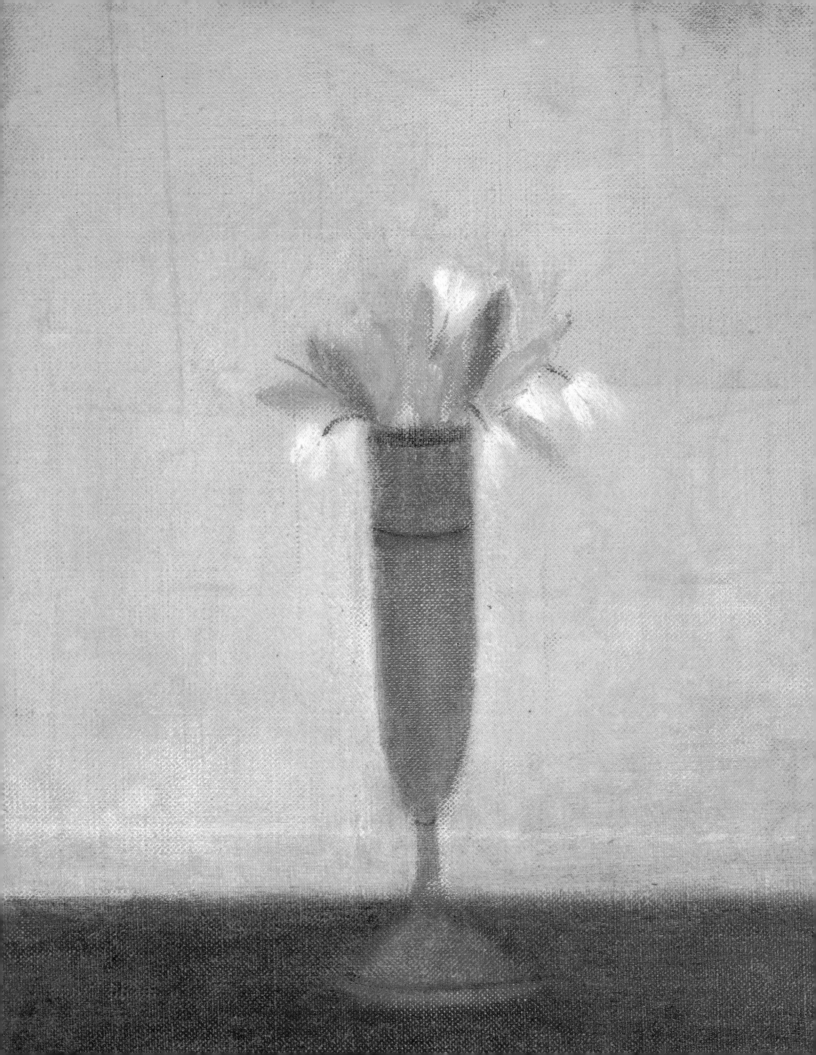

1 Edinburgh, Aitchisons and the Law

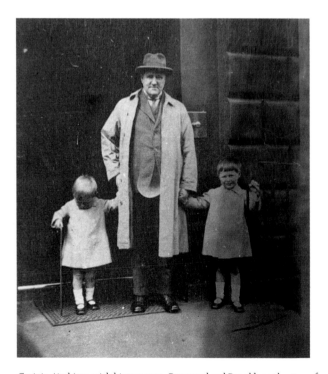

Craigie Aitchison with his two sons, Raymund and Ronald, on the steps of No 12 India Street, Edinburgh c.1929. 'Craigie' is the younger.

1 Crocuses, 1959

London where Craigie Aitchison has lived and worked since the early 1960s is to enter a different world. Walls, ceilings and paintwork glow with vibrant colour, and what must be one of London's most diverse collections of colourful kitsch inhabits every nook and cranny. Somehow the atmosphere contrives to be magical: a small revolving lamp casts a rainbow of colourful shadows; a jug shaped like a fish perches on the mantelpiece; a diminutive madonna smiles benignly down from the comfort of an illuminated mandorla. Craigie's friend, the artist and dealer Helen Lessore, described the atmosphere of the artist's home as 'nightclub' and she was right. There are the dogs, too. A bizarre electric bar fire shaped like a Scottie glows in the grate, while the real licking and panting things, Craigie's family of three adored and excessively affectionate Bedlington terriers, Candy, Dusty and Sunday, bask in its warmth.

Whatever may be said of his house, it is undeniably unconventional; some might call it eccentric. And so the surviving tell-tale evidence of his family roots is all the more surprising. Apart from various pieces of 'good' furniture lurking beneath the colourful collection of artists' 'props', there is a velvet-covered chair with embroidered crest made for George VI's coronation, and a couple of shabby 'red boxes' of the kind brandished by the Chancellor on Budget Day. These are heirlooms, and they point to origins anything but bohemian.

John Ronald 'Craigie' Aitchison was born in Edinburgh on 13 January 1926, the younger son of the advocate Craigie Mason Aitchison and his wife, Charlotte Forbes Jones. The house where he was born, No 12 India Street, stands in one of the elegant Georgian streets of the capital, and brass plaques indicating that the majority of the street's residents are advocates still abound. When the newly married Aitchisons arrived in India Street in 1919, they must have thought it an ideal location from which a lawyer in his late thirties could start 'going places' after the

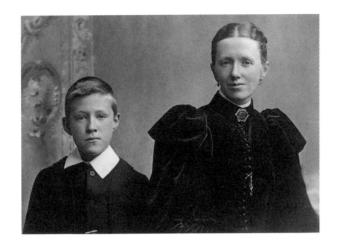

Craigie Mason Aitchison, Craigie's father, with his mother Elizabeth Craigie, c.1894

hiatus of the First World War. The architects of Edinburgh's New Town had provided plenty of room for family-rearing, servants and entertaining.

Perhaps surprisingly for those unfamiliar with a city that, in those days, lived up to its nickname of Auld Reekie more convincingly than now, slum conditions festered in the heart of Edinburgh. The town's eighteenth-century planners had intended it a model housing scheme for the professional class, but very early on it degenerated. Right opposite the abode of the Aitchisons in the New Town then, Jamaica Street presented a vision of Gin Lane, squalor that served as a constant reminder to well-shod residents that the poor were not only with them but near them.

The Aitchisons, however, were not the kind of people to turn a blind eye to grimy reality – their political persuasion saw to that. During the 1920s Craigie Aitchison senior was busy forging a legal career which was to earn him a reputation as Scotland's foremost champion of the underdog (his name was regularly mentioned in the same breath as that of England's greatest criminal barrister, Sir Edward Marshall Hall); but during the following decade he added political laurels to his achievement by applying his intellectual brilliance to the Socialist cause.

Craigie Aitchison's career provides an object lesson in how to win political influence and power. Having tried but failed to win a parliamentary seat as a Liberal, he joined the Labour Party in 1924, and at Kilmarnock in 1929 won a by-election victory for the party which was then embarking on its second spell in power. Already however, he had been singled out for promotion. Earlier that same year, Craigie Aitchison had been appointed Privy Counsellor and the Prime Minister, Ramsay MacDonald, selected him as Lord Advocate for Scotland. And Ramsay MacDonald's faith in the Edinburgh lawyer was soon rewarded: in 1931, unlike so many of his colleagues, Craigie Aitchison agreed to serve under MacDonald in the controversial Conservative-dominated National Government.

Against such a left-wing background, it is hardly surprising to find the Lord Advocate's wife Charlotte running a toddlers' playground for the poor of Jamaica Street, and generally engaging in good works. Her artist son, Craigie, remembers it well.

Politics then, must always have been in the air at No 12 India Street, although Ronald (Craigie was always known by his first name within the family) and his slightly older brother Raymund do not seem to have had their noses rubbed in it. Yet the example of a formidable father is a tricky one for a sensitive child, and Craigie admits to never having been close to a father he remembers as harsh. Furthermore, in the case of the two Aitchison boys what was surely a dominating male presence was made an even harder act to follow by the inspiring shadow cast by an extraordinary paternal grandfather.

Craigie's grandfather, the Revd James Aitchison, who baptised 'Ronald' at his son's Edinburgh home in 1926, was a cleric of extraordinary energy and is by far the artist's most creative and fascinating ancestor. If the concept of hereditary talent has any validity, then Craigie must owe something to the genes passed down from this quarter. The minister not only lived a life of dramatic romance, shocking for a United Free Church clergyman at this period, but transcribed it in astonishing detail. His three-volume autobiography is a colourfully written chronicle of his

times, all the more entertaining and informative for having been penned with a historian's eye to posterity.

The Revd Aitchison had been born in humble conditions in Glasgow in 1846, the son of an unemployed potter and Chartist activist who fled to New York to escape political hounding and unemployment within three years of James's birth. It turned out to be a very bad decision. Having scoured the eastern seaboard for several months looking for work, the enterprising potter expired of sunstroke, still searching.

James and his brothers and sisters then were brought up in near penury by his widowed mother, an industrious lady whose memory stretched back to washing clothes on the banks of the Clyde and drying them on Glasgow Green. James became the very model of the self-educated, highly-motivated Victorian Scot; three-times married, first in secret to an unfortunate Miss Stewart who succumbed to tuberculosis, then to Edinburgh-born Elizabeth Craigie, whereby the name Craigie entered the family, and thirdly to a lady twenty-five years his junior who, not surprisingly, outlived him.

His sincere faith, however, seems beyond dispute. Inside the Erskine Church in Falkirk a carved stone tablet bears witness to the central element in his life's work. It reads *In Grateful Memory of the Reverend James Aitchison, Distinguished Citizen, Theologian and Ecclesiastic, and Minister of this Church*

1875–1930, and was unveiled by his illustrious son, by then Lord Justice-Clerk, in 1935. Having made his way from errand-running and watch-repairing to Glasgow University and Edinburgh's Faculty of Divinity, James Aitchison was called to the Presbytery in Falkirk in 1875 and, over the next half-century, transformed himself into the burgh's most respected citizen. He is credited with having been the driving force behind establishing a decent secondary school in his adopted town.

But this matter-of-fact résumé does little justice to the sparkling personality that comes across in the minister's writings. There are signs of more than a little aesthetic susceptibility, and not only to a pretty female face. He waxes lyrical about Paris, Venice and the Alps and has an eye for telling detail; in short he evinces what may be described as an artistic sensibility. An extraordinary, allusive, photographic self-portrait [*illustrated below*] testifies to both his romantic nature and visual awareness .

So frequently do Scotsmen who make good in public life turn out to be 'sons of the Manse', that it would be surprising had not one of the minister's three sons shot to some kind of fame. Their horizons must certainly have been wider than those of their peers: James junior,

Tripartite photographic self-portrait made by Craigie's grandfather, the Revd James Aitchison, to accompany his romantic poem 'The Transformation', 1901. Note the 'transformation' in the background.

second-born Craigie Mason and the youngest, Bert, were regularly hauled around the Continent by their travel-hungry father, albeit usually on a shoestring. The minister himself accomplished thirteen grand tours in all, travelling as far afield as Algiers and Eastern Europe. It was Craigie, however, who was to fulfil his father's hopes for his children beyond his wildest dreams.

Educated at the Falkirk high school his father had helped establish, the future Lord Advocate embarked upon a career studded with glittering prizes. At Edinburgh University, apart from winning the Vans Dunlop Prize for Mental Philosophy, he was singled out as the most promising civil law student of his year. Called to the Scottish Bar aged twenty-five, he soon won his spurs in the courtrooms of Edinburgh and Glasgow, achieving a reputation for wit,

cogent argument and a capacity for mastering complex detail which was unequalled. His artist son well remembers his father rising at dawn to prepare himself thoroughly for the cut-and-thrust of the courtroom.

It was only after serving with the Royal Garrison Artillery during the First World War, however, that Craigie Mason Aitchison made his mark at the criminal Bar. Three cases in which he defended an unlikely group of clients quite brilliantly put him on the map: the Glasgow Prison Van Murders in which he came to the rescue of a group of Sinn Feiners, a case that became known as the 'Bickerstaff case', and – most glamorously – that of Donald Merrett heard at Edinburgh in 1927.

Of the three, the last was by far the most sensational, and deserves brief description here as an indication of the

Craigie Mason Aitchison at the height of his success in the late 1920s

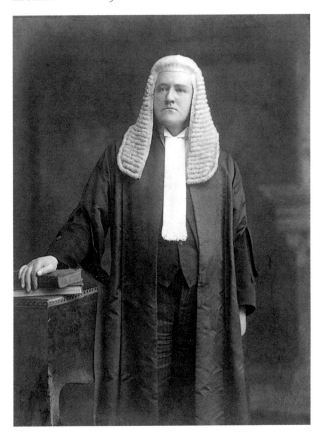

Craigie Aitchison with Sir Arthur Conan Doyle following the successful appeal he conducted on behalf of Oscar Slater in 1928

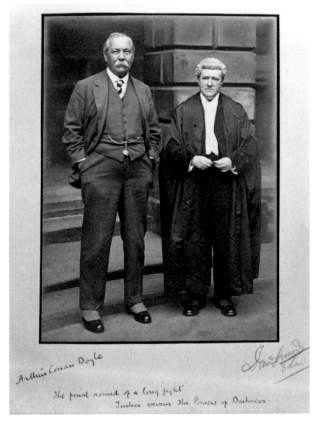

skill and stature of Craigie's father. The legendary case transformed the forty-six-year-old King's Counsel into a national celebrity overnight.

Donald Merrett was a well-built eighteen-year-old Edinburgh University medical student who stood accused of his widowed mother's murder. Mrs Merrett had been found with a gunshot wound to her head and, although she survived her injury for a fortnight, during that time she never positively indicated that her son was the culprit. The circumstantial evidence, however – Merrett had been forging, or 'uttering' to use the quaint Scottish legal term, his mother's cheques – weighed heavily against the apparently nonchalant Donald. But Aitchison, aided by the pioneer pathologist Sir Bernard Spilsbury whose testimony had sent Dr Crippen to the gallows some seventeen years earlier, managed to elicit an instance of Scotland's unique Not Proven verdict from the jury. After serving a twelve-month sentence for the forgery offence, Donald Merrett walked free.

In some respects, Aitchison's skill in securing the Not Proven verdict was rendered even more impressive by the dénouement of the case which touched upon the artist. Twenty-seven years later Lady Aitchison phoned her artist son in London with the postscript to her late husband's most famous case. In 1954 Merrett, having drowned his wife and strangled his mother-in-law, shot himself dead in a wood in Germany where he had been living. Before doing so he had apparently also confessed to the matricide he had committed so many years previously.

Lord Aitchison died suddenly and prematurely at home in India Street in the spring of 1941 and was, therefore, spared any retrospective embarrassment which might have resulted from the ultimate exposure of Merrett's guilt. It was, however, his role in connection with an equally celebrated and no less controversial earlier murder case that assured his widespread reputation throughout his last years as a dogged crusader for justice.

In 1908 a German-Jewish immigrant had been convicted of the murder in Glasgow of Marion Gilchrist, a wealthy elderly spinster. At the last minute Oscar Slater, although sentenced to death, was reprieved and given a life sentence. But already at the time of the conviction there had been doubts raised about the safeness of the verdict, mainly based on the credibility of witnesses at the trial. Slater, however, languished in gaol for nearly twenty years until his case was taken up by Sir Arthur Conan Doyle. A campaign followed and in 1928, Craigie Aitchison KC having conducted the successful appeal, Slater was finally released. The case remains Scotland's most notorious example of a proven miscarriage of criminal justice, and a touchingly inscribed photograph testifies to the esteem in which Conan Doyle held his friend. The inscription reads:

The final round of a long fight
Justice versus the Powers of Darkness.

Successful KCs, even in the 1930s, received respectable incomes (Aitchison's was somewhere in the region of £5000 per annum), and Craigie Aitchison could certainly afford to buy the occasional trinket for his wife as his son recalls him doing. But thrift was not amongst the virtues inherited from the Falkirk minister, and, had it not been for the strikingly more comfortable financial circumstance's of his wife's family, the Aitchisons' standard of living might not have been quite as high as it was.

During the artist's early childhood, for example, Craigie enjoyed the attentions of a resident nanny, and it was, incidentally, one of these who gifted her charge his first art work. The print by an artist called Margaret Tarrant is entitled *All Things Bright and Beautiful* and Craigie still treasures it; the abundant fauna and flora depicted now seems to portend much of his own subject matter.

Craigie's mother, Charlotte Forbes Jones, one of nine children, was the daughter of James Jones, a wealthy self-made iron-founder and timber merchant, who had amassed his fortune by introducing founding techniques developed in his native Wales into southern Scotland; he was an inventor of no mean achievement, glorying in the fact that he had had his own nail – the 'J-nail' – named after him.

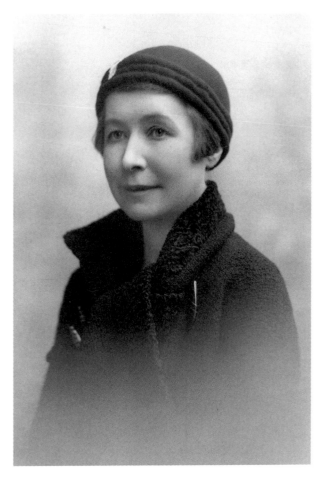

Craigie's mother, Charlotte Forbes Aitchison, the most supportive individual in his life, c.1930

From its establishment in the 1880s, the firm of Jones & Campbell at Larbert prospered, and by the time of Charlotte's early adulthood during the First World War, the Jones family had acquired extensive property in the area. Not only was there Torwoodhall, the family home in Larbert itself, but Tulliallan Castle across the River Forth in Fife, and Middleton Hall, near Gorebridge, south of Edinburgh.

But it was one of the dependent properties that most impressed Craigie as a young boy. The extraordinary 'Dunmore Pineapple' situated in Dunmore Park near Airth in Stirlingshire is undoubtedly the most exotic garden folly in Britain. Built in 1761 by the young Earl of Dunmore, later in life a Governor of New York, the giant stone fruit

(now, since restoration, let by the Landmark Trust for holidays) remains an unexpected focal-point of the area. It is the kind of architectural caprice guaranteed to make an indelible impression on a sensitive young mind, and Charlotte Aitchison took the young Craigie to view it several times. During the first years of the war, prior to Craigie's father's death in 1941, the family actually moved temporarily to the parsonage near to the Pineapple.

As is often the case, the baby of the family was to grow increasingly close to his mother as he grew older, and this enduring bond lasted until Charlotte died in 1970.

Charlotte Aitchison, however, was more of an outdoor type than her husband. During the First World War she drove an ambulance behind the lines in France and later played hockey in Scotland's national team. Her interest in art, therefore, was decidedly less marked than that of Craigie's father. Yet, indirectly, it was Charlotte who was responsible for Craigie's earliest experiences of painting. Her private income facilitated her husband's regular extravagances, and purchasing good pictures featured prominently among them. Charlotte Aitchison also took her younger son to picture galleries.

The art collection Lady Aitchison's background wealth allowed the family to acquire and which surrounded Craigie during his childhood could not be called extensive, but it did contain a number of decent paintings typical of the kind purchased by the city's professional class during the 1920s and 1930s.

Apart from a small oil by David Wilkie, the pioneer early nineteenth-century Scottish painter of genre subjects, the Aitchisons owned an impressive seascape by the Edinburgh-born Scottish Colourist S. J. Peploe, now in Aberdeen Art Gallery, and four pictures by the Scottish specialist in freely impressionistic seascapes, William McTaggart; the best depicted Kilbrennan Sound. A painting of a fir-tree by an artist of the younger generation, William Gillies, was still in Craigie's collection until the 1980s when financial circumstances obliged the artist to sell many of his inherited pictures.

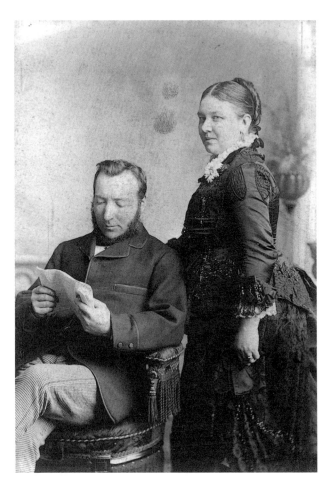

Mr & Mrs James Jones of Larbert, Craigie's maternal grandparents, c.1880

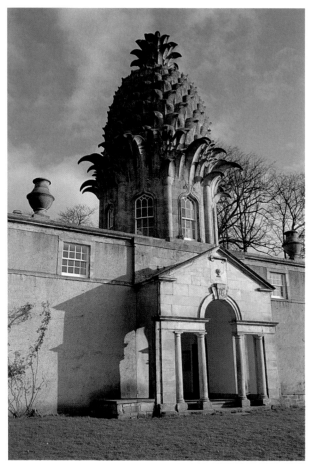

The 'Dunmore Pineapple', the eighteenth-century garden folly near Stirling which belonged to Craigie's Welsh grandfather, James Jones

Not long before Lord Aitchison died, however, he purchased two reproductions of works by Gauguin and another of one of Van Gogh's paintings of irises. These he apparently propped up in their little wooden frames atop his bookcases in front of the McTaggarts and, for his fourteen-year-old son, the flat areas of bright colour, set off as they were against the turbulence of McTaggart, were an introduction to a new and appealing kind of painting. Lady Aitchison thought that this was an indication of how her husband's tastes may have developed had he lived longer.

The lawyer and politician also expressed himself regularly in public on artistic and related subjects. Most notably, he advocated the 'revolutionary spirit' in art at the opening of the 42nd Society of Scottish Artists exhibition, in 1935, going on to inveigh against the timidity of native artists: 'If Scottish art two generations ago had shown something of the boldness and abandon of French art and had not allowed itself to be oppressed by too strong a sense of respectability it would have opened the door to a larger field of vision and achievement.' At the Old Glasgow Club he waxed nostalgic about the city's extinct archaic street names, while at the opening of an exhibition of the city's Socialist Art Circle he demanded why no one had ever bothered to paint Glasgow Green.

When in 1938 it came to having his own portrait painted in all his judicial finery for the Faculty of Advo-

cates, the choice of artist was local man and one-time director of the National Gallery of Scotland, Stanley Cursiter. Sadly, confronted by the judge, Cursiter put in a tame performance far removed from the exciting Cubist experimentation which had earlier marked him out as one of Scotland's most progressive modernists. One is tempted to suggest that Sir John Lavery, an artist who made a much better fist of Aitchison's friend Ramsay MacDonald, might have been a happier choice. Considering Aitchison's appearance and demeanour were occasionally likened to those of Lord Newton, the bibulous judge immortalised by Henry Raeburn in one of his most memorable portraits, it would seem that Cursiter missed an opportunity.

Lady Aitchison's involvement with the arts is less well documented than her husband's although she was one of the vice-presidents of the Scottish Society of Artists throughout the 1940s and into the next decade. She was also among those who, after the war, lobbied for the establishing of Scotland's own modern art gallery, although it was not until 1960 that this event actually came to pass.

But it was Lady Aitchison who introduced her son to what appears in retrospect to have been a seminal artistic experience.

Kirkcaldy may sound an unlikely home for an important art collection. But until it was dispersed in the early 1960s Kirkcaldy Museum & Art Gallery housed a loan collection of French and Scottish pictures of exceptional quality. The owner, local linen manufacturer John Waldegrave Blyth, collected in the same areas if not on quite the same scale, as the Glasgow shipping magnate Sir William Burrell, and, like Lord Aitchison, he collected William McTaggart.

It was on a tour of the gallery with his mother conducted by Blyth that Craigie enjoyed his first meaningful experience of a first-rate modern picture. The collector – his generosity perhaps prompted by the presence of the captivating Lady Aitchison – asked which of his pictures her little boy would like as a gift, and was astonished when Ronald immediately pounced on the jewel of his collec-

tion. What the boy desired was the tiny landscape by the French artist Édouard Vuillard. Not surprisingly Mr Blyth refused it him.

That Craigie should have had the taste to choose this particular picture at such an early age is significant. Of all the pictures in Blyth's collection, Vuillard's *Les Toits Rouges*, painted in 1890, was the most historically important. It is demonstrably unfussy; the simple scene is described in broad swathes of flat muted colour, brought to life by the brilliant orange accents indicating the tiled roofs. The work represents a milestone in the development of Vuillard's art and marks the painter's conversion to the aesthetics of the Nabi group. It was painted probably from memory in an attempt, in line with Nabi philosophy, to imbue the subject with the artist's feelings about it rather than simply describe it. But for Craigie it was the clarity of the image which constituted its chief appeal. The majority of Craigie's best pictures depend for their impact on precisely this quality.

In spite of the artistic leanings their son evinced, however, the Aitchisons do not seem to have taken them into account when it came to choosing a suitable school. Living in the south of Scotland there was no lack of choice, not least in Edinburgh itself, where schools such as Fettes

The painting most admired by Craigie as a child, Édouard Vuillard's Les Toits Rouges (Paysage), *1890, 23.5 × 29 (Private Collection)*

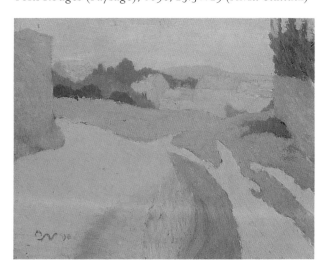

College and George Watson's were the traditional educational repositories for sons of notable lawyers. But the Aitchison lads found themselves despatched little more than half an hour east of the city along the coast to Loretto School in Musselburgh.

Named after the chapel of Our Lady of Loretto which once stood on the same site (and for the final destruction of which during the sixteenth century the reforming citizens earned themselves an annually re-imposed papal excommunication), Loretto School dates from the 1820s and originally drew its constituency of pupils from worthy local families with episcopal leanings. It claims to be the oldest boarding school in Scotland.

From its founding, however, the traditions of the school were very much of the fresh air, clean minds, clean bodies variety, and the emphasis, if not anti-academic, was certainly on field sports and healthy boyish activity. The school's roll call of headmasters bristles with sporting achievement, mostly on the rugby pitch, and Dr J. R. C. Greenlees whose régime held sway during Craigie's time at the school from 1936 to 1941, although previously a physician by profession, had also played rugby for his country.

This was certainly not the ideal place to send a sensitive boy with artistic leanings, and Craigie has few happy memories of the place. He received regular beatings for cutting corners on the compulsory cross-country runs, and although there was an art master, he did not attend art classes. Indeed, the only creative experience with which Loretto appears to have blessed the future artist was by way of the science class; Craigie remembers making outline drawings of the various practical paraphernalia presented to him and diligently colouring in his efforts.

Within the family, however, there was certainly no active discouragement of young Craigie's keen visual sense. Lord Aitchison delighted in a fine view, especially those offered by the incomparable landscape of Scotland's west coast, and this love of scenery he eagerly passed on to his children.

The Isle of Arran, the famous beauty spot in the Firth of Clyde, was at the top of his list. Lady Aitchison had known the place since her childhood and introduced her husband to it; it was a wonderful place for family holidays. From the early 1930s the entire Aitchison clan, therefore, complete with servants, cat, dog and canary, would take off for several weeks each summer to Arran where they rented a house called Miramar in Lamlash that overlooked Holy Island. In later years they used to take the Old Manse in Brodick.

These family holidays on Arran form Craigie's happiest childhood memories, but the Aitchisons could not have anticipated the life-long impact the holiday island would have on their younger son: Arran has continued to haunt the artist's imagination, and the salient aspects of its scenery have played a most significant role in his subject matter. The view of Arran's highest peak, Goatfell, and that out across the minch from Lamlash towards Holy Island have become virtual *leitmotifs* in Aitchison's work. Goatfell appears hesitantly in certain religious paintings as early as 1964, and in several canvases painted during the early 1990s it is the principal subject.

In spite of his distaste for the general scheme of things at Loretto, Craigie proved himself an academically competent pupil. But in 1941, after the death of his father, he was only too happy to leave, under the pretext of needing to be more readily attendant on his widowed mother. The fifteen-year-old, however, still needed to pass the School Certificate if he was to have any hope of higher education, and so, for the next two years, in addition to lessons at home from a governess, he attended the local 'crammer', Basil Paterson & Ainslie.

Private tuition seems to have done the trick, and Craigie departed Basil Paterson in 1943 clutching more than acceptable grades in all subjects with the exception – ironically, in view of his father's habit of subjecting the family to a different church almost every Sunday – of Religious Knowledge. There were, however, still two years of the Second World War to run, and, briefly, it looked as if

conscription into the services was to interrupt Craigie's career much as it had his father's.

The experience would surely have proved vastly more unpalatable than the rigours of Loretto. But here Craigie was fortunate. A recent nose operation coupled with earlier appendicitis might not have been sufficient to elicit the local Conscription Board's mercy. A letter from Dr Ninian Bruce of Morningside Asylum however, swiftly ensured Craigie's rejection; Dr Bruce's name was unequivocally linked with certifying criminal insanity in Edinburgh's courts. 'They were immediately convinced I must be a loony,' recalls the artist.

At this stage Craigie had no burning ambition as far as his career went, and when in the following year he enrolled at Edinburgh University to study law, it came as no surprise to his family. The vast law library Lord Aitchison had left at India Street and which had set the tone for Craigie's childhood, had always fascinated him, so following in father's footsteps seemed the logical, almost preordained option. Craigie, however, found slaving away in the university's libraries boring in the extreme; trying to master the complexities of British history and jurisprudence was soul-destroying. Nor can his enthusiasm for his courses have been helped by his mother's jaundiced opinion; Lady Aitchison made no bones about the fact that she had always felt the law to be 'sordid'. Yet the practical operation of the law, the drama of the courtrooms in which his father had played such a leading role, did attract him, perhaps because it brought into sharp focus the personalities of the participants. Craigie was then frequently to be found savouring the spectacle of the law rather than attending lectures about it.

So, it was a general disenchantment with his studies coupled with a growing desire to escape the social confines of a city whose conservative character had yet to be transformed by the Edinburgh International Festival, that prompted Craigie's move to London in 1948. Here, he was to spend three years at the Middle Temple in preparation for the English Bar. Once again, however, the theatricality of the courtroom proved too much of a temptation; lectures were missed and exams passed (if sat at all) thanks only to cheating. And then, of course, the metropolis, even during this austere post-war era, had many other distractions to offer.

Not least among them were its art galleries, and Craigie spent many afternoons wandering entranced through the National Gallery, admiring the early Renaissance paintings and anything else that took his fancy. There can be few better places to excite a nascent desire to paint, and it was really during these excursions that his artistic ambitions were fired.

The problem, however, was how to go about it. Craigie, of course, had missed out on the natural progression from school to art college, and so, in a pragmatic frame of mind typical of a lawyer, he took the kind of step a late-flowering amateur might take: he began copying pictures. The first he chose turned out to be prophetic in a way. It was a portrait of Dorelia in the Tate Gallery by Augustus John, the most famous alumnus of the art school Craigie was eventually to attend. The artist well remembers his faltering attempt being interrupted by an American who suggested he might follow John's example by beginning with a pink-primed canvas. Craigie started afresh.

Yet even having embarked upon some kind of path towards becoming an artist, it took some time before Craigie was wholly convinced; and, while taking a desultory attitude towards his law studies, he continued to make occasional forays into other possible career territories, some bringing unexpected results.

In an almost farcical episode, for example, having purchased a book entitled *How to be a Secretary* by one Percy J. W. Daniell, Craigie wrote to the author in the hope of eliciting more personalised advice. What came back was an invitation to attend Daniell's wedding in Cumbria in the capacity of best man (the author's 'friends at the Bank of England' were too busy it seemed). Craigie promptly accepted; and so, kilted and sporting a red rose, the law student travelled to Carlisle, made a speech at the wedding

2 Landscape at Tulliallan, 1950

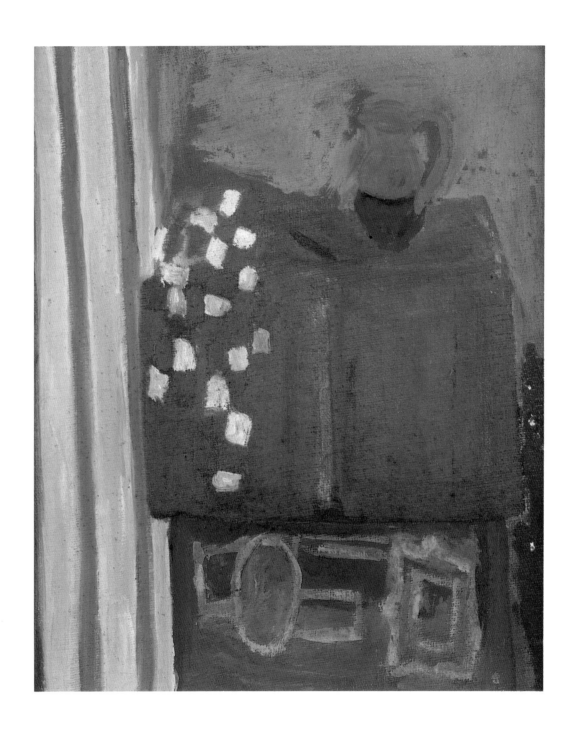

3 Still-life with Jug and Check Cloth, 1952

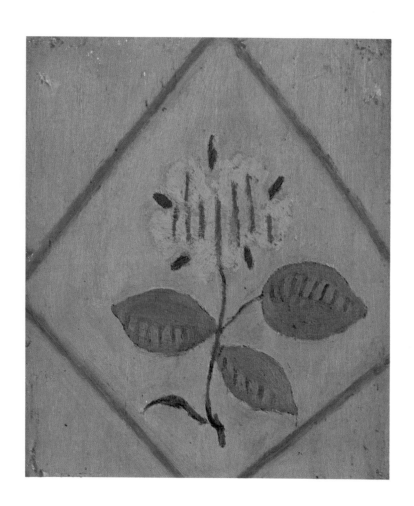

4 Dovecot Tapestry Still-life, 1952

of a total stranger, and returned to Edinburgh with a new watch for his pains. It was their only encounter, and, needless to say, Craigie never learnt to be a secretary.

It is a characteristic Craigie story, and no less so were his next moves to cross the divide which separated the dun-coloured prospect of a club life in courtroom and library from the brilliant-hued possibility of one clutching palette and brush.

At the suggestion of a friend, Craigie began taking private lessons from an artist and teacher called Adrian Daintrey. Theirs was not to prove the most fruitful of relationships: Daintrey was of seriously academic bent, and scarcely the kind of man who could single-handedly transform an unenthusiastic law student into an artist. But Craigie persevered for a period of four months, making almost daily trips to Daintrey's Chelsea studio. Here, he was obliged to make laborious perspective drawings of the master's rooms and even of his bed, while Daintrey got on with his own work, painting mainly local street scenes and still lifes.

Craigie found some of the exercises set by Daintrey, copying a watercolour by the eighteenth-century English artist John Sell Cotman for example, 'fantastically difficult'. But, no matter how unconstructive Craigie found his teaching methods, Daintrey was at least perceptive enough to see that his pupil needed the stimulus of an art college. He advised Lady Aitchison, during one of her periodic visits to London, that she should encourage her son in this direction, and once even went as far as telephoning his friend, Rodrigo Moynihan, then Professor at the Royal College of Art, to arrange an interview for his pupil. Craigie, perhaps unaware of the magnitude of the honour, promptly objected, saying that maybe he should look around first.

Daintrey though was not Craigie's only stab at private tuition. Late in 1951 he began making his way to Muswell Hill in the hope of receiving from the artist Gerald Frankl what he felt had been absent from Daintrey's teaching.

If not as conventional in his approach as Daintrey, Craigie found Frankl almost equally unhelpful. Handicapped, as Craigie saw it, by an almost obsessive fascination with Cézanne, Frankl seemed unable to tailor his tuition to somebody who, even at this stage, was showing a distinct and original painterly personality. Yet the encounter with Frankl had one positive outcome: Frankl lectured on Cézanne occasionally at the Slade School of Art, part of University College, and it was this connection that first suggested to Craigie that the Slade might be a possible solution to his problem of achieving a proper art education.

It was at this stage that Craigie embarked upon the plan that Daintrey's call to Moynihan had earlier suggested. For several days he scoured London's art colleges until he found one that he felt would be conducive. First came Camberwell; then, from the Royal College in Kensington, he went on to the Central and St Martin's. Not until he arrived at the Slade School in Gower Street, however, did he feel 'right' about it. 'The Slade was by far the nicest,' Craigie recalls, 'with the garden and the staircase and the dome and everything. So I thought: This is the one!'

Although, by this period, the Slade School had become used to accepting 'mature' students whose educations had been interrupted by the war, acceptance into a college which catered for less than a hundred students was by no means easy. And, in this respect, the reference Gerald Frankl provided for Craigie must have carried weight. Frankl wrote to his colleague, the Slade Professor Sir William Coldstream, 'I have found him eager to learn, and, as far as I can say, probably gifted: at any rate he is "out of the ordinary" in a positive way.' It was a perceptive observation, and earned Aitchison a place at the Slade where he enrolled as a part-time student in October 1952.

The Slade was to transform Craigie in many ways, but it is clear from the works he had already completed before he began his serious studies, that it also consolidated the artist in the direction he had, independently, found.

What must be considered Craigie's first professional painting, for example, a landscape painted at home in Scotland at Tulliallan in 1950 [2], is a surprisingly mature

picture for an artist yet to receive any kind of formal art education. The brushwork – the confident fluidity with which the greenery has been described – might easily lead some viewer, even an expert, to ascribe the picture to Bonnard, or perhaps to Renoir. But it is the simplicity with which Craigie has organised the composition which portends the way he was to tackle so much later work. There is no element of bluff about the picture; nor, and this is most striking, is there any attempt to paint finicky detail. The landscape is seen in terms of broad areas of tone.

Much the same might be said of a painting Craigie completed the following year, but which is now, unfortunately, in too poor a condition to allow it to be reproduced. Again it depicts a scene not far from Tulliallan, but this time he chose a view of extreme banality, comprising a perfectly horizontal horizon punctuated by the silhouettes of four telegraph poles. Again the paint is loosely and lightly scumbled on to the piece of hardboard Craigie used as a ground, but here the emphasis is on the oddness of the effect created by the telegraph poles. An ability to perceive the peculiarity in the commonplace is intrinsic to Craigie's art and this is the first significant instance of it.

The impression that Craigie was a fully-fledged artistic personality before he began studying at the Slade School would, however, be misleading. A number of still-lifes painted in the studio he kept for a short time at Church Lane in Edinburgh in the early 1950s form a distinct contrast to the only slightly earlier landscapes and seem far less informed by Craigie's idiosyncratic visual sense.

They consist mainly of jugs, fruits and other conventional still-life elements placed on cloths and cupboards [3]. The colours are bright and the compositions straightforward. Horizontal surfaces are tilted forwards in the direction of the picture plane, very much in the post-Cézanne manner favoured at least since the 1920s by several generations of not particularly distinguished British still-life specialists; and – unusually for Craigie – the oil paint is applied with a tangible impasto.

Yet, while the overriding impression they create is one of stylistic uncertainty, they already show Craigie composing pictures in terms of flat, succinctly modelled shapes floating on simple colour grounds. This is particularly noticeable in a picture he made based upon the design of a tapestry made by the Dovecot Studios in Edinburgh for the back of a chair belonging to his mother [4]. The emblematic flower, painted with spontaneity and with paramount concern for its decorative integrity, floats within its lozenge upon a pink ground. The result is that the flower acquires a spurious but very attractive symbolic significance. When it came to tackling similar subjects at the Slade School, Craigie saw no reason to modify this unusual quality.

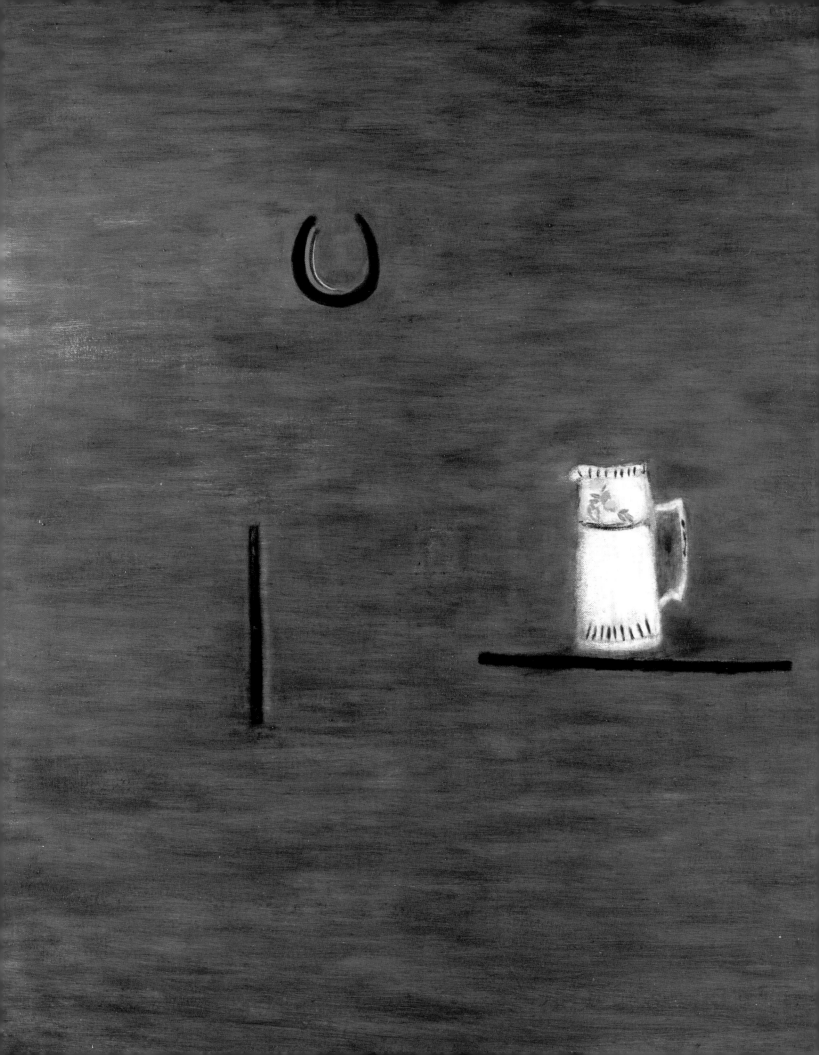

2 London, the Slade and Italy

Slade School treasure an amusing memory of him. His dog, a beagle named Somerset, would appear from around a corner, and then what seemed like an age would pass until Craigie, with his characteristic ambling gait, materialised at the other end of a very long chain. Craigie and Somerset were inseparable [6]. On his first day at the Slade another student, Victor Willing, directed Craigie to the basement where – he lied – the janitor responsible for dogs would look after Somerset. When Craigie attempted to hand over his cherished dog he was confronted by a bemused then indignant janitor.

Somerset was to be part of the reason for Craigie's itinerant way of living during his first decade in London. When in 1948 he first arrived in the metropolis to begin his studies at Middle Temple, the reluctant law student found lodgings in an oppressively respectable house in Montpelier Walk in Knightsbridge. It was Somerset who ensured their stay was short; objecting to the preposterous rule that she was not to use the spare bed in Craigie's room, the dog protested in the conventional canine manner – on the carpet. Both tenants were obliged to leave, but, luckily, Craigie soon found a more relaxed environment.

The room in the house at 19 Adam's Row off South Audley Street in Mayfair was advertised in the Mayfair branch of the English-Speaking Union, an organisation

5 Jug and Horseshoe Still-life, 1952

6 Somerset – Little Head, 1965

that in those days acted as a kind of club for expatriate Scots. It was rented by Michael Blakemore, a young Australian then training to be an actor at the Royal Academy of Dramatic Art just along the street from the Slade School. Blakemore, later to become one of Britain's most successful theatre directors, together with his flatmates took a shine to Craigie and they agreed to let the art student – and

Craigie while studying law at the Middle Temple in 1948

his dog – stay. That the female resident at Adam's Row turned out to be secretary to Edith Sitwell, an icon of English eccentricity in the 1950s, added a further artistic dimension to the household.

Michael Blakemore's experience and worldly manner did much to ease Craigie's transition from the tight, circumscribed ambience of the Middle Temple to the free-thinking artistic life, and it was the months he spent at Adam's Row that really initiated Craigie into the more sympathetic, bohemian and stimulating side of London.

Blakemore remembers Craigie at this time sporting a three-piece tweed suit made deliberately a couple of sizes too small and ordering bespoke shoes with the unusual specification that there should be no shine to the leather; apparently when the shoes eventually arrived they resembled pieces of old tyre! 'He looked like the New Boy arriving at a particularly unpleasant boarding school,' recalls Blakemore, adding perceptively 'he was one of those people who, in a word or two, or simply by the way they respond to something that amuses them, seem to offer up their entire personality.'

Thanks to the freedom allowed them by the rather flashy 'Singer Le Mans' sports car Craigie owned at that time (Blakemore reckons Craigie deliberately kept it uncleaned), Blakemore and Craigie were able to get out of London, on theatrical jaunts to Stratford-upon-Avon for example. And the would-be actor, two years the art student's senior, did his best to make his new friend feel comfortable among other creative people. It was during this happier period that Craigie made his first realistic effort to change direction by taking private painting classes.

This pleasant location, however, was by no means the final solution to Craigie and Somerset's accommodation problems. Over the next two years art student and beagle moved to several other addresses, and all of these in one way or another conspired to give Craigie a broader impression of metropolitan life.

During his first term at the Slade Craigie found lodgings not far from the Slade School just off Baker Street in

Gloucester Place, Marylebone. It was not the best of experiences: a clumsy attempt at seduction by a Dutchman in a neighbouring room, not to mention Somerset's devouring of a lady resident's shoe, again made him *persona non grata* after a relatively short time. But even this was less unsettling than subsequent accomodation. In a room in the Portobello Road, Craigie, usually a sound sleeper, instantly found himself insomniac. It transpired that only a week earlier a man had hanged himself in the same room. Not until the last term of his final year at the Slade after experiencing the delights of hotels in Bloomsbury and nearly eighteen months in the Slade's own hostel, did he 'find a niche' when he joined what would now be termed an artists' commune, 22A Lower Marsh near Waterloo Station.

Such an unsettled existence might have been more disruptive for a new art student had not Craigie quickly become enthusiastically involved with the new kind of life the Slade School offered him. 'I was in paradise,' recalls the artist. Both the fact of his coming late to art school and the difficulty he had in getting there undoubtedly made him more committed. Even during his first, part-time year, for example, Craigie surreptitiously began exceeding his allotted time of three days per week. During his second year he increased his quota to six days.

Superficially the Slade School would not have seemed the ideal choice for a twenty-six-year-old student who had already displayed predilections for painting in a markedly unconventional way. At the heart of the Slade tradition had always lain an emphasis on mastering academic drawing techniques. But Craigie had shown very little inclination to 'learn to draw', and indeed was never to become an accomplished draughtsman in the ordinary sense; neither has he ever, for that matter, utilised drawing as a preparatory stage towards making a painting.

Of all London art colleges, the Slade, since its founding in the 1870s, had built up the most ambivalent of traditions; and this was important even as late as the early 1950s for someone like Craigie. For at the Slade he found his natural bent both denied and facilitated by the kind of teaching delivered and the general ethos of the school.

While on the one hand the Slade stressed the necessity of students learning some kind of academic, representational means of drawing, an aspect of its teaching that dated right back to the early professorships of Edward Poynter and Alphonse Legros, on the other there was a general openness to progressive ideas. This had its roots in the approach of Frederick Brown, Henry Tonks and Philip Wilson Steer among others, who had all taught at the Slade during what is considered its heyday, the first twenty years of this century. It was during this period that English art was first obliged to come to terms with avant-garde art movements issuing from the Continent, and it was here that the Slade made its mark.

Although Tonks, Slade Professor from 1919, and his colleague Steer were eventually to turn in dramatic fashion against the ideas of Post-Impressionism, for example, it is surprising how many progressive figures in English art are numbered among the Slade's alumni. Mark Gertler, Paul Nash, Duncan Grant, Wyndham Lewis, Matthew Smith and Ben Nicholson all passed through the Slade's doors at one time or another. And it may well be argued there is nothing unusual about an art college that could foster a talent as individualistic as Stanley Spencer, also helping Craigie Aitchison. Augustus John, the most brilliant and celebrated of all Slade students, set an example of artistic self-consciousness which Craigie, inadvertently, has followed with dedication.

A further aspect of the Slade tradition that Craigie seems to have absorbed during his seminal two years at the school was its francophile tendency. The Slade's history of cognisance of French twentieth century art movements is a chequered one; but even during Tonks's day, when students were apparently actively discouraged from looking towards France and the Post-Impressionists for inspiration, there seems to have been a sneaking respect at the Slade for French 'stylishness'. By the early 1950s, under the broad-minded offices of Professor William Coldstream, this had matured

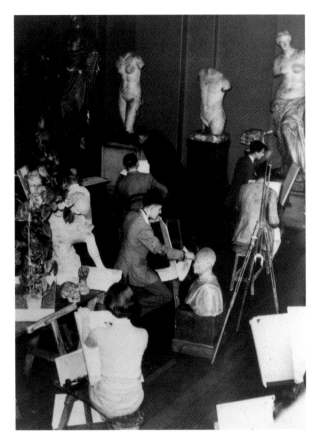

The Antique Room at the Slade School of Art as Craigie knew it in the early 1950s (Slade Archive)

into a healthy respect for unconventional talent.

Helen Lessore, the artist and director of the Beaux Arts Gallery, and the first dealer to perceive Craigie's unique qualities, certainly recognised in him a non-English sensibility. 'Of all the artists now working in Britain, there is none with such a naturally Mediterranean soul as Craigie Aitchison,' she wrote in 1975. Elsewhere, Helen Lessore refers to the artist as being 'uncontaminated' by the Slade, by which she presumably meant that the strict instruction in naturalistic draughtsmanship for which the school is famed had passed him by. Lessore was forgetting the multi-stranded nature of the Slade tradition; more importantly she was ignoring the fact that artists often benefit unconsciously from that to which they are exposed during formative art school years.

Craigie retains the greatest respect and admiration for William Coldstream and for the circumstances for which he was responsible at the Slade in the early 1950s. The artist was never directly taught by Coldstream and, as a part time student, was not obliged to take the college diploma and therefore was never subjected to the kind of disciplines that were enforced on full-time students; Craigie was not obliged to submit life drawings for criticism for example. Nevertheless, according to many students at the Slade at that time it was Coldstream's personality that coloured the atmosphere of the school and this had its effect on Craigie.

The Slade Professor of Fine Art who had taken up his post only three years prior to Craigie's arrival certainly detected something valuable in Craigie Aitchison. When, after being 'found out' for breaching his part-time status, Craigie applied to attend classes full-time, he heard nothing for six weeks. Passing by the Professor's office one day, however, he found the pictures he had submitted in support of his application – they included a copy of a Rouault – propped up admiringly on Coldstream's mantelpiece. 'That's fine. Of course you can come full-time,' Coldstream responded nonchalantly to Craigie's inquiry.

Coldstream's catholic approach to teaching at the Slade

was largely a result of his personal reaction against his own experience there as a student under Tonks in the 1920s. 'We were supposed to draw like Leonardo da Vinci or Ingres,' he quipped. 'Painting was taught in the Velázquez / Manet tradition'. Coldstream and Slade students of his generation such as Claude Rogers, as well as successors such as William Townsend, who did teach Craigie, saw through the inherent fallacy in the academic nostrum that fine painting resulted – logically – from technically accomplished drawing. It was for this reason that, under Coldstream's régime, a student like Craigie could 'get away' with never mastering the basic drawing techniques; twenty years earlier when Randolph Schwabe was in charge it is unlikely that Craigie would even have got across the threshold of the Slade.

Drawing, nevertheless, was still the linchpin of the Slade curriculum under Coldstream and diploma students at the school in the early 1950s followed a rigid programme of drawing from the life model as well as from the casts in the Antique Room. Among them were Myles Murphy and Euan Uglow who were to become Craigie's closest personal friends. Having found himself painting next to Myles in the studio, Craigie's first social encounter with the pair was on a bus in Tottenham Court Road. 'Your picture's so good. I wish I could get it like that' Craigie said in his disarmingly mild manner to Myles. The next day Murphy, rather thrown by such admiration, took down the picture he was working on and relocated himself within the studio. This was the beginning of an enduring friendship.

Murphy and Uglow were virtual protégés of Coldstream during their time at the Slade. Uglow had already studied at Camberwell School of Arts and Crafts where Coldstream had been Head of Painting before promotion to the Slade professorship, and the painting of both artists owes much to what was learnt first-hand from Coldstream. Much of this related to the necessity of 'measuring' out the image with the utmost objectivity and precision before and during the painting of it, and the marks – small strokes and

Sir William Coldstream, Slade Professor of Fine Art 1949–75, one of the first to appreciate Craigie's talent (Slade Archive)

crosses – which are a characteristic feature of both artists' work were very much a response to Coldstream's teaching.

Craigie was never wholeheartedly to adopt this method, distinguished very noticeably as it is by measuring marks left visible in the finished work, perhaps because his art depended from the outset on an emotional involvement with the subject. But he certainly learnt from Murphy and Uglow the necessity of measuring out invisibly a painting in order to achieve a resemblance to reality. 'Unless I'd learnt that' he admits, 'I could never have done my portraits.'

Overwhelmingly, however, it was the general philosophy of the Euston Road School, of which Coldstream had been a founder member in 1937, that Craigie absorbed during his two years at the Slade School.

This was less a formalistic lesson than a general attitude towards picture-making that stemmed from the Euston Road School's reaction against the pretensions of Abstraction and Surrealism which had dominated so much painting, both on the Continent and in Britain, during the 1920s and 30s. A picture drew its integrity from the fact that it was at least based upon observed reality, however else it might be interpreted. Craigie always thinks and talks in formal terms about his painting, whether it be a portrait of a black model or a still-life; the authority of his interpretations of the Crucifixion derives from his resolute refusal to delve into the sentimental associations of the subject.

There was certainly a political element underlying the aesthetic philosophy Craigie imbibed at the Slade. Coldstream himself had become convinced of the need for painting to be socially useful during the Depression of the 1930s when he had collaborated with the film-maker John Grierson and the poet W. H. Auden on documentary films. Considering Craigie's politically tinged upbringing, it is hardly surprising that such involvement heightened the appeal for Craigie of Coldstream's Slade.

Unlike his diploma colleagues, Craigie was not tied to an individual tutor and had the freedom to consult whoever he wished. Thomas Monnington, at that time one of the many distinguished visiting lecturers of the older generation, was the most outspoken in his disapproval of Craigie's work.

Monnington was one of the tamest of former Slade students who had trained under Henry Tonks in the years immediately after the First World War, and was not the most open-minded of tutors. Unlike his more imaginative old friend Coldstream, Monnington was blind to the qualities in Craigie's painting. Once, Craigie had the audacity to descend to the male life class from the Antique Room where he had been painting, only to find himself humiliated by Monnington who greeted him with an extraordinary put-down. 'I suppose you brought your work to show to the Slade Professor!' he blurted, implying that Coldstream should never have let him in in the first place! Craigie quickly retreated. Monnington's later advice that he should try and get to grips with anatomy and perspective Craigie found insulting.

Others were equally dismissive of Craigie's art school efforts. Victor Pasmore and John Piper, two of the better known of the visiting lecturers, suggested in no uncertain terms that he was wasting his time. (Pasmore, who, along with Coldstream had been a driving force behind the Euston Road group in the 1930s, should have known better.) Yet Robert Medley, who during the 1950s was Head of Theatre Design at the Slade was unswervingly supportive and encouraging. Perhaps it was the very subtle sense of theatricality which permeates Craigie's approach to painting that enamoured Medley, and Craigie was also reassured by the praise he received from L. S. Lowry. But fellow students, and Victor Willing and Tony Pacitti in particular, were as much if not more help to Craigie, and it was Euan Uglow who, taking him under his wing, explained how to perceive and transcribe the relationships of forms and shapes to one another – the 'visual proportion' of things to use Myles Murphy's phrase.

As is usually the case with student work, very little of the painting Craigie accomplished while at the Slade survives. Nevertheless, that which does is astounding for two

reasons. First, it is surprisingly sophisticated for student work; second, it demonstrates that even in these earliest years, he had identified his strengths and was already moving in a very definite direction.

A still-life called *Scissors and Pink String* was clearly admired by Coldstream, for it was the Slade Professor who picked it out as being prize-worthy; Craigie received a worthy book of essays called *Artists on Art*. Unfortunately, however, in a fit of pique over its only half-achieved aims, and in spite of the prize, Craigie later destroyed this particular work. But a larger and more ambitious still-life does survive in University College's own collection of works by past Slade pupils. It is called *Jug and Horseshoe Still-life* [5] and is notable inasmuch as it was a ground-breaking work and convinced Craigie that the simpler he made his pictures, the more impact they would have.

Unlike the still-lifes with which the artist had experimented before his arrival at the Slade, here there has been no attempt to create illusionistic space, nor even to refer to it. The main elements of the picture, the simple black horseshoe shape and the flower-decorated jug, float against a ground of rich magenta purple. Apart from a second black vertical to the left of the composition which alludes to a partition against which the original still-life had been set up, there is nothing else at all in the picture. Indeed, the real subject is the ground as much as it is anything else. A clock Craigie had originally included, he later painted out, having re-primed the canvas on the advice of Robert Medley. The translucence of the ground was, Craigie knew, important to the success of the picture and there was no way he was going to lose it.

Jug and Horseshoe Still-life, in its sheer flatness, betrays a knowledge of American 'colour field' painting which, at the time it was painted, was already becoming a talking point in British art circles. But from the point of view of Craigie's later painting, a more important thing about it is the way the main elements teeter on the brink of becoming symbols of themselves; the jug's form is merely indicated while the horseshoe has been left little more than a hieroglyph. This was a way of describing things that was to become central to Craigie's art, and this is more or less the first instance of it.

While the thickness of the paint in *Jug and Horseshoe Still-life* is evidence of the struggle Craigie went through to realise this important picture, other works painted at the Slade show the artist more persuaded of what might be termed the school's 'house style'. Craigie was not immediately accepted into the most testing life painting class organised by Coldstream at the Slade. Here, a nude model would retain the same pose for six weeks and so very considered works were supposed to result; only the most advanced students were deemed eligible.

Eventually, however, Craigie was allowed to join his friends Murphy and Uglow and, in the life painting he produced showed himself perfectly capable of the kind of subtle tonal study of which the Slade wholeheartedly approved. *Nude - Jackie Seated* [7] is a lovely lyrical ghost of a picture in which nothing has been left to chance while, at the same time, the general effect is almost casual. It could easily hold its own beside any of the figurative works Pasmore produced before his momentous conversion to the virtues of abstraction. But it is the way Craigie has stained the canvas more than any other feature of the picture that most strikingly asserts the artist's individual personality – even though students at the Slade were never actively encouraged to take advantage of the vast range of textures allowed by oil paint. This wispy nude, however, is an extreme example of a young artist restricting himself to glazes.

If the lessons learnt in painting *Nude - Jackie Seated* were predominantly technical, then in a related, more complex work these were put to the service of more poetic aims. *Girl in Field with River* [8] must be judged Craigie's first wholly confident, large-scale composition. Again, simple and clearly defined elements – a girl's head in profile, a chalky blue line – float on a translucent ground, this time an unusual lime green. The blue line is perplexingly abstract, juxtaposed as it is beside the profile, and

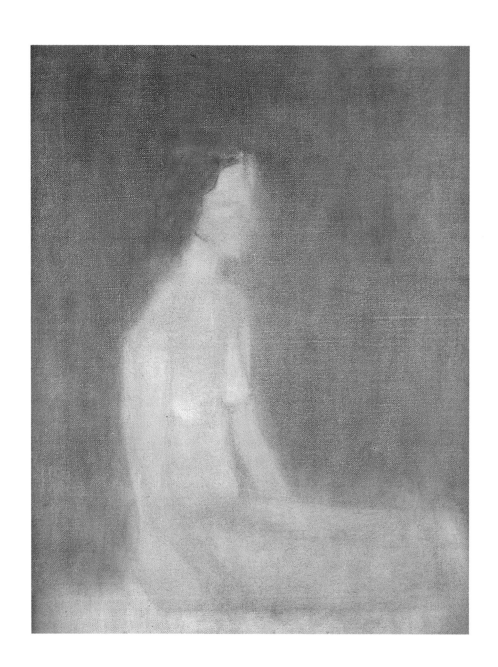

7 Nude – Jackie Seated, 1953 **8** Girl in Field with River, 1953

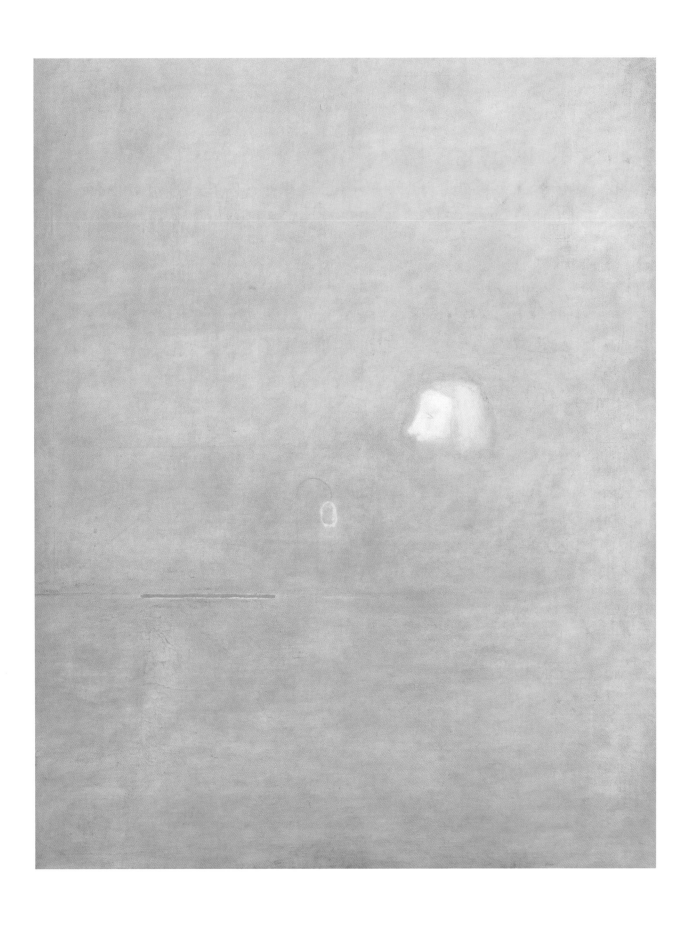

38 yet it came about in a mundane way. Craigie was having difficulty painting a 'real' river and asked the advice of Victor Willing. His response was simple, 'Just put in some blue.' Perhaps he did not expect Craigie to take him so literally, but the result is a decorative visual metaphor that looks quite logical in its context.

Apart from drawings, most of which are unfortunately lost, Craigie made several other paintings while still at the Slade which are quite mature-looking. A number of small-scale portraits of the girl with whom he was for a time romantically involved, Mary Newbolt [9] are painted in a low-key, almost Sickertian palette, the tonal modelling concise to the point of austerity. Looking at them it is not hard to imagine what the critic David Sylvester dubbed the 'Kitchen Sink School' of painters, artists such as John Bratby, Edward Middleditch and Derrick Greaves, slaving away at their dreary canvases in Craigie's mental if not physical orbit, although Craigie exempted himself from any doctrinaire attitudes toward painting even at this early stage in his career.

He could not, however, exempt himself from the *Look Back in Anger* atmosphere of mid-1950s London, and reminiscences of the Orange Tree pub on the corner of Euston Road and Gower Street where Craigie and other Slade students gathered habitually after work during these years certainly have about them the tang of Joyce Carey's hilarious period novel, *The Horse's Mouth* (1944). Mr Brady, the Irish publican, and his vastly fat barmaid cannot have guessed what illustrious and potentially famous artists and intellectuals they were serving. Apart from Craigie and his friends, William Coldstream himself frequently joined his students for a drink, and other notable regulars included the Marxist chemist and philosopher, J. B. S. Haldane and his famously outrageous wife Helen Spurway. Craigie was actually present when Mrs Haldane, having trodden on a police dog's tail in Gower Street, took a swing at policeman. As a direct result of this the Haldanes eventually relinquished their jobs in University College and emigrated to India.

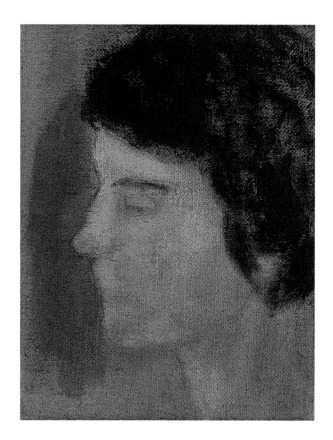

9 Portrait of Mary Newbolt, 1953

Until his second year at the Slade School in 1953, Craigie was little more than a peripatetic visitor to the bohemian world which was very much what being an art student was about in the early 1950s. But in that year, after an extended period living in the Slade School Hostel near King's Cross, Craigie eventually found himself at the stimulating centre of 1950s bohemia when he moved to an address fabled among several generations of London art school students: 22A Lower Marsh.

The house, which still exists, is a piece of rather matter-of-fact 1930s modernism thrown into the unprepossessing environs of Waterloo Station, and already when Craigie moved in it had accumulated half a dozen or so years of artistic pedigree. Most of its connections, however, had been with Camberwell School of Arts and Crafts rather than with the Slade. Originally it had been leased by Christopher Pinsent, who moved in with his fellow Camberwell students, Andrew Forge (who later taught Craigie at the Slade), and Patrick George, (ultimately himself Slade Professor). But they had been superseded by Anthony Eyton, Jo Higson and Anthony Fry – again all Camberwell students. Craigie and Myles Murphy, by this time one of his closest friends, moved there in 1953 not long before Patrick George and his family moved out.

The unconventional ambience of 22A Lower Marsh and the attractions it held for art students is not hard to understand. In the days of the original trio an eccentric philosopher and his young family shared the house and there was a constant round of vituperative debate. W. H. Auden, who had taught all three at a Quaker preparatory school called Downs School in the West Country, would come to lunch and even bought one of Andrew Forge's paintings. And an added attraction for artists in those days of 'kitchen sink' subject popularity, were the dingy street scenes all around. These provided subject-matter for several residents, and Patrick George in particular made a speciality of painting the shabby environs of Waterloo Station.

The originality of Craigie's personality was by all accounts much appreciated by the other students at Lower Marsh, although his 'private income', such as it was, made him rather more relaxed, financially, than his house-mates; his purchasing of bread rolls on his first morning at the Marsh was thought highly extravagant by Patrick George who had previously tried to run the place in a regimented, frugal fashion. If anything, however, it was Craigie who benefited from Lower Marsh. For the first time he felt that he had found a 'home' in London.

In such a set-up there was more than ample scope for bizarre incident, but none has etched itself into art world folklore of the period as indelibly as one in which Craigie was intimately involved: the episode of Myles Murphy and the burning wedding dress. Although it is now recounted with glee by all those who were involved in one way or another, the incident in which Myles Murphy set himself alight at Lower Marsh was potentially fatal.

Over Easter 1955 both Myles Murphy and Craigie were preparing paintings to use for their submissions for Rome Scholarships, a postgraduate award for art students at that time sponsored by the British Council. Clearly the major painting one presented had to be impressive, and Murphy had decided to paint a portrait that featured a wedding dress. Unfortunately, however, thanks to his model deciding to take an Easter break, he found himself obliged to improvise. Murphy donned the wedding dress and proceeded to paint himself with the aid of a mirror. There was a gas fire in the upper room studio at Lower Marsh and the inevitable happened.

The conflagration, with its echoes of Miss Havisham, was instantaneous, and Craigie's attempt to come to his friend's rescue – he was the only other person in the house – was hindered by the fact that Murphy had locked the door. Eventually, however, when Craigie did gain access, there was little he could do but try and douse the flames, tearing the burning fabric from Murphy's body and hurling it out of the window onto the busy market street. Within minutes Lower Marsh was filled with firemen, policemen and ambulance men, and Murphy spent several months in hospital recovering from serious burns.

Local newspapers had a field day with their headlines, and the police were sceptical of Murphy's explanation of how he came to be dressed in female attire.

According to Murphy, the originality of Craigie's personality – his off-beat way of looking at the world, his acute perceptiveness belied by apparent nonchalance – was much appreciated by his colleagues at the Slade School, and what Craigie himself construed as indifference or disapproval from the staff was very likely their simply not knowing how to take him. He was always inclined to behave in an other-worldly manner and to engage in activities or take actions which seemed, at least on a superficial level, bizarre.

Not the least of these was his decision about the mode of transport he and Murphy were to use for their epic continental sojourn. Murphy having recovered from his near-fatal injuries, both art students had succeeded in their quests for Rome Scholarships, and in September 1955 they set out on what was to prove for Craigie a voyage of aesthetic discovery. The train would have been the obvious way to go, but Craigie promptly went out to a garage near the Elephant & Castle and bought, for £45, a 1936 London taxi cab. It was this antiquated vehicle with all its urban accoutrements – the inevitable klaxon and even a silver flower-holder by way of interior decoration – that was to get the pair across the Channel and across the Alps. After an arduous working life on the streets of London the taxi's maximum speed was no more than 35 miles per hour.

The first leg of the journey to Paris (Slade friends, the painters Euan Uglow and Natalie Dower, and sculptor Ken Hughes went along for the ride) presented little difficulty even if progress was slow, and the group arrived safely to spend a pleasant enough few days in the capital. The departure, however, was sudden: sitting in a café Murphy remembers Craigie turning to him quite unexpectedly and saying 'OK, let's go then!' And after hasty goodbyes to quietly astonished friends off the intrepid duo went in their decrepit transport.

Nevertheless, the antiquated taxi behaved itself better than could be expected, at least as far as Grenoble; and it was only at this point that the journey began to acquire a Tati-esque quality. On the threshold of the French Alps the vehicle decided it would go no further and the pair found themselves surrounded by taunting amused villagers. One of them, the blacksmith, managed to help discover that the problem had something to do with the first gear; in second gear, it turned out, the taxi would still function. But even though the taxi was now mobile, there was a more serious fault: the reverse gear was as inoperable as first.

It was the impossibility of reversing that led to myriad hair-raising incidents between the Alps and Rome. To save petrol (by now the taxi was swallowing as much oil as petrol) Craigie decided to free-wheel down treacherous corniches. Then, half-way across a single-lane viaduct a thousand feet over a pass, the taxi was confronted by a caravan of coaches. All of them eventually got the message and reversed. In San Remo, to escape a group of obnoxious English undergraduates, Craigie ascended the drive of some grand villa where a party of well-dressed dinner guests sipping early evening *aperitivi* stood open-jawed as an ancient London taxi circled majestically beneath them.

Things got even worse when Craigie and Myles Murphy finally arrived in Rome, weeks after leaving London, for here the taxi took centre stage of their experience and all but threatened to sabotage it. The Italian authorities somehow got to hear that two students at the British School had managed to import a London taxi illegally, and Craigie and his friend were forced to try and find some kind of solution to what looked like becoming a nasty international incident.

The Italian Finance Minister suggested they take the illegal taxi back across the border into France, a solution to which Craigie objected with the lawyerly observation that if it was illegal to have brought it into Italy it was probably equally illegal to take it back into France. 'There's no no man's land you know,' he pointed out to the high

official. And eventually the affair nearly reached the door of the Pope. Myles Murphy's brother who happened, conveniently it at first seemed, to be a priest, got in touch with a fellow priest working in the Vatican secretariat who tried to help the pair out. But to little avail. The taxi ultimately had to be abandoned, and some years later it was discovered that parts of it had found a fittingly illustrious resting place: the bowels of the Vatican. Some enterprising priests had taken it upon themselves to dismantle it and put it into store.

Understandably, neither of the artists made much of the prescribed object of their trip to Rome, a period of active study at the British School; the city was enjoying the first flush of 'La Dolce Vita' and the buzzing, fashionable Via Veneto presented a more amusing way of passing the time than the dusty studios filled with antique casts in the neoclassical building on the edge of the Borghese Gardens. Naturally they did the round of obligatory sights, from the Forum to the Sistine Chapel. But it was the remainder of their trip accomplished on indigenous public transport, northward through Umbria and Tuscany to Florence and finally to the Veneto, that was to radically alter Craigie's artistic perception and have an enduring effect on his painting.

According to Myles Murphy it was the landscape south of Siena more than anywhere else that taught Craigie about arranging colour on the surface of a picture. In that area of Tuscany the balance of greens and earth colours and the clarity of the light which casts an even glow over them creates what Murphy calls 'an equality of colour', and it is precisely this harmoniousness which, ever since that time, has imparted the timeless, spiritual quality to so much of Craigie's painting. The same quality is, of course, observable in the work of a range of Italian Renaissance artists, but most conspicuously it is found in Piero della Francesca. Craigie already had an inkling of what this great master was about from looking at The Baptism in the National Gallery; and Piero's fresco cycles indeed, both at Arezzo and Borgo San Sepolcro, were to prove a revelation. But nature

in this case provided a more persuasive influence than art.

A number of pictures Craigie painted in the wake of his Italian experience are imbued with the contemplative atmosphere of the ordered landscape of the Italian campagna, but it is a captivating small picture entitled Landscape from inside a Cathedral [10] that most forcefully conveys the impact Italy had on Craigie. The composition is arranged with almost geometric precision, each element from cypress tree to crucifix finding its nîche; but what really clinches the success of the picture is the precise tonal organisation. Greens, ochres and, above all, the pellucid pale blue, hang together in perfect balance. And the air of melancholy that emanates from the picture results, as so often in Craigie's work, more from the absence of incident than anything that is 'happening'. The scene viewed tantalisingly through the window is one that has been transformed by the fact of the Crucifixion; it does not pretend to be its real context.

The sites Craigie and Myles Murphy visited once they had left Rome and the dead taxi behind them were the usual stopping-points for the art pilgrim to central Italy: Orvieto, Assisi, Arezzo, then on to see the Byzantine marvels of Ravenna, followed by Padua, Venice and the Veneto.

Craigie, however, was far less the art historian than his companion, whom he still describes as an 'encyclopedia' when it comes to the history of his craft. It was Murphy who had taken full advantage of the improvements made by Coldstream to the teaching of art history at the Slade – Ernst Gombrich and Rudolf Wittkower were among the eminences who were enticed to come and lecture – and it was he who had to actively encourage Craigie to pay attention to the glories on offer. At Arezzo Murphy let on only at the very last moment that Piero had made of The Story of the True Cross one of the world's masterpieces, and Craigie had to be cajoled into entering the church. Once inside, however, he was totally absorbed. 'Craigie's speed of recognition was tremendous,' observes Myles Murphy. 'He sensed immediately what Piero was getting at and saw no need to linger.' At Ravenna, after hurriedly viewing

10 Landscape from inside a Cathedral, 1957 **11** Pope Walking in the Garden, 1957

the mosaics in San Apollinare in Classe, Craigie suddenly disappeared, only to be discovered pinching apples from a nearby orchard.

While Piero taught or – perhaps it is more accurate to say – confirmed Craigie in his natural approach towards tonality in picture-making, and demonstrated what was anyway very much a Slade School maxim: that the parts of a painting which are not intrinsic to the description of the subject are of equal importance to the composition as a totality, it was the experience of Giotto at Assisi, and even more significantly in the Arena Chapel at Padua, that proved to Craigie that complexity and obfuscation are the enemies of cogent visual argument. For Craigie, as for Giotto, the aim in a picture has always been to make explicit the observed fact, and it is tempting to see in this evidence of the trained legal mind. 'The law is about getting it "right",' Craigie is fond of saying, 'and that is what I try to do in a painting.'

More than any other of Craigie's post-Italy pictures, the spirit of Giotto informs a small unpretentious still-life which acquired the nickname '*Swan Vestas*' [12] because of the way the sprig of flowers standing in the jug resembles, amusingly, the brand-name matches. The faded colours might have been lifted from one of Giotto's peeling frescos and there is something quietly confrontational about the way the simple subject has been presented for what it is. But more significant for Craigie's future development is the conviction with which the pigment is stained onto the canvas. Rarely was Craigie again to be waylaid into trying his hand at investigating the rich potential of oil paint, and it is for this reason that '*Swan Vestas*', unassuming little picture that it is, marks a milestone in the artist's struggle to achieve a definitive mature style.

The impact of Italy on Craigie lasted in its intense form for several years. Two years after returning he was still painting lyrical memories of his visit as, for example, *Pope Walking in the Garden* [11], a picture which, even if it lacks the sense of conviction which stems from directly observed fact, still has an authentically Italian quality in terms of light about it, not to mention a freshness which is very pleasing.

Other pictures, however, also resulting directly from Craigie's experience of Italy, display a more investigative instinct and are mould-breaking in a different sense. Painted in the year following Craigie's return from Italy, 1956, *Purple Landscape* [13] and *Butterflies in a Landscape* [14] are, in the light of Craigie's previous and subsequent work, shockingly devoid of subject.

The motifs around which these important paintings are built – butterflies, poppies – insinuate themselves amidst what amount to 'colour fields', and it is certain that one of the encouragements predicating their creation was the impact made on London art circles of the late 1950s by American Abstract Expressionism. Craigie could hardly have avoided the controversy which surrounded the 'Modern Art in the United States' exhibition which opened at the Tate Gallery in 1956, and these works, with their large flat areas of pure colour, can be regarded as his response to it. But Craigie, of course, was a good deal younger than the majority of notable British artists whose work at that time was transformed by the first-hand experience of the new American painting, and anyway a picture such as *Yellow Painting* [15] appears closer to one of Odilon Redon's mysterious dreams than anything by Jackson Pollock or Arshile Gorky.

Experimental in some respects then these canvases may have been, but for Craigie they confirmed a new confidence in the use of bright colour which he was to put to good use in a whole range of figurative works over the course of the next decade, not least in the series of small-scale 'Crucifixions' which were increasingly to occupy him.

Already at the Slade School Craigie had made tentative attempts to treat what was at that time an unusual subject for a contemporary British artist, but the first successful *Crucifixion* picture did not come about until 1958, when, thinking back perhaps to the opulent glowing effects he had witnessed in the mosaics of Ravenna, he produced a tiny icon-like panel [17]. It is an unusual and unexpected

12 'Swan Vestas' Still-life, 1956

13 Purple Landscape, 1956

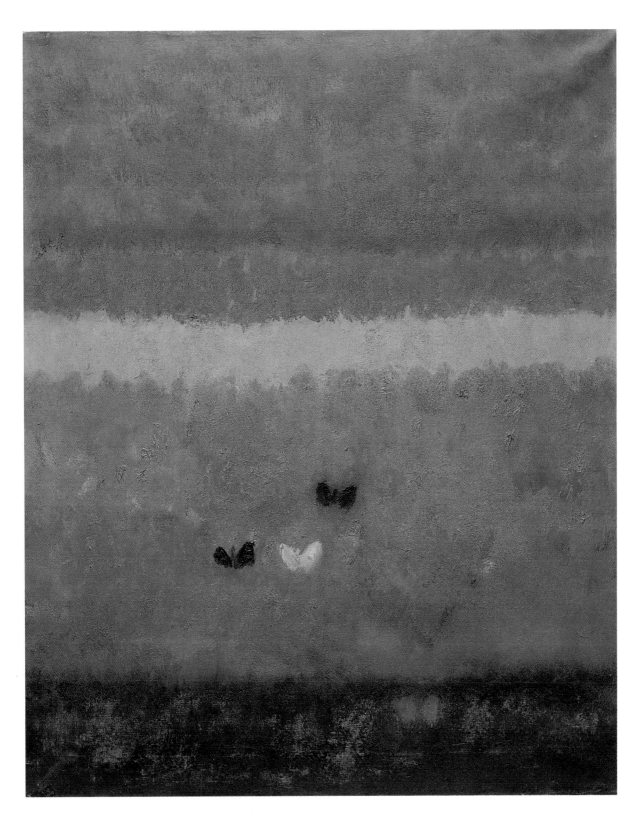

14 Butterflies in a Landscape, 1956

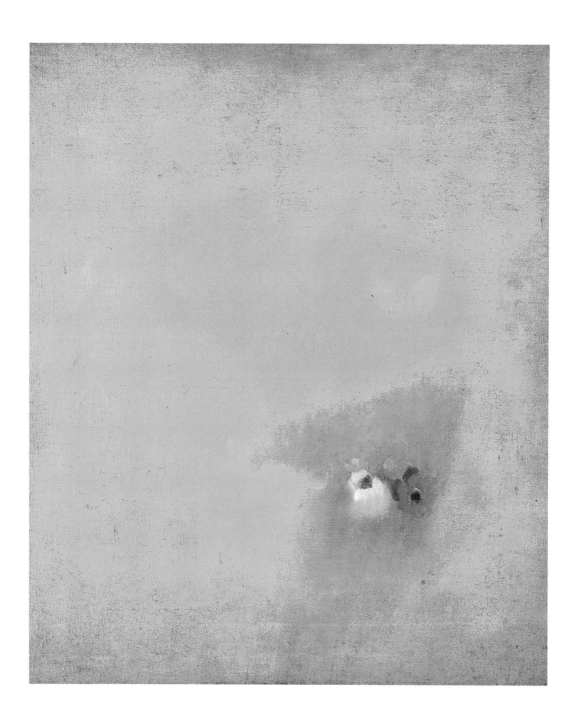

15 Yellow Painting, 1957

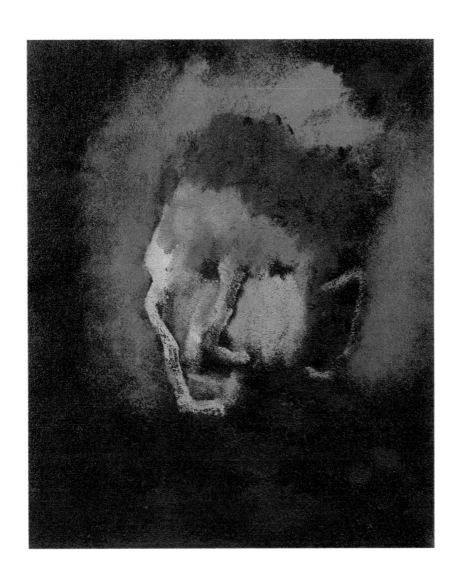

16 Self Portrait, 1957

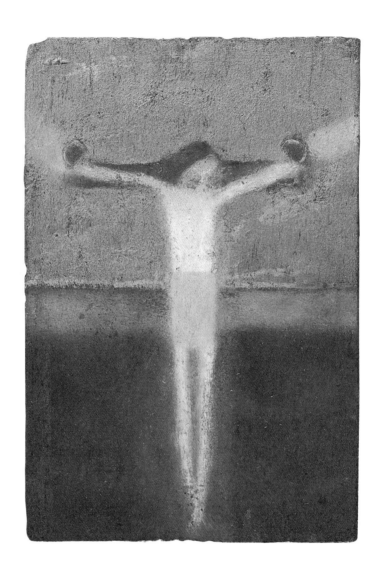

17 Small Crucifixion, 1958

picture, especially when seen in the context of the larger-scale colour-saturated works painted about the same time; but in it one feels that Craigie is wholly himself for the first time. The refusal to draw in outline, the dependence for effect on large roughly stained areas of colour, the denial of what other artists might have thought to be significant detail – all these features portend the manner in which Craigie was to develop this major theme over the next three decades.

This tiny, early *Crucifixion* is impressive in its sheer professionalism, and there is plenty of evidence to suggest that Craigie was already taking himself very seriously as a professional painter.

Even during his final year at the Slade Craigie had exhibited and been singled out by critics in public exhibitions; at the Young Contemporaries exhibition *Time and Tide*'s critic, Joseph Rykwert, described the picture which had won the painter a prize at art school, *Scissors and Pink String Still-life*, as 'mannered, sophisticated and acid', while at an exhibition of six young artists at Gimpel Fils, Eric Newton noted the similarities between Craigie and Odilon Redon, as did David Sylvester who gushed about Craigie's imagination being 'as authentic as it is refined'.

In 1956, however, it was an anonymous critic in *The Times* who made the first genuinely revealing comments about Craigie's painting. Reviewing a three-man show at Gallery One in d'Arblay Street, the writer perceptively observed, 'Mr Craigie Aitchison...earns the label "romantic" by his ability to convey the mood felt in a certain place rather than the physical details of its appearance. His best paintings... are so simplified that it would be tempting to compare them to abstract works, were it not that they are conceived entirely as attempts to represent a certain aspect of reality, and not as formal compositions.' Had the writer but known it, he or she had hit on the nub of an art of which the pictures on view represented merely the seed.

3 Beaux Arts, and Georgeous Models

well integrated into the London art scene and felt very much at home in his adopted city. But throughout his first decade there he had kept up close links with Scotland, mainly because of his mother; if anything the filial bond had been strengthened by the extended periods he spent in London and, anyway, Lady Aitchison visited her son frequently. Craigie, for his part, was well used to jumping on the night train between King's Cross and Waverley, an adventure that had first thrilled him as a child when his parents had treated the family to best seats at various ceremonial occasions. Quite often Craigie took Slade School friends back home to Scotland with him.

Several of Craigie's contemporaries became well acquainted with Lady Aitchison and all testify to her charm, humour and exceptional personality. She is described as 'captivating', as having 'an infectious, very Edinburgh, wry sense of humour'. Certainly she was a 'character' and in this respect Craigie takes after her, even if the skiing and other energetic sports she had indulged in as a young woman have not appealed to him. But the most striking aspect of Lady Aitchison's character seems to have been her complete lack of snobbishness. During her husband's lifetime Lady Aitchison had, of course, been introduced to the highest social and political circles, (Craigie remembers being taken as a boy to the House of Commons to meet the future Labour Chancellor, Sir Stafford Cripps), although, revealingly, among the Aitchisons' closest friends were the authors E. V. Lucas and Dr Halliday Sutherland. When, in later life, however, she was introduced by Craigie to the very different world of bohemian London she accepted it all, nonchalantly, as simply a further instalment in life's great adventure.

Until 1948 the Aitchisons never actually owned the family home in India Street, but in that year Lady Aitchison decided to buy it. Its largeness, however, became impractical for her as she approached her seventies, and so in the early 1960s Craigie's mother exchanged the home where she had lived since her marriage for the house on her fam-

18 Poppies in Tulliallan Garden, 1963

ily estate at Tulliallan where her eldest son Raymund, by this time working in the shipping business at Buckie in Fife, had previously been installed with his young family.

It was to Tulliallan then that Craigie retreated after returning from his revelatory trip to Italy. The move back to Scotland seemed logical; the tenancy at 22A Lower Marsh had expired, and now that the Slade School was making no demands upon him there was no imperative to stay full-time in London. But the return to Scotland signalled no let up in Craigie's dedication to painting. On the contrary, it is in the Tulliallan pictures that one first feels a rounded artistic personality emerging. Mostly small landscapes and scenes in the immediate vicinity of the house, this homogeneous group comprises many of the first pictures Craigie exhibited professionally in London.

The countryside around Tulliallan is scarcely the most dramatic scenery in Scotland, although the rolling hills making triangular peaks on the coastal horizon contribute something grand to what might otherwise be nondescript. Craigie's art, however, has always been based upon his ability to perceive the special or unusual in the mundane and at Tulliallan he often deliberately chose to paint the least ostentatiously dramatic views.

A case in point is *Tree and Wall Landscape* [**19**], a misty gem-like picture which comes as close to abstraction as anything Craigie painted at Tulliallan. The composition could scarcely be simpler: bands of the colours Craigie discovered in Italy sensitively scumbled across the canvas, with only the suggestion of the tree acting as a figurative reference point. It is the most concise picture Craigie had painted to date; as if he was consciously trying to generalise the main components of the view to a point where the representational quality of the whole might disintegrate altogether.

Other works completed at Tulliallan are less austere

TOP *Craigie at Noel Road, c.1959, an etching by Susan Campbell*
LEFT *Craigie painting in the garden of Susan Campbell's house in Noel Road, Islington, in the late 1950s*

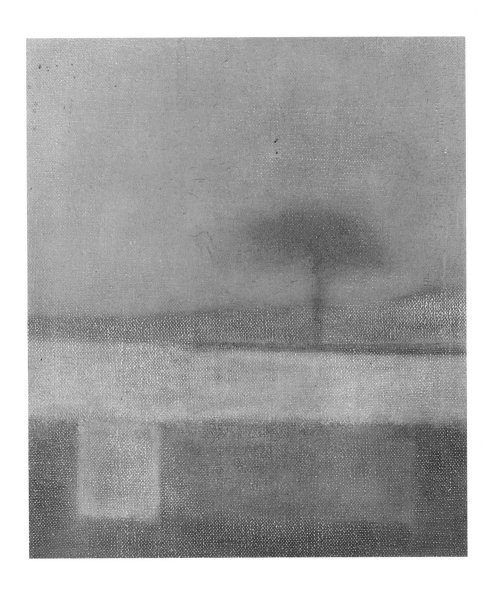

19 Tree and Wall Landscape, 1958

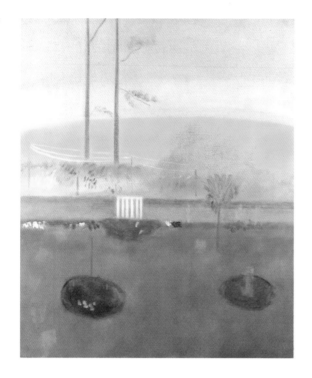

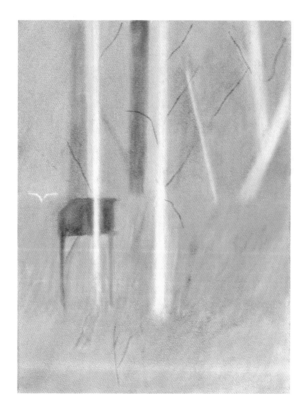

20 Garden at Tulliallan, 1963

21 The Pigeon House at Tulliallan, 1958

and more ingratiating owing to the decorative freedom Craigie allowed himself. *Garden at Tulliallan* [**20**] for example, is, by comparison, a pretty picture, with the specks of brilliant colour describing in most cursory fashion the flowerbed. And the same might be said of *Poppies in Tulliallan Garden* [**18**], a work where Craigie synthesises the two-dimensionalism he first investigated in the poppy pictures made after his return from Italy with the visual information he was presented with at Tulliallan.

But the key to appreciating the Tulliallan pictures is found less in their formal qualities than in the original sense of poetry which at Tulliallan found its first mature expression. A process of elimination is occurring in a picture such as *The Pigeon House at Tulliallan* [**21**]; all is subordinated to the ambiguity engendered when each element is depicted in its most basic form. The pigeon coop itself is a mere rectangle, trunks of birch trees are scarcely more than clear vertical apertures in the picture plane, foliage is evoked in contrasting shades of green without the hint of a leaf. But what comes out of this carefully modulated essay in distillation is something mysterious and perplexing.

All this is true of the most ambitious and imposing landscape that resulted from Craigie's years at Tulliallan, *Wall and Fields at Tulliallan* [**22**]. Painted between 1960 and 1961, as was not always the case with Craigie, directly from nature, this was the largest landscape the artist had yet attempted and was certainly a challenge, if only in terms of scale.

Helen Lessore later wrote a description of this 'audacious and successful picture':

It is a perfect example of the austere and economical architecture of composition which underlies the surface gentleness of his technique. In this large area, an inch or two this way or that from where they actually are, in the case of any of the four straight tree trunks, the horizon, or the wall, would have destroyed the picture. The slim trees, three on the left, one on the right, with a few bare branches sloping up, rise like the calculated skeleton of an antique temple into the luminous blue sky; the fields are flat and blonde, the long low wall stone-colour; there is nothing else but three white rams sitting there; and a telegraph pole.

22 Wall and Fields at Tulliallan, 1961

58

Symposium I by Helen Lessore, 1974–77, 106.8 × 213.7cm (The Tate Gallery) in which are depicted the artists with whom she was most closely associated. Craigie, with Wayney, is shown beside his friends Myles Murphy and Euan Uglow.

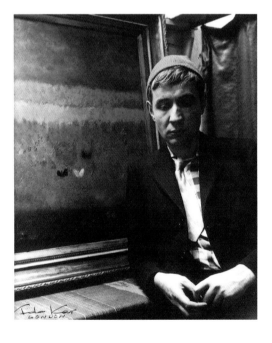

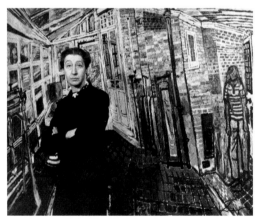

Helen Lessore, Craigie's first and most encouraging dealer, photographed by Ida Kar.

Craigie photographed by Ida Kar in 1956 at the outset of his career. The picture, Butterflies in a Landscape, was a milestone for the artist

Lessore's emphasis on the economy and precision of the picture correctly identifies what was to be an ever more salient quality of all Craigie's work, and which here was successfully accomplished on a large scale for the first time. But the ambiguity in the treatment of space which distinguishes this particular picture was also to become a hallmark of Craigie's painting and characterises not only landscapes but also still-lifes and portraits; Myles Murphy points out an 'autocratic attitude towards the picture surface', an intuitive way of thinking about the picture primarily as a flat plane to be decorated that gives rise, unintentionally, to precisely this ambiguity.

The Tulliallan pictures, together with numerous still-lifes and works on religious themes, formed the backbone of Craigie's initial three one-man shows held between 1959 and 1964 at Helen Lessore's Beaux Arts Gallery in Bruton Place, Mayfair. This gallery acquired a legendary reputation for its fostering of young unknown talent during the 1950s, and for Craigie it was by far the most important single factor in motivating the early stages of his career.

The redoubtable Helen Lessore had herself trained as a painter at the Slade School under Henry Tonks in the 1920s. Her husband's sister had married the English Impressionist Walter Sickert which connected her intimately with the most prestigious circles within the English art establishment, and it was from her husband that in 1951 she inherited the proprietorship of the Beaux Arts Gallery. She was, however, a reluctant art dealer and, as she admitted, not a good one in terms of selling pictures or making profits.

But she did have an unerring eye for new and original talent, and, more importantly, the conviction to promote it even when it seemed unfashionable; during the early 1950s she picked up a glittering array of painters, mostly former Royal College of Art students, including Jack Smith, Edward Middleditch, John Bratby and Derrick Greaves. Francis Bacon showed at the Beaux Arts Gallery in 1953, and then later in the decade Frank Auerbach, Leon Kossoff, Euan Uglow and Michael Andrews replaced Lessore's original stable. In the 1970s, many years after her gallery closed, Helen Lessore painted a group portrait of all the artists who had at one time or another been part of her stable [*illustrated opposite*]. Craigie is portrayed, touchingly, with his favourite Bedlington terrier, Wayney, to the left of the canvas.

It was Michael Andrews who had been at the Slade School at the same time as Craigie, who introduced his work to Helen Lessore. Having shown at the Beaux Arts Gallery himself in 1958 he suggested that the dealer go and take a look at Craigie's painting and she took his advice. The following year saw Craigie's first one-man exhibition in the West End of London.

The relationship between Helen Lessore and Craigie was to develop into something like a maternal one – Lessore was a constant source of advice and encouragement – and the two stayed friends long after the Beaux Arts Gallery closed in 1965. Lessore immediately appreciated the quiet, calculating, unbombastic nature of Craigie's talent – his 'Japanese spacing' – and the fact that there was nothing at all primitive about his approach.

For Craigie, a dealer who understood his intelligence and appreciated his sophistication was a wonderful asset, and Helen Lessore's purchasing of his pictures during these thin years was both a moral and a financial boost. 'I know that Helen's encouragement and help in buying the pictures when I needed to sell them enabled me to continue painting freely' the artist later reflected, 'then, when the Beaux Arts closed and I was taken on by 'dealers', I learnt the hard way'. Craigie's subsequent involvement with the 'art market', typified for him by a short and distressing experience with Marlborough Fine Art, was never to be so smooth again.

Helen Lessore included several of Craigie's Tulliallan pictures in early exhibitions of his work at the Beaux Arts, and even some earlier pictures inspired by his stay in Italy. Sales were not wonderful, but then again neither were they negligible, and the experience certainly sowed in Craigie the seeds of an enthusiasm for exhibiting that has

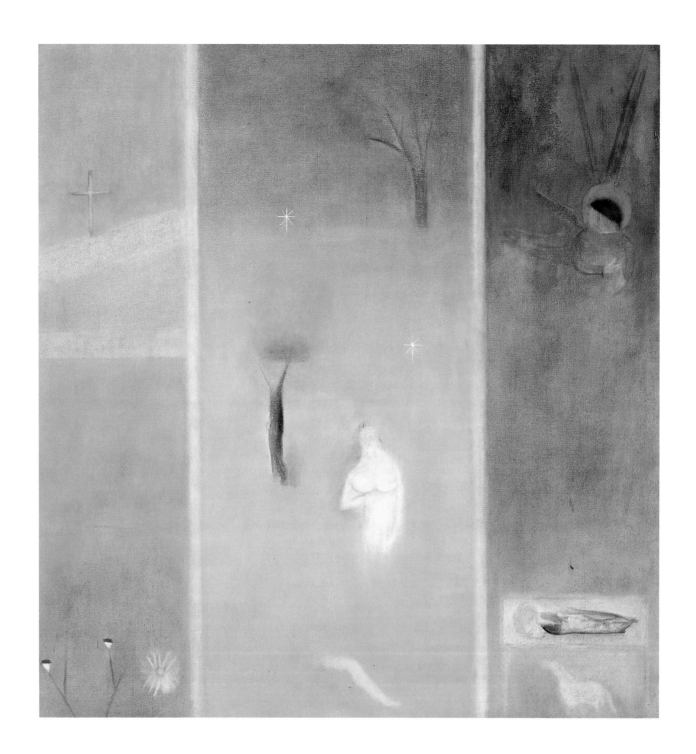

23 Triptych, 1959

grown ever since. Craigie was especially encouraged when the artist Anthony Fry bought *Landscape from inside a Cathedral* for himself. 'I can't be so bad after all if a painter has bought my picture' he thought at the time.

But it was the 'Crucifixions' and the other quasi-religious works that drew most critical attention. Graham Sutherland, at that time the most highly respected English painter of the older generation, had painted 'Crucifixions' during the 1940s and, of course, Francis Bacon's angst-ridden *Three Studies for Figures at the Base of a Crucifixion* of 1944, was a tangential though anti-traditional extension of the theme; but for an artist to treat the Crucifixion in what appeared superficially to be an archaic, even reverential way, was certainly at odds with the mood of the period.

The 'Crucifixions' and related Christian subjects Craigie painted in the early 1960s are clearly inspired by the altarpieces the artist had seen in Italian churches. A *Triptych* painted in 1959 [**23**], both in its form and spirit, harks back to Fra Angelico with its dive-bombing, haloed angels, and it is unusual in that Craigie combines both Old and New Testament incidents. On either side of a depiction of Adam and Eve in the centre, are two panels: on the left a Crucifixion, on the right a Nativity. Each scene has a misty romanticism about it, as if seen in a dream, but what saves it from coming across as some sort of pastiche or ironic comment on well-worn themes is that the subjects are set in the artist's native context. Imagined they may be, but they are painted with precisely the same lack of affectation and infused with the same logical pictorial objectivity as any of the Tulliallan pictures. In this way Craigie avoided the off-putting sentimentality which threatens to undermine any treatment of religious themes in our atheistic age.

The *Triptych* is atypical in its complexity and presented Craigie with numerous difficulties; there were endless alterations, 'rubbings out', trial and error. But the way the artist dealt with a pictorial impasse he reached in the main central panel is particularly illuminating. In an interview he gave in 1961 he referred to this precise problem:

Sometimes in the course of rubbing out something, I arrive at the conclusion I have been seeking. Once when painting Adam and Eve I suddenly realised when taking out the figure of Adam, that I liked the leg, and so I decided that I would repaint it alone, it was sufficient to indicate what I wanted, the very idea that I once had, of painting the whole figure again, seemed completely unnecessary and wrong.

This method, of course, is really no more than a sophisticated type of selection; but what distinguishes Craigie from other comparable figurative painters is that he feels completely emancipated from the diktats of visual reality. In other words, if, in formal terms, an arm, an eye, a branch, or a gate, does not 'fit in' to a composition, then he will either simply omit it or 'rub it out'. Critics have long found this habit difficult to cope with (for nearly forty years Craigie has been berated for painting 'armless' Christs), and in the instance of the *Triptych* even the sympathetic critic Robert Melville quipped amusingly that the Adam and Eve panel portended 'a long wakeful night for St Anthony'.

By the time he came to paint a pair of 'Crucifixions' [**24** & **25**] some five years later, however, Craigie had resolved the kinds of compositional problems that cropped up in the learning process of the *Triptych*. Largely they were circumvented by placing the incidents in more 'realistic' settings, but there is also a confidence about these pictures which is absent from his earlier imaginary scenes.

The earlier of the two is called *St Sebastian* [**24**] although this particular martyr-saint is wholly unpunctured and, as far as one can tell, no archers are taking aim in the wings. A pair of angels holding candles hover beside the cross, however, and a solitary tree strikes a poignant note on the rolling horizon as stormy skies threaten. It is a sombre and very atmospheric picture charged with devotional energy. The associated *Crucifixion* [**25**] is less crepuscular in mood but foreshadows most of Craigie's later more ambitious interpretations of the subject in that a dominating feature of the setting is the almost triangular blue hill framing the cross. The emaciated armless Christ, in this case endowed

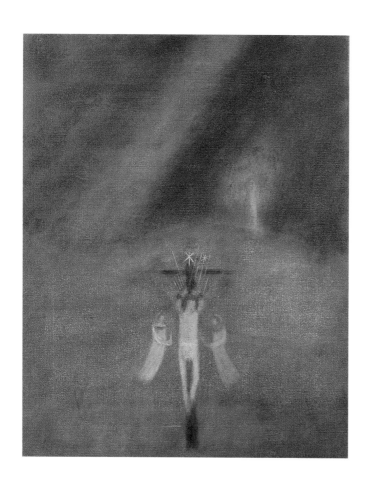

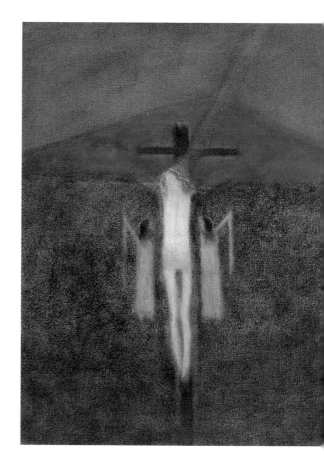

24 St Sebastian, 1964

25 Crucifixion, 1964

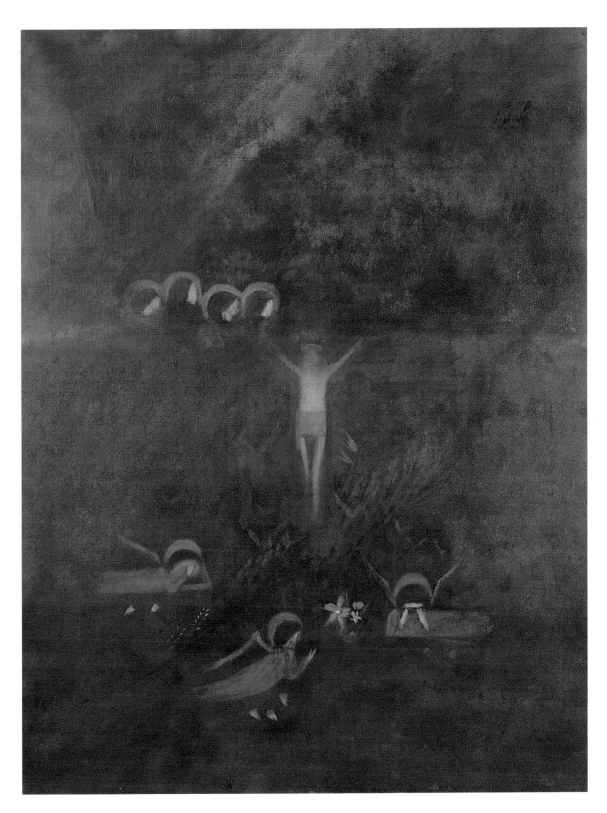

26 Crucifixion and Angels, 1960

with a crown of thorns picked out in pink, is a lovely tender invention, and the shaft of heavenly light beaming down onto Christ's head from an unseen source in the heavens is both a logical component of the composition and a dramatic device that elevates the picture onto a spiritual plane.

Scale plays an important role in Craigie's art for the simple reason that he is acutely sensitive to the emotional changes that he can ring by manipulating it. In the religious works he was exposed to in Italy, and especially in those by Piero della Francesca, he observed that by altering the scale of the principal subject of a picture in relation to its context, the entire mood of a work could be pitched differently; by adding auxiliary, 'second subjects' as it were – a single sheep, a tree, a bird – further changes could be made. In the largest Crucifixion [26] from this period the smallness of the crucifix itself against the landscape strikes a melancholy note, and this was sounded with yet more resonance in what is the most beautiful Crucifixion painted in the late 1960s [27].

Here, on a large canvas, the climax of the Christian passion occurs in the far distance against an especially broody dark blue sky. On the hillside dominating the foreground has been placed a lonely sheep that, in its isolation, echoes and augments the tragic tone of the scene. There is also of course the further iconographic connotation of the 'Lamb of God', but the sense of intense melancholy exuded by this picture results mainly from a clever manipulation of scale. When Craigie returned to use the Crucifixion as the principal theme of his compositions in the late 1970s the potential of scale within the picture was investigated thoroughly and to magisterial effect.

In taking the central incident in Christian faith as a theme Craigie has inevitably begged the question of his personal belief. And it has to be said that he is unusually reticent on this subject, content to tell the curious how he considers the Crucifixion 'the most horrific story I have ever heard', and little more. He is certainly no church-goer, but then again 'the manse' is in his blood, and as children he and his brother were regularly taken to churches of various, often opposed, denominations by their socialist-minded parents, a way of giving them, presumably, a broad-minded attitude towards religion. It would not be at all surprising if the austerity of the Scottish kirks Craigie was subjected to at an early age has something to do with his love of the 'bells and smells' of the Roman Catholic churches he came across in Italy. 'Those churches were so glamorous … all those candles,' Craigie once commented.

But there is more to it than that. In spite of the fact that Craigie is an artist fastidious to a degree about the relationship between shapes, harmony of colour and balance of tone, and even though when forced to discuss his painting he talks almost exclusively in formal terms, he is also enamoured of narrative for its own sake. Confronted by one of Craigie's pictures the question 'What has happened?' frequently presents itself, and this applies also to his portraits where, magically, he succeeds in imbuing his subjects with a sense of their personal history. There is no better story than the Passion and this is doubtless the reason it fascinates him.

Although Craigie was based at Tulliallan during the first years of his association with Helen Lessore and the Beaux Arts Gallery, he never really lost touch with his community of friends and professional colleagues in London. When in town he would stay in Islington with one of his closest female friends, the artist and writer, Susan Campbell. He was certainly not out of touch with what was going on in the art world; Susan's husband, Robin Campbell, was at this time Head of the Painting Department of the Arts Council of Great Britain.

Craigie also frequented the celebrated artists' drinking clubs of Soho which, in the late 1950s and early 1960s, were enjoying something of a revival. Another friend, the journalist Juliet Lygon, introduced him to the fabled Colony Room and its doyenne, Muriel Belcher, although Craigie was never to be the dedicated habitué of the Colony that Francis Bacon became. In the late 1950s Craigie was once introduced to the legendary hell-raising artist duo, Robert

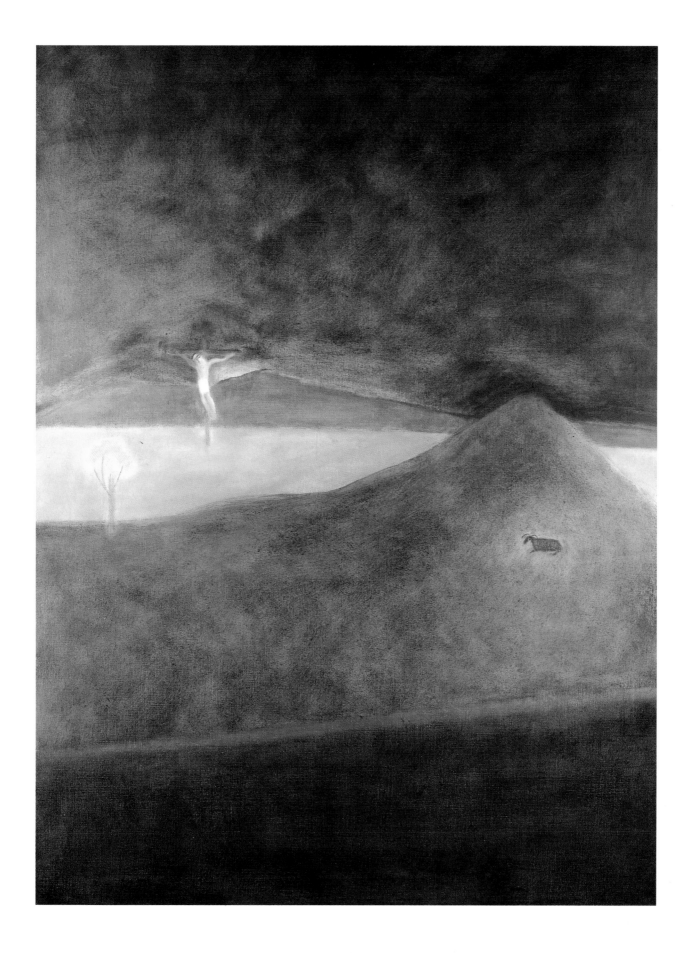

Colquhoun and Robert MacBryde, and recalls his compatriots recommending he drink vodka rather than whisky. Nevertheless, Craigie's closest friends Myles Murphy and Euan Uglow were not *aficionados* of Soho, and usually the trio would seek out their old friend Mr Brady who, the Orange Tree having closed, was by this time dispensing hospitality in his new establishment in Beak Street.

In 1963, however, Craigie's schizoid habits, dividing his year between Scotland and London, came to an end, when Lady Aitchison, now in her late seventies, decided to sell the house at Tulliallan and join her son in London. Although it must have been a wrench for someone of advanced age to move from the Scottish countryside to London, Lady Aitchison's adventurous spirit, still intact, and the vicarious stimulus of the life her son had created for himself, made the transition less arduous than it might have been. And Lady Aitchison was of course no stranger to London, even if as one friend commented, her idea of London was really Mayfair and little else.

Accommodation, however, at first proved a problem, not least because of the still present Somerset. On first arriving in London Lady Aitchison stayed at the Curzon House Club in Curzon Street, then after some months she and Craigie managed to find a flat to rent off Piccadilly in Albemarle Street. Not until having spent several months in Albemarle Street did Craigie succeed in the house-hunting expeditions he and his friend Juliet Lygon conducted by bicycle. Craigie knew the area of London 'south of the river' through his stay as a student at Lower Marsh, and so the discovery of a perfectly acceptable house to rent in Kennington was a definite thrill. After some gentle persuasion the landlord agreed to rent the property.

The house that Craigie has lived and worked in since 1963 is so much a part of his life and, indirectly, has influenced the character of his painting to such an extent that it merits some description.

It is one of a terrace looking onto a quiet featureless square in a kind of no man's land between two major traffic arteries. When asked to go there taxi drivers become flummoxed, so seldom are they directed to this area, and when they get there they inevitably comment on how charming and hidden away it is. Although the area is slowly being 'gentrified' it still has a lost, down-at-heel quality about it.

Craigie's house is easily identifiable by the battered orange and white Triumph Herald, apparently held together by string, which stands guard. It is a treat to be entertained within. The walls are a vivid pink, the paintwork bright blue; a chandelier dispenses an eerie light and this is qualified by the shimmering images cast by one of those revolving cylindrical lamps presumably made to entertain children.

On the walls there are all sorts of images – small paintings gifted by friends such as Euan Uglow, postcards, a picture of the Last Supper painted by a Welsh miner turned artist; on horizontal surfaces there is all manner of ornament mostly of the cheap kitsch variety and several items identifiable from Craigie's still-lifes. The artist lives mostly on the ground floor, while the most important room in the house, the 'painting room' – or at least the room Craigie uses for 'doing the pictures' most often – is upstairs. The general impression is of Craigie being cramped, and at various times the artist has acquired larger studios elsewhere in London to allow him to work on a large scale.

The house in Kennington has changed over the years, and a burglary in the 1970s deprived Craigie of some of his most cherished objects. But in 1963, when Lady Aitchison arrived, a great deal needed to be done to make it habitable, and one might assume that she would have found the experience depressing after a life spent in the comfort of Edinburgh's New Town. Apparently, however, this was not at all the case. The various pieces of quality furniture which had been transported from Tulliallan were arranged on this much smaller scale in much the same way that they had been in India Street, and Lady Aitchison found her new more modest home 'delightful'.

It was without doubt a comforting and stimulating environment for Craigie, since it was after his move to

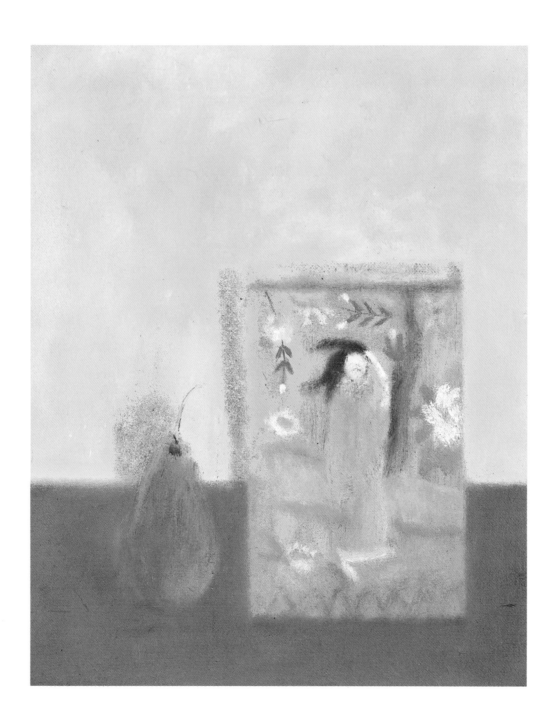

28 Japanese Tin Still-life, 1964

Kennington that he began to paint a succession of extraordinary pictures which laid the foundations for his most original work. Apart from the 'Crucifixions' there were the still-lifes, a genre in which Craigie had first discovered an interest while at the Slade School. An extremely colourful and exotic example is *Japanese Tin Still-life* [**28**] in which, when it was exhibited in Craigie's last exhibition at the Beaux Arts Gallery in 1964, the critic Stuart Penrose, over-egging the pudding perhaps, identified 'romantic depths'; at any rate it has more of a tâchiste spontaneity about it than earlier examples. Beside it, a picture such as *Candlestick Still-life* [**29**] painted in 1960, looks tame in spite of the immaculate tonal control and sense of quietude Craigie achieves; this is the closest the artist was ever to come to the undisputed twentieth century master of the still-life, the Italian painter Giorgio Morandi.

But it was Craigie's rediscovery of the model that really sparked off a fresh period of creativity in the years after his

move to Kennington. Strangely, a number of small-scale female nudes – standing before arches, leaning against curtains – have more of an appearance of art school works than the pictures he actually completed at the Slade; as Helen Lessore observed, they have a 'northern', almost Gothic, air about them, as if Craigie is distancing himself from a sexually charged subject; certainly they entirely lack sensuality. In the largest, *Woman against a Blue Background*, an easel with stretched canvas propped up on it dominates the background and this emphasizes the art school atmosphere. Not until Craigie met up with a very special model was he really to succeed in this new enthusiasm.

In 1962 Craigie's friend Myles Murphy managed to secure for him a day's teaching every week at the Regent Street Polytechnic, at that time before its amalgamation with Chelsea School of Art, an independent institution. And it was here one day that he was introduced to the Nigerian model, Georgeous Macaulay. Georgeous was to be the subject of more than a dozen of Craigie's most memorable pictures over the next fourteen years and has never been superseded in the artist's affections as his most inspiring male model.

For Craigie, the discovery of Georgeous was more than simply the arrival of a new subject; he represented an entrée into a whole new way of making pictures of people. This was largely due to the exquisite colour of his skin which, Craigie found, could be set off against bright primaries without losing any of its resonance. At this time Craigie was becoming more and more interested in local colour for its own sake and more and more confident about using it for dramatic effect; by choosing to paint black people his sense of colour was unfettered. He is quite unapologetic when cross-examined about his predilection: 'When people ask me why I only paint black people,' he says, 'I always ask them why they only paint white people.' For him it is merely a visual preference.

The first pictures Craigie painted of Georgeous were life studies in which the model is viewed from some distance standing against a blue background. There are two

of these pictures and clearly they relate to his previous pictures of female models. Unlike them, however, there is virtually no attempt to place the figure in a context – he is exhibited very much as a specimen – and, unusually for Craigie, the model casts a shadow on the wall behind him which gives a strong impression of three-dimensional space. In the second, and more important, *Model Standing against Blue Wall with Crucifix* [**30**] Craigie adds the device of an ornate gilded crucifix propped up against the wall beside the model. This naturally implies some kind of religious significance and expands the scope of the picture to embrace a whole range of possible meanings, not least the possibility that Craigie is reflecting in some subtle way on the iniquities of the slave trade. That the picture is also about colour itself further extends its meaning.

In a way *Model Standing against Blue Wall with Crucifix* is an intensely theatrical picture and, in this, relates to Craigie's love of suggested narrative; and in future pictures of Georgeous he would play all sorts of tricks of this type,

dressing up the model to imply the exotic, glamorous life he led 'off-stage', as it were.

Curiously though, Craigie is not an artist who insists on or finds it necessary to get to know his models in any profound or intimate way, as does Lucian Freud for example. He was certainly intrigued by Georgeous and his unlikely life: the model seemed to spend most of his non-modelling time doing various correspondence courses on interior decorating, learning to hang wallpaper, and trying to learn the piano. (Craigie once bought a piano for Georgeous to help him in this last endeavour.) When, in 1976, he simply vanished from the scene without as much as a goodbye – Craigie assumes he returned to his native Nigeria – it seemed wholly in keeping with Georgeous's inventive existence.

In the portraits Craigie made of Georgeous the model occurs on several occasions wearing a peaked cap, medallion on front, a smartish jacket with black lapels and a brightly coloured shirt. There is a naval air about these

31 Georgeous Macaulay in Red against a Yellow Background, 1970

32 Georgeous Macaulay in Blue against a Red Background, 1965

depictions of Georgeous – he could easily have stepped off the backstreets of Marseilles in some louche novel by Jean Genet – but, on the other hand, there is no pretence that he is not posing for his portrait. *Georgeous Macaulay in Blue against a Red Background* [**32**] is a particularly fine example. The pensive gaze and the nobility of the sitter suggest a self-assuredness as convinced as any eighteenth-century grandee. The clear way in which the composition is organised leaves no questions unanswered. The tonality is perfectly pitched. And the painting of the face itself is an essay of marvellous subtlety: the shadow of the sitter's beard is used cunningly to suggest the form of the head and line is used sparingly to delineate his fine features.

A very similar picture, *Georgeous Macaulay in Red against a Yellow Background* [**31**] where Georgeous sports the same cap but this time a bright scarlet T-shirt, rings the changes on dramatic colour juxtapositions by setting him against a brilliant cadmium yellow background. But it is in a slightly smaller portrait of Georgeous, painted a year later, *Georgeous Macaulay in Uniform* [**33**], that Craigie succeeded in making what is arguably his definitive image of the model. By dressing Georgeous up in the uniform his father had once worn as a Privy Counsellor, Craigie transformed Georgeous into a personality of heroic dimensions, a Toussaint L'Ouverture for the urban jungle. This impression is heightened by the sitter's direct steady gaze – unusual in Craigie's portraits – and the bust-like composition. In terms of actual painting the portrait is a paradigm of economy and has the sense of immediacy and life so admired in ancient coptic mummy masks.

During the 1960s Craigie also painted a number of profile heads of Georgeous in which great play is made of the model's geometrically shaved beard and hairstyle; charming though they are, they lack the authority of the larger pictures. But Georgeous had no monopoly on Craigie's attentions. Between 1967 and 1968 the artist painted two large standing nudes [**34 & 35**], one male, one female, which both in their scale and ambition break new ground and pave the way for the more complex large

33 Georgeous Macaulay in Uniform, 1969

Craigie's father wearing the uniform of Privy Counsellor in which the artist later depicted Georgeous Macaulay

34 Model Standing in front of a Black Background, 1966

35 Ivan Standing in front of a Yellow Background, 1968

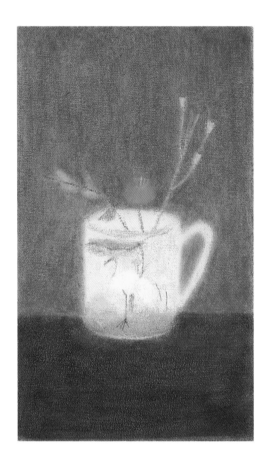

compositions of the following decade in which nudes feature prominently.

Both pictures are characterised by the tripartite fashion in which Craigie vertically divided up the canvas and by the way the figures appear to float against the central panel. *Model Standing in front of a Black Background* [**34**] is the more satisfying of the two. Not all Craigie's painting of nudes depend for their authority on the accuracy with which he explains form, by any means, but in this case the naturalism of the stance and the breathy way in which the form of the figure has been described are entirely convincing, and the same applies to the figure of a male in *Ivan Standing in front of a Yellow Background* [**35**]. There is something whimsical about the striped effect of these compositions, as if Craigie were making his own riposte to the Op Art movement of the swinging sixties and in doing so was saying 'Ah, but the great tradition of the nude in Western art must survive!' But if they are, in some ways, experiments then they are very beautiful ones.

But if, in the nudes he painted in the late 1960s, Craigie was breaking new ground and preparing the way for the richer and more complex series he was to paint over the next ten years, then in the realm of still-life he was also rethinking and extending the possibilities of this genre.

By 1965 when he painted a rare oval picture called *Fish Jug Still-life* and a related, larger one of wild flowers standing in an elegant jug made by his friend Euan Uglow, Craigie had left behind the tentativeness of the way he had treated his Japanese tin [**28**] and Chinese cup [**36**], and moved on to a more organized, and in some ways more traditional, method of treating the still-life.

In one of the most successful from this period, *Black Glove and Tangerine Still-life* [**37**], for example, three main elements – a decorated vase, a glove, and a tangerine – are positioned before a backdrop simply divided up into areas of black, pink and orange. Apart from a single bloom in the vase, indicated with no more than a flick of the brush, there is no line drawing whatsoever in the picture. It is all about colour: the lighter shade of the tangerine drawn to

36 Chinese Cup Still-life, 1963

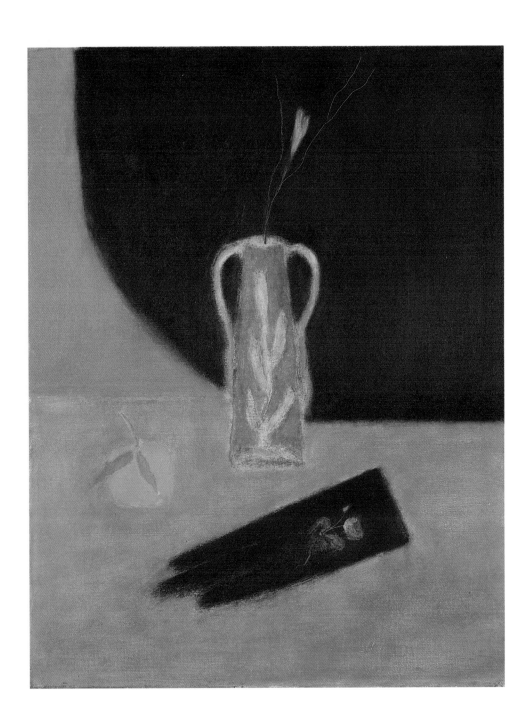

37 Black Glove and Tangerine Still-life, 1968

one's attention by the two green leaves, is played off against the more intense shade of orange in the background, the black of the glove answers the large black area; the red and yellow of the vase vivifies the whole. The picture is as calculated as a mathematical equation.

Two years later in an especially witty and interesting picture, *Blue Bird Still-life* [**38**] – now thankfully and wonderfully restored after disastrous fire damage – Craigie set himself a more complicated set of problems. Much of the picture's charm derives from Craigie self-consciously paying attention to the ambiguity of the picture plane, from

his modest attempts at illusionism and from his amusing 'short-circuiting' of three-dimensional forms. The highly stylised blue bird sits both on and against its coloured stalk, while flecks of white crudely indicate highlights on bottle and lemon, and two square pieces of patterned paper are collaged onto the picture's surface. Craigie developed an enthusiasm for using collage at this time; a small light-hearted work called *African Boy with Rose, Flowers and Budgies* [**39**] is more collage than painting and in *Japan* [**40**], a design later turned into a successful print, the effect is similarly collage-like.

38 Blue Bird Still·life, 1970

39 African Boy with Rose, Flowers and
Budgies, 1969–70

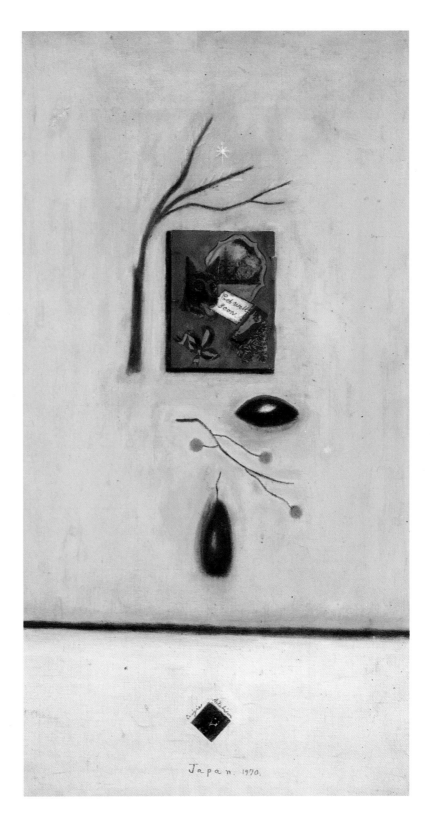

40 Japan, 1970

By 1968 when Craigie held his first one-man show since the Beaux Arts Gallery closed in 1965, this time at the Marlborough Gallery, the entire range of his artistic repertoire – both in terms of subject-matter and technique – was firmly in place. He could even look back and paint pictures which are nostalgic recreations of earlier successes.

Two works, delightful in their own way, come into this category. *Strawberry* [41] and *Butterfly in a Purple Landscape* [42], dating from 1966 and 1968 respectively, might easily have been painted a decade earlier. The latter in particular, is a reworking of the kind of mysterious, wholly two-dimensional picture he had made after returning from Italy and which, when exhibited, critics immediately read as being inspired by Odilon Redon.

But while there is certainly 'development' in several senses in Craigie's work, his search for more ambitious, more resonant subject-matter, for an ever more personal-

41 Strawberry, 1966

42 Butterfly in a Purple Landscape, 1968

ised means of expression – it is a mistake to try and impose conventional ideas of stylistic development on him. He is just not that kind of artist.

In 1961 Craigie gave an illuminating interview in which he expounded his method and philosophy of painting. It is typical of the artist that he should still, thirty-five years later, stand by what he said at that time:

I don't learn much from paintings, by this I mean, I do not feel one picture helps the other much, they might teach me something technically, or I might learn to have a bit more patience, wait 'til the first arm dries, once I have decided it is right, for to paint into it when it is wet, muddles it, apart from that I do not associate one picture with another, though all the pictures I have got at home, I associate together if they have been done at the same time. I have only once done a series of paintings, by this I mean that the pictures were connected. I did a very gloomy picture of a moor with telegraph poles, then I did from memory a very bright picture, it was of butterflies in a red and orange landscape, then afterwards I painted a very dark purple landscape, for by then I was against the bright picture. I disliked each one when I finished it, but liked them all in the end. They should have been all one picture really, I do not like remembering them separately, and one seen without the other loses its force.

Viewing the pictures to which Craigie was referring [**13** & **14**] it is easy to see what he means, but the ramifications of this anti-traditional way of an artist perceiving his 'progress' is that compositions can be reworked with only very subtle differences after long intervals, much as a pianist might re-record in his old age a concerto he first learnt as a young man. In 1988 Craigie painted a Crucifixion set in a landscape [**44**] which, though smaller, is almost identical in terms of composition to that he first invented twenty years earlier [**27**].

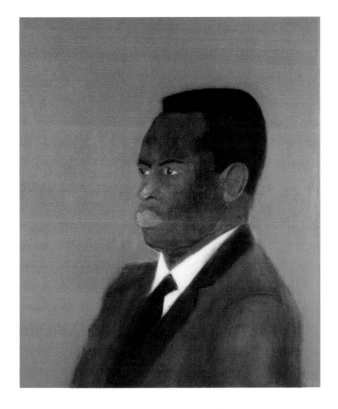

43 Portrait of Michael de Courcey, 1968

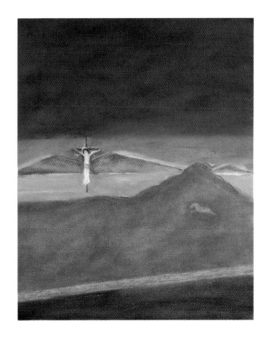

44 Crucifixion in a Landscape, 1988

79

ised means of expression – it is a mistake to try and impose conventional ideas of stylistic development on him. He is just not that kind of artist.

In 1961 Craigie gave an illuminating interview in which he expounded his method and philosophy of painting. It is typical of the artist that he should still, thirty-five years later, stand by what he said at that time:

I don't learn much from paintings, by this I mean, I do not feel one picture helps the other much, they might teach me something technically, or I might learn to have a bit more patience, wait 'til the first arm dries, once I have decided it is right, for to paint into it when it is wet, muddles it, apart from that I do not associate one picture with another, though all the pictures I have got at home, I associate together if they have been done at the same time. I have only once done a series of paintings, by this I mean that the pictures were connected. I did a very gloomy picture of a moor with telegraph poles, then I did from memory a very bright picture, it was of butterflies in a red and orange landscape, then afterwards I painted a very dark purple landscape, for by then I was against the bright picture. I disliked each one when I finished it, but liked them all in the end. They should have been all one picture really, I do not like remembering them separately, and one seen without the other loses its force.

Viewing the pictures to which Craigie was referring [**13** & **14**] it is easy to see what he means, but the ramifications of this anti-traditional way of an artist perceiving his 'progress' is that compositions can be reworked with only very subtle differences after long intervals, much as a pianist might re-record in his old age a concerto he first learnt as a young man. In 1988 Craigie painted a Crucifixion set in a landscape [**44**] which, though smaller, is almost identical in terms of composition to that he first invented twenty years earlier [**27**].

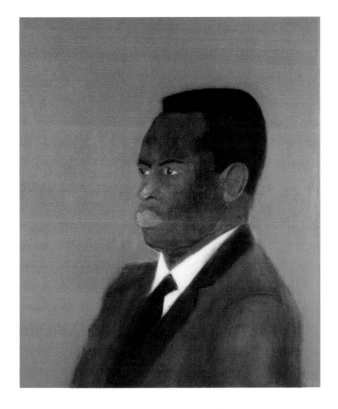

43 Portrait of Michael de Courcey, 1968

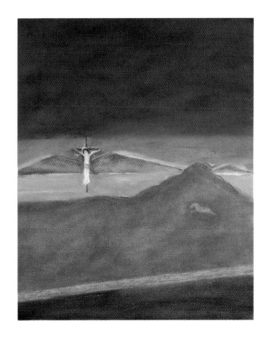

44 Crucifixion in a Landscape, 1988

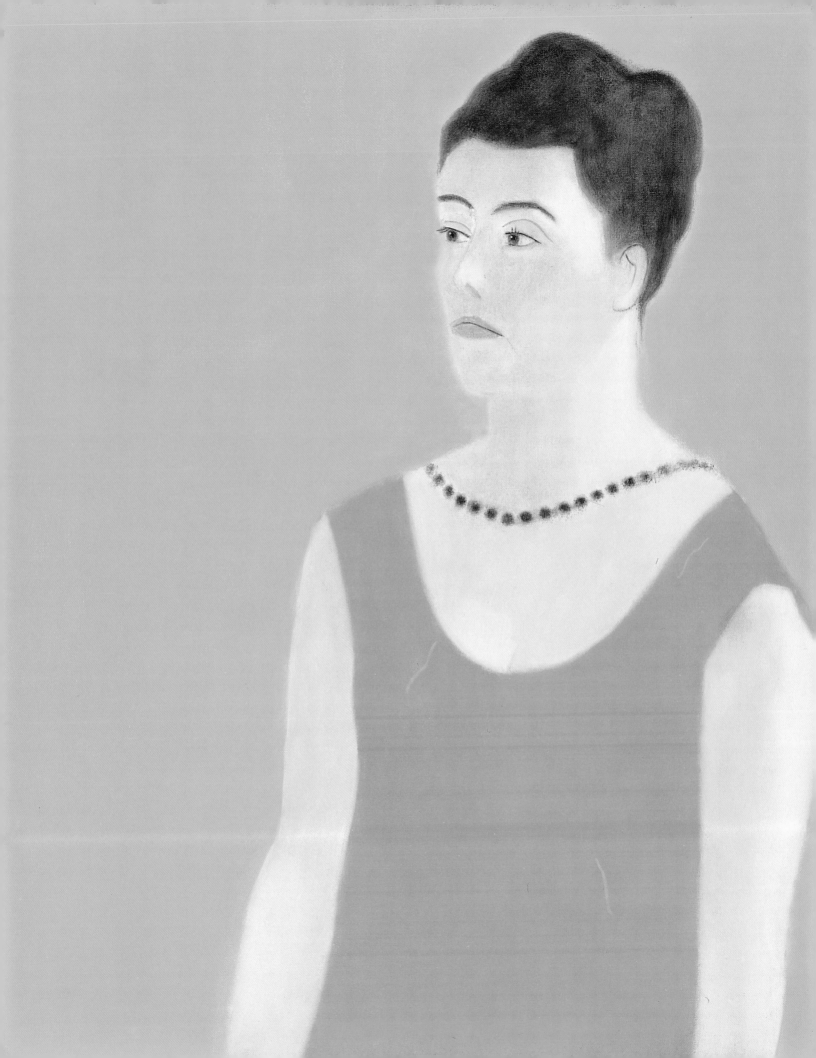

4 Daphne, Chicago and Friends

between his portraits and studies of models, nude or otherwise. And it is for this reason that, in the case of Georgeous Macaulay for instance, it is hard to tell where studies end and portraiture begins. The personality of the sitter is of only subsidiary interest to Craigie, and one result of this approach is that he only rarely accepts commissions for portraits; knowing the subject, he insists, however slightly, seems to sabotage the effort; the onus to produce a likeness (which actually Craigie is good at), or at least to please, is much too intimidating. So Georgeous in this respect was the ideal model. He took hardly any interest in the paintings, never asked to look while being painted, and in general treated Craigie as if he were passing the time of day.

The artist continued to paint Georgeous in the 1970s until the model's abrupt departure, and indeed there are at least two further fine pictures of him. The first, a simple head and shoulders on a small scale [**46**], is a delicate study

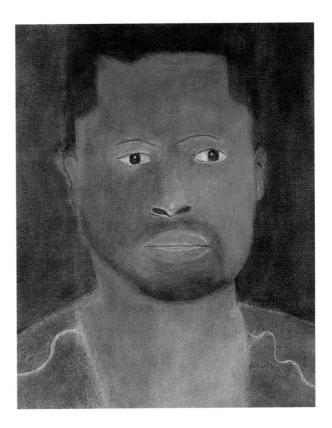

45 Daphe with Black Necklace, 1968

46 Portrait of Georgeous Macaulay, 1973

executed with breathtaking sensitivity. The presence Georgeous possessed seems to project from the canvas and the serene quality of the picture is uniquely seductive. *Georgeous Macaulay in a Sou'wester* [**48**] is the palest version of Georgeous and is notable for the way in which what could have looked ludicrous, the sou'wester, has been transformed into a logical component of the composition. The perfection of the shape Craigie has created ensures that it is read first and last as a shape; the title comes as a surprise.

But while black male models continued to occupy Craigie in the early 1970s – Carl Campbell [**47**] inspired a number of fine paintings at this time – when it came to painting larger, more ambitious pictures, pictures in which he wanted to expand the emotional range and create works richer in terms of meaning, Craigie usually turned to female models.

In the late 1960s the artist began teaching part-time at Chelsea School of Art where, since 1965, the School's Principal, Lawrence Gowing, had occasionally allowed him to borrow a large studio. It was at Chelsea that he came across a model who was destined to become his muse for several years.

Daphne Charlton had been a ballet dancer until, in her forties, she turned to modelling. She was statuesque with finely proportioned limbs and delicate features; an ideal subject not just because she was a professional model but because her training as a dancer meant she knew how her positions and movements would be seen by the artist. Craigie found this a great help. He has always been extremely particular about the poses of his models for he is wholly reliant on visual information, at least in his figure studies and portraits.

In 1968 Daphne sat for Craigie twice, both times clothed. In the first picture, *Daphne Seated against a Yellow Background*, she was painted sitting on an upright chair, arm over back, legs crossed. The dominant key to the picture was the brilliant yellow background and this was offset by a black panel occupying the left-hand third of the rectangle; here was painted a design of vertically cascading flowers. In

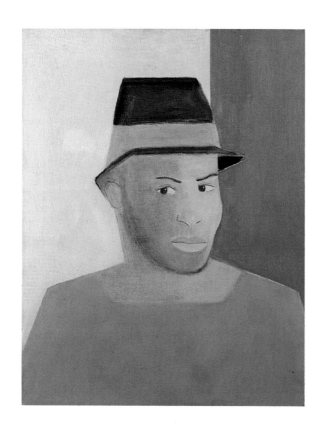

47 Carl with Black Hat, 1969

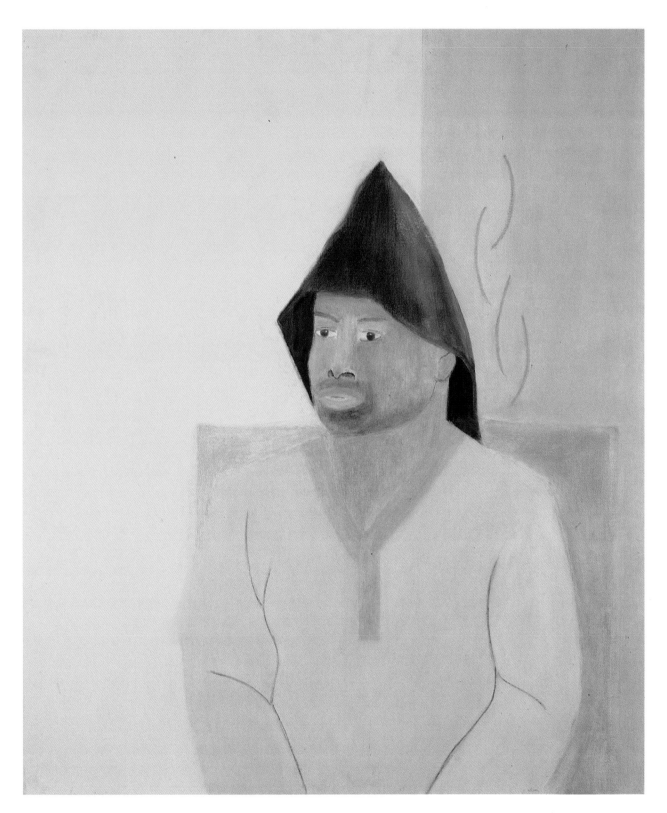

48 Georgeous Macaulay in a Sou'wester, 1976

1970 Craigie exhibited this picture at the Compass Gallery in Glasgow (the only one-man show at a commercial gallery he has ever had in his native Scotland); but during the exhibition he became discontented with the impression it gave and subsequently destroyed it.

Although this was a regrettable action, the sister picture, *Daphne with a Black Necklace* [**45**] argues in favour of the artist's dissatisfaction. It is a brilliant portrait, probably the finest picture of a non-black sitter Craigie has ever painted; despite the warm tonality, the design is spare to the point of austerity; the geometric division of the background which occasionally in Craigie's work appears arbitrary has been studiously avoided; local colour – blue eyeshadow, red lipstick, black beads – has been used in an entirely natural manner both to describe the sitter and to enliven the composition. Nevertheless, like the best of Craigie's work, the picture remains mysterious; there is an almost classical serenity about it.

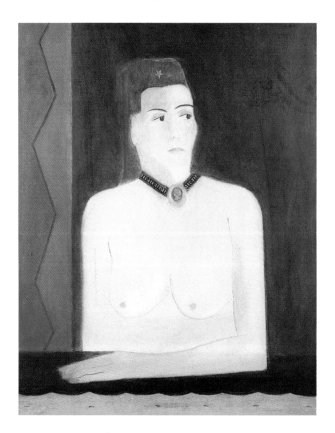

49 Daphne with her Arm on a Table, 1971

In the following years Daphne posed nude on several occasions and from these sessions two other works of comparable quality emerged. *Daphne with her Arm on a Table* [**49**] is the more opulent of the two, and it would seem for once as if Craigie had some precise Renaissance prototype at the back of his mind while painting it. The device of the arm resting on what in, say, the portraiture of Raphael, would have been a parapet, not to mention the proportions of the figure within the composition and the use of a decorative hanging as a foil to the figure, endows the portrait with a very definite classical feel, as does the cameo on the choker. Applied as collage to Daphne's quasi-Roman piled hair is a silver star, which, had the artist had a crescent moon to hand, would have transformed Daphne into the Diana she does indeed resemble. Again Craigie has made the most of local colour, in this case calling attention to Daphne's unusual pale blue nail varnish. Yet it is in the artificial manipulation of the nude form that Craigie's artistry truly displays itself: no elbow ever formed such a perfect right angle as Daphne's in this wonderful picture, and yet one accepts it unquestioningly because in this context 'it is right', to use the artist's phrase, just as in the work of an Italian Mannerist such as Parmigianino a neck, elongated beyond all possible anatomical normality, might also be 'right'. *Daphne with her Arm on a Table* brings to mind another revealing passage in Craigie's 1961 interview:

I'm suspicious if the whole picture comes right ever, I don't really expect to get more than one bit or 'The Bit' right, but it would be marvellous if one day all of it got right with equal intensity. I never change the first bit, because if it is not there after the first day I know there is no point in continuing that canvas, for I have tried doing so, it is simply that I have not been sufficiently interested in what I see to paint. There is always one bit that has to be good enough to stay forever, and if the picture is to be painted at all, it has to be there immediately.

If the half-nude of Daphne is Craigie's most exotic version of this model, then *Daphne with her Eyes Closed* [**50**] is the most sensual and, in a very cool way, erotic. Once more

50 Daphne with her Eyes Closed, 1969–70

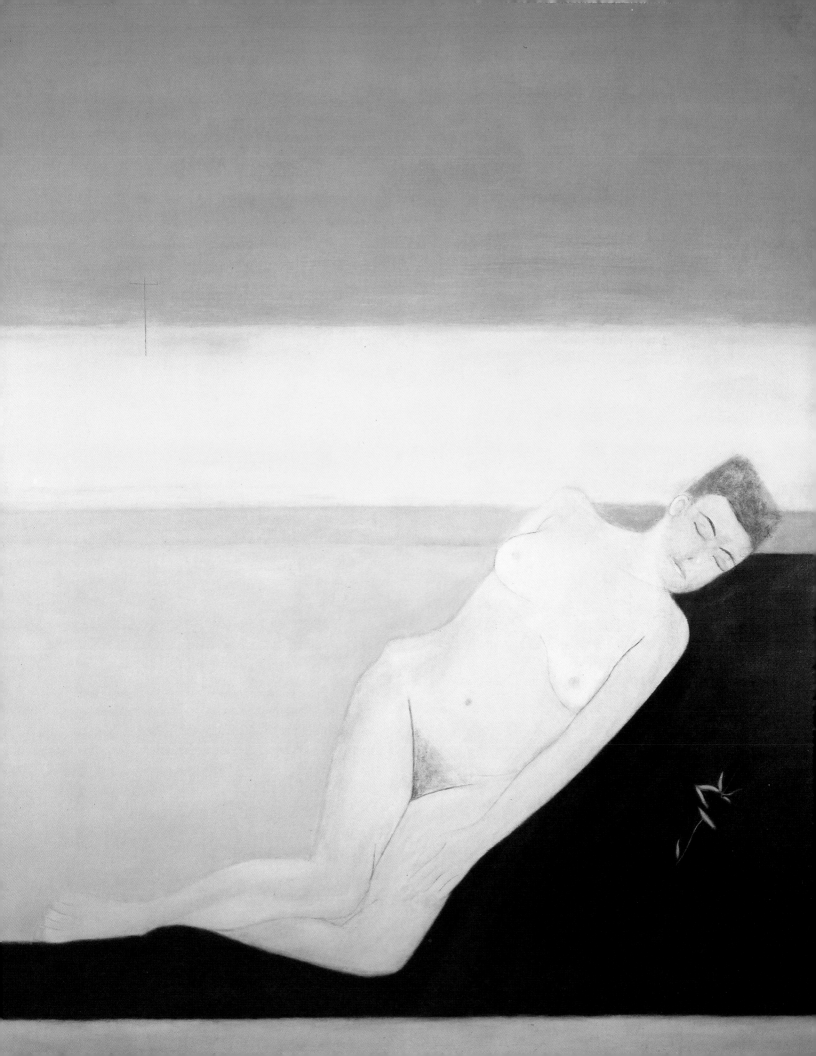

Renaissance depictions of nudes spring to mind: she is a Venus imagined by Cranach, posed by Titian. While the modelling of the form is of the most peremptory and subtle kind, the contours – scarcely a line in sight – are made with an exquisite sensitivity, nudging serpent-like into the simple bands of pastel colours which Helen Lessore described as 'a haunting fusion of outdoors-indoors, of night and day, as in a dream'. Indeed, there is something wonderfully dreamlike about *Daphne with her Eyes Closed*; she dreams but we are encouraged to dream about and with her. Craigie has rarely achieved more poignant poetry.

But start analysing the reclining, or rather floating Daphne (for there is nothing at all for her to recline upon) and, again, she becomes an impossible, even ridiculous invention. What has happened to that arm? What has happened to that foot?

The artist himself provides the answer:

Painting from the model I find very different to painting without somebody there. If there was a nude model posing in front of me, I could paint away for some weeks completely unaware that I had not put in part of a leg for instance, I wouldn't notice, for what I am doing there is a visual activity and it would never occur to me to paint something I did not see to such an extent that I wanted to paint it.

Daphne with her Eyes Closed won third prize in the 1974 John Moores' Competition. The critic Robert Melville commented in the *New Statesman*: 'It is the only picture in the show that discloses a deeply personal vision.'

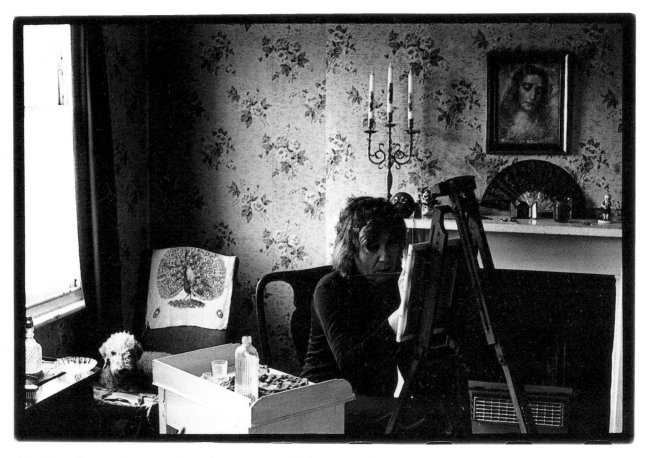

Craigie 'doing the pictures' – Wayney keeping him company – in the 'painting room' at 32 St Mary's Gardens (Nicholas Bechgaard, 1975)

Daphne with her Eyes Closed was a 'discovery picture' for Craigie. In it he discovered how by contextualising the nude it can be given all sorts of subtle inferences; how it can become something to be desired, to be worshipped, to be pitied.

In the years following, Craigie was to expand this vision with brilliant ingenuity and, in doing so, he became one of the few contemporary British artists able to treat the nude with the seriousness its provenance demands; one of the few artists who can get away with leaving out the irony, the tongue-in-cheek, 'nod's-as-good-as-a-wink' knowingness with which most other contemporary British painters feel obliged to endow it. David Hockney's male nudes are less memorable, perhaps because they are more accurately observed; Lucian Freud's lack equivalent magic because they are conceived in terms of substance rather than appearance. As one of Oscar Wilde's characters observes, theatre is so much more real than real life. He might have substituted dreams.

It was while Craigie was in the midst of his 'Daphne' series that, in 1970, Lady Aitchison died. She had become increasingly frail – by then she was well into her eighties – but she had at least enjoyed a fascinating last few years, becoming acquainted with Craigie's friends and models and constantly amused by the weird and wonderful tales of life beyond her ken – though frequently on her doorstep – in Kennington. St Mary's Gardens, however, could never provide the kind of space Craigie needed to work on large canvases, and so, in 1975, with the help of the writer John McEwen, Craigie took one of the first studios set up by the SPACE organisation in London, five floors up at the end of Shaftesbury Avenue overlooking Cambridge Circus near the heart of London's theatreland. Distracting as such a location may sound, it was here that Craigie managed to accomplish some of his most ambitious pictures, consoled perhaps by extraordinary views of the London skyline.

At about this time the writer and journalist Ann Barr, herself a Scot and great niece of a long-standing friend of Lady Aitchison from her Edinburgh days, introduced Craigie to his second most-important female model. Unlike Daphne Charlton, the American journalist Lendel Scott-Ellis was no professional model; at the time Craigie was introduced to her she was working for the fashion magazine *Vogue*. But as a model she possessed precisely the right kind of vaguely oriental beauty that Craigie could make something of, and he painted her several times in his new large West End studio.

Lendel Scott-Ellis was less voluptuous than Daphne and, therefore, Craigie instinctively knew that she demanded a different type of picture. In *Girl against a Pink Background* [51] Lendel Scott-Ellis takes on a totemic quality. She is viewed straight on, from the waist up, her head turned very slightly to the side, a panel of vivid pink silhouetting her severely geometric haircut. The flesh tones are warm, and the accuracy of Craigie's observation can be seen in the way the paler untanned breasts contrast with the deeper-hued body. Most strikingly though, the features are pencilled in with the succinct but telling skill of an oriental illuminator. In this image one feels as if occidental and oriental traditions of representing the figure have joined in partnership. It is this that lends the portrait its hypnotic quality.

Although painted three years later, *Model in a Black Hat* [52] forms a pair to this earlier picture. It is, however, an altogether more hieratic image; this time Lendel Scott-Ellis stares directly out of the picture with the solemn intensity of an ancient Greek kouros. If anything the overtones are even more oriental – the hat in particular looks like some concoction served up in a Chinese restaurant – and there is a Gothic, medieval quality to the elongated form; the figure is naked rather than nude, a fact accentuated by the hat which perfumes the work with the air of the nineteenth-century brothel.

In what is the most important picture built around this model, however, the nude appears more Gauguin than Gothic. *Model and Dog* [53] is the most complex compositional machine Craigie has ever assembled and exhibits every facet of his artistic identity. The nude is typically

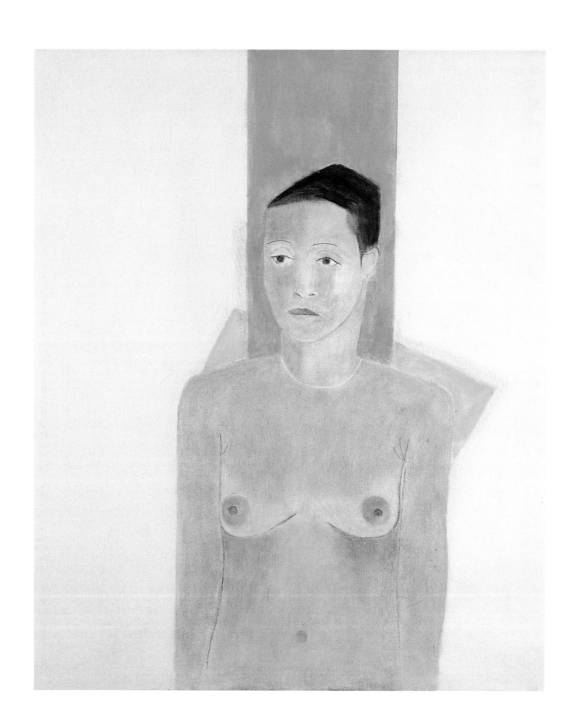

51 Girl against a Pink Background, 1974

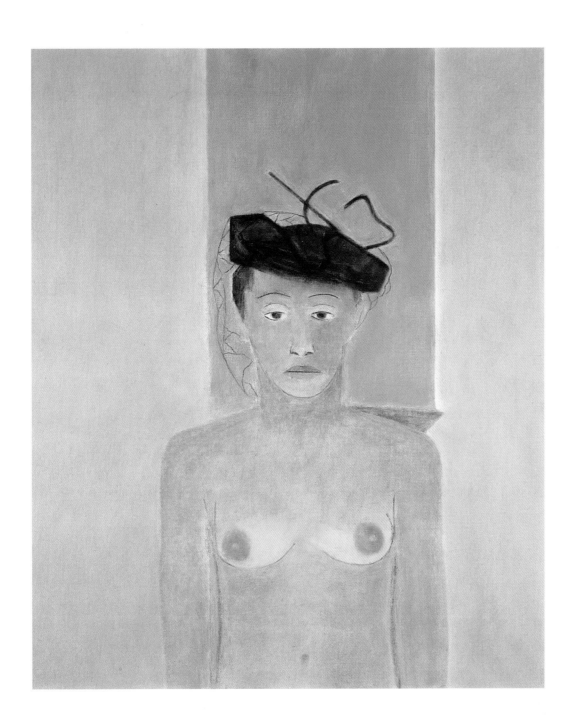

52 Model in a Black Hat, 1977

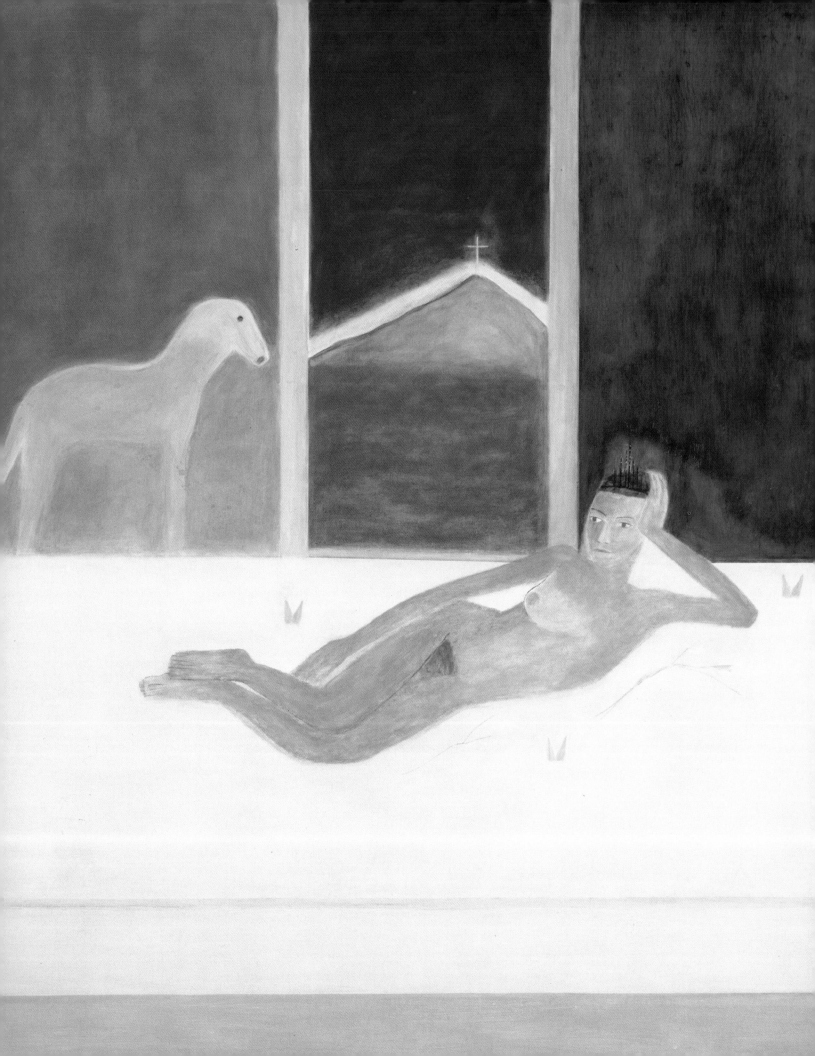

distant and exotic looking. Above her a view extends to some stylised imaginary Golgotha. Butterflies dance around her, increasing the dream-like quality. And then there is the dog, which seems both to guard and haunt this goddess propped up in her sanctum.

From the early 1970s dogs, or more precisely Bedlington terriers, crop up with increasing frequency in Craigie's paintings, although not until the 1980s was the artist to give free rein to his fantasy and include them in all kinds of allegorical situations, linking them iconographically not least with the Crucifixion. Craigie first came across the Bedlington breed at Crufts in 1971, immediately acquired one, and has remained faithful to the breed ever since. *Dog in Red Painting* [**54**] of 1975 is the first major picture he devoted exclusively to his adored companion Wayney. In 1977, a Bedlington flag he designed at the behest of Vera Russell, the driving force behind and organizer of the Artists' Market held in Covent Garden [**55**], gained instant popularity.

In *Model and Dog* the unmistakable shape of the Bedlington, with its smooth, aquiline, earless head, brings to mind the ancient lions of Delos (although the animals in Craigie's pictures rarely sit), adding a further ritualistic dimension to the work. (Not that Craigie has much truck with attempts to analyze the images he invents in order to fire the imagination). But again, one of the most fascinating aspects of this particular picture is the way in which Craigie has painted the nude; it is only after taking in the painting in its entirety that one notices the fact that she is missing one breast. The formal logic of the figure within the composition marginalises such considerations. It is highly likely that the picture was complete before the artist even became aware of the anatomical solecism he had committed.

A comparable omission occurs in one of Craigie's most spectacular portraits of the early 1970s, *Carl with Blue Watch* [**58**]. The subject of the picture is the stunning electric blue of the watch-face set against the bronze flesh tones as much as it is anything else, but Craigie clearly took great

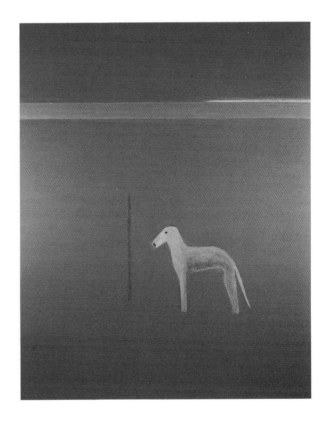

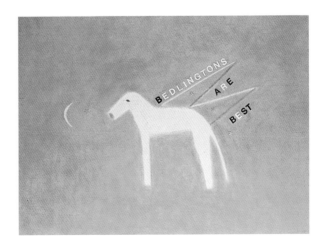

54 Dog in Red Painting, 1975

55 Bedlingtons are Best, 1977

53 Model and Dog, 1974

pains with the painting of the head and knew instinctively that it would work better within the picture if he withdrew after painting only one of the sitter's eyes. Unarguably it gives Carl a slightly dangerous look, but the picture functions admirably. Carl's variety of fantastic headgear presented Craigie with endless pictorial possibilities. In *Portrait of Carl Campbell* [**56**] his hat has almost the appearance of a biretta, and the solemn tone of the picture is strengthened by the pastel shades and generally low tonality. With *Vida Menzies* [**59**] Craigie perceived the similarity between the turban his sitter was wearing and some ancient Egyptian headdress. With the timeless quality that characterises all Craigie's best portraits, Vida comes to resemble Nefertiti. The silhouette in this portrait is one of the loveliest Craigie has ever painted.

In terms of consistent quality the mid-1970s marks a high point in Craigie's portraiture, but however adept he became he was forever seeking out new solutions and there is virtually no feeling of repetitiveness. When he was presented with a Greek model, for example, he turned out a very different kind of portrait. *Girl in Red Blazer* [**57**] is larger than Craigie's usual standard portrait scale and altogether more baroque in feeling. Partly this is because of the girl's hairstyle which lent itself to a more painterly treatment, but there is also a sense of movement about her jacket. While sticking to his favoured yellow for the background, Craigie here made clever use of mauve, using the colour for earrings, buttons and lipstick, and generally making from it a visual counterpoint to the dominant bright red of the jacket.

Having made such a success of painting black models, it was hardly surprising that Craigie should become rather weary of tackling white sitters. Yet when he did, as in the case of Gerald Incandela [**60**], he made more than an

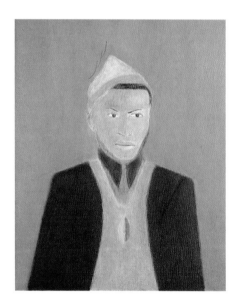

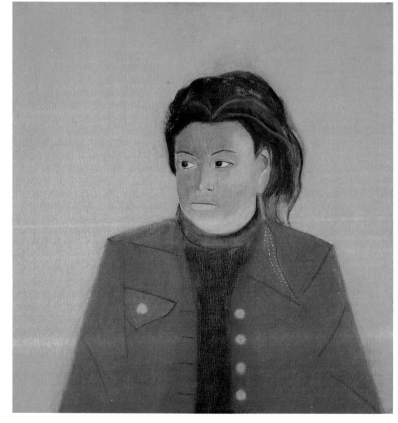

56 Portrait of Carl Campbell, 1973 **57** Girl in Red Blazer, 1974

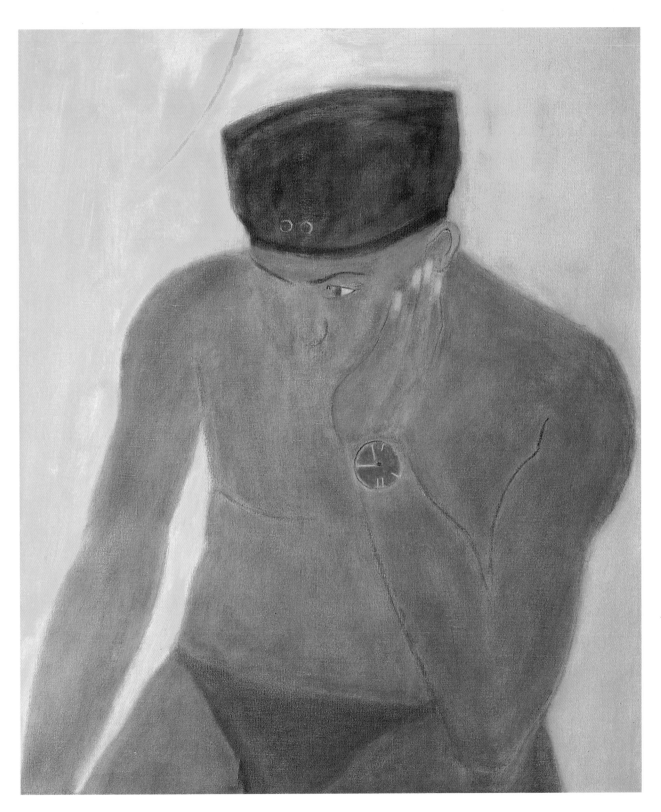

58 Carl with Blue Watch, 1971

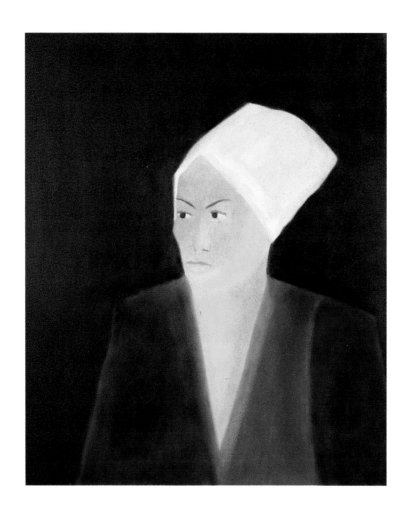

59 Portrait of Vida, 1973

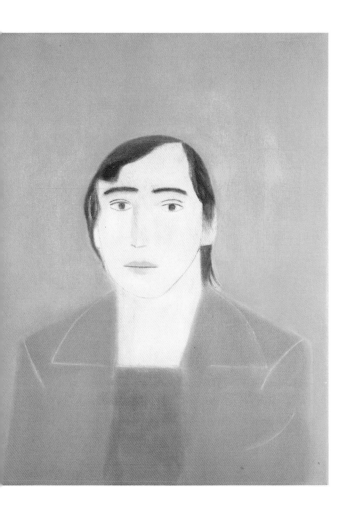

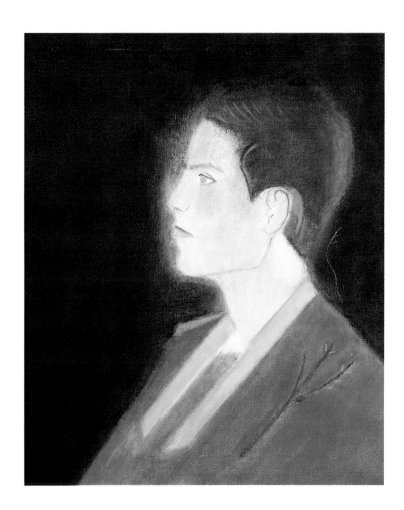

60 Portrait of Gerald Incandela, 1977 **61** Portrait of Francis Fry, 1978

average fist of it. Aware that the pale flesh tones would not be able to tolerate bright primary colours in clothing or background, he chose to improvise with various shades of pink, from cool pinks to almost hot pinks, all of which serve to emphasise the pallid quality of the face itself. In the painting of the hair it would appear that Craigie has made something special from an undramatic hairstyle merely by observing it intensely and accentuating its individuality; one senses that Craigie's painted equivalent of Gerald Incandela's hair is probably more interesting than the hairstyle itself.

Clearly, in portraiture there is less room for imaginative manoeuvre than in any of the other genres in which Craigie has chosen to specialise over the years, but it should not be assumed that he has developed a radical method; that he would think of painting a portrait in a very different way from a still-life, for example. The artist will usually start with an eyebrow and then works outwards, measuring in the manner he learnt at the Slade School but without leaving any marks as evidence of his procedure. Areas of painting which are 'not right' may be taken off with a rag or the fingers; if the picture is not going 'right' then some prop – a tie, a patterned hanging, even one of his Bedlingtons – may be introduced to try and rescue it. If

62 Butterflies and Lemon Still-life, 1974

this does not work then the portrait might be abandoned altogether or left for some weeks for careful consideration. There is always an element of chance about a Craigie picture and the excitement of the potential for disastrous failure usually manages to permeate the ultimate success.

Such is the case with one of the most interesting profile portraits of the late 1970s, the *Portrait of Francis Fry* [**61**]. Perhaps because the sitter was a close friend, it seems as if Craigie had acute difficulty in realising his image and there was a great deal of 'nudging the paint about, getting things wrong before you get them right'. The profile itself looks as if it has been heavily worked and eventually a kind of nimbus has resulted from repeated rubbing and repainting. As a whole, however, the picture works quite satisfactorily – Craigie insists that it was the sitter's dyeing his hair which helped him to bring the work to successful fruition – not least because of its unusual design and the way the patterns in the foreground distract the eye from the hard-won profile.

There has been no period in Craigie's career during which he has completely forsaken the still-life and while in the 1970s he concentrated more on extending his range of portraits and on coming up with more and more ingenious solutions of how to treat the nude, he persisted in developing a richer and more atmospheric still-life. A picture such as *Butterflies and Lemon Still-life* [**62**], painted in 1974, appears to have set the artist thinking deeply again about the problems of two dimensions – how to paint something which, while remaining decorative, can yet accrue meaning outside itself. Later in the same year, therefore, he painted a much more highly organised picture in which still-life and landscape elements are combined in much the same way that in *Model and Dog* the artist had combined the nude and landscape.

Lily Still-life [**63**] is one of Craigie's first paintings of the flower which he was to increasingly favour. It is the shape of the lily more than any connotation it might have that attracts him. In painting flowers he always thinks primarily in terms of shape although he is also concerned with

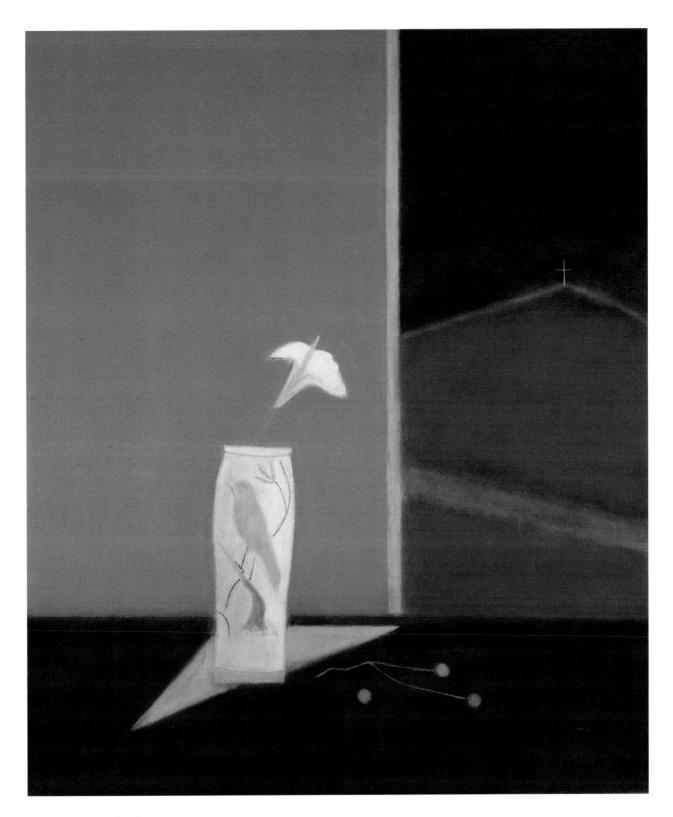

63 Lily Still-life, 1974

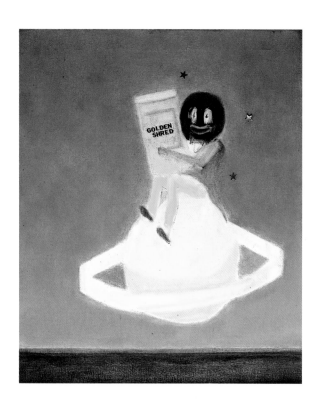

64 Mr Golly on any Planet, 1977

the flower's identity. Referring to a painting he made of irises in the late 1950s Craigie said:

It's got to be a shape but an iris as well, the two things at once. I hate when a flower turns into just a shape, that is what had happened, there, and yet it has to be a shape when all is said and done. But then if the shape is right, the whole painting will have taken on a life of its own, and then the shape will be completely forgotten, but it will still be there for anybody who wants to look at it for itself alone. I find in painting that it becomes a flower first, very quickly, then it goes into a shape then back into a flower, if it does not go back, then it's useless and the picture is terrible.

The lily in this still-life makes a wonderfully elegant simple shape but whereas Craigie might have just left it at that, by the mid-1970s he was happy to augment all the other meanings of the flower – innocence, its Christian symbolism – by introducing a distant Crucifixion into the composition. On the other hand, the dominating scale of the main subject of the picture, the lily standing in the vase, makes it quite certain that the picture is read as a still-life; the Crucifixion is a supporting argument, as it were.

A similar playful manipulation of scale occurs in what is the most immediately appealing of all the still-lifes Craigie painted in the 1970s. *Uncle Tom Still-life* [**65**], a picture that once belonged to the pop singer Elton John, is a brilliant arrangement in terms of shape and colour. The Staffordshire figurine is drawn in more detail than is usual for Craigie although he has avoided over-emphasis on the intrinsic tweeness of the ornament by simplifying its shape. The guitar, however, strikes a deliberately ambiguous note since it seems to relate in some way to the character of Uncle Tom although one knows it must be an independent item incorporated into the composition by the artist and cannot really have anything to do with the central object on display. Likewise, the hillscape painted in the upper section of the picture appears to be both a view through a window and a design painted onto the backdrop. In contrast to the *Uncle Tom Still-life*, *Mr Golly on any Planet* [**64**] is more ostentatiously humorous although it is ambiguous

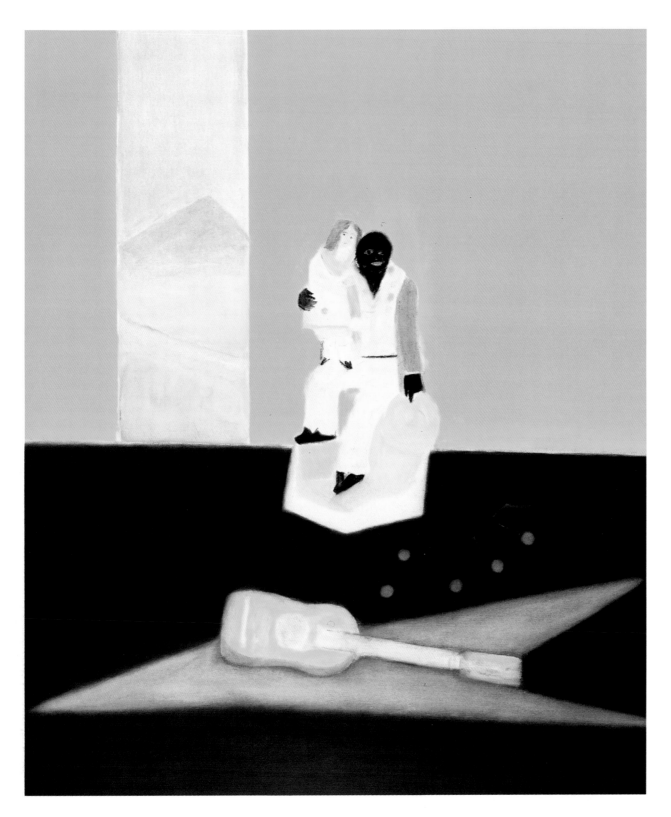

65 Uncle Tom Still-life, 1973

in a similar way. Based on an old advertising prop, Mr Golly on his pot of marmalade floats in the heavens; there has been no attempt to make the spectator aware of what the object actually 'is'. Amusingly, when exhibited at Kettle's Yard, Cambridge in 1977 the subject's proper title, 'Gollywog on any Planet' was judged 'politically incorrect' and metamorphosed into 'Mr Golly on any Planet'.

Another development in Craigie's life during the 1970s was the beginning of his more regular stays in Italy. Since his student trip in 1955 the artist had returned with friends such as Euan Uglow at one time or another, but in 1975, with the help of his friends Tim and Harriet Behrens, he acquired a large old farmhouse at Montecastelli in an iso-

Craigie's house and chapel at Montecastelli near Siena

lated mountain location not far from Siena. With the help of other friends Craigie moved a great deal of furniture from his London house and stayed there for eighteen months. The property includes a medieval chapel, complete with altar and crucifix, which appeals to Craigie's religious sense. The artist has frequently contemplated moving full-time to his house in Italy, but the quarantine regulations which would apply to his three Bedlington terriers if he were to return has so far deterred him from making the final decision.

During the first years after he acquired his house at Montecastelli Craigie would usually make the journey from London by car, sometimes fitting in a visit to Paris *en route*. And it was during one forced delay in Paris that Craigie, staying at a friend's flat directly opposite the church of

66 Sacré Coeur, 1978

67 Portrait of Chicago, 1981

Sacré Coeur in Montmartre, painted his one and only picture of a building. The artist has never wanted to paint buildings – they do not seem to him have the right kind of pictorial qualities to suit his talent – which in view of the success he made of the Paris painting seems a pity. *Sacré Coeur* [**66**] is a magical nocturnal view of the famous landmark. Craigie avoided all extraneous detail and re-invented the church as Chagall might have done. The street lamps, at least in the position they are in the picture, are presumably fictitious, as is the tree; in other words Craigie has used Sacré Coeur more as a prompt than anything else to create his own imaginary cathedral.

In 1977 Craigie met up with the final and most unusual black model who posed for him in the 1970s. The eighty-five-year old former boxer David Smith, known to all as 'Chicago', was a legendary *habitué* of the 'French Pub', arguably the friendliest and most popular hostelry frequented by writers and artists in Soho, and Craigie must have rubbed shoulders with Chicago frequently over the years. Craigie was amazed when he agreed to pose for him and thus began a very fruitful relationship; sometimes Chicago would visit Craigie at his studio not far from the French Pub in Shaftesbury Avenue, at others he would journey to Kennington.

Like Georgeous Macaulay, Chicago evinced no particular interest in the pictures Craigie made of him and so in that respect he was an ideal model; and at such an advanced age he was also content to sit still – sometimes dozing off – for several hours at a stretch.

The portraits Craigie made of Chicago are some of the most touching he has ever painted [**67**]. Chicago's surprisingly unlined skin, the fuzz of white hair, his compassionate eyes, all contribute to each picture's sense of profound melancholy. Confronted by an older sitter Craigie found himself unable to retain his usual objectivity and the result was a series of fine pictures which exude a moving sense of humanity.

In 1982, at the time of Craigie's major retrospective organised by the Arts Council of Great Britain at the Serpentine Gallery in London, a film was made about Craigie for BBC television. It was not a happy experience for the artist and was never in fact broadcast in the 'Arena' slot for which it was destined; the director seemed intent on making the artist appear an eccentric and total recluse. Characteristically, Craigie never deigned to view it, although it was shown privately by the Arts Council in the cinema. But *Painting Chicago* does contain some excellent footage of Craigie painting the elderly former boxer and the amusing exchanges between two men whose experiences of life could scarcely be more different are highly entertaining.

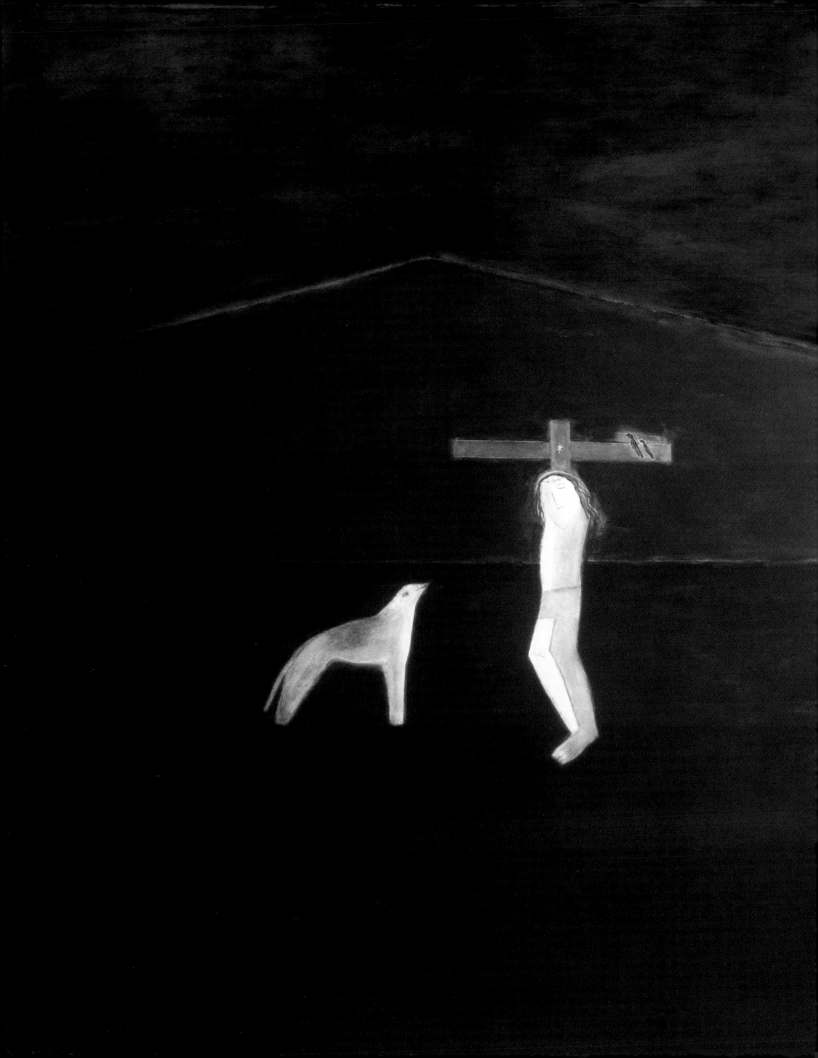

5 Bedlingtons and Other Passions

figures in themselves. Apart from David Hockney it is hard to think of a single one who might turn heads in a restaurant. Craigie, however, has become a minor media celebrity; his birthday makes it into newspaper anniversary lists, his outspoken letters get printed. Craigie is mystified as to how his fame has spread, but suspects it has something to do with the fact that he paints animals. In 1986 he designed some neckties for the Royal Academy, and these, decorated with brightly coloured birds, quickly became bestsellers.

The Bedlington terriers which are Craigie's greatest passion certainly seem, through him, to have captured the public imagination. Once, on a country outing, Craigie, three dogs in tow, found himself accosted by a tweedy middle-aged woman as he crossed a village street. 'Oh, look!' she cried gleefully, 'There are the Wayneys!' In the mind of the anonymous fan the entire Bedlington breed had become synonymous with the late Wayney, the first Bedlington Craigie immortalised in his paintings. And Bedlingtons have become synonymous with Craigie.

The Bedlington breed originated in the Northumberland town of Bedlington. Achieved by crossing a Dandie Dinmont with an otter hound and the offspring with a whippet, it was found to be an excellent 'ratter', and consequently very useful in the local coal-mines. The dog has an idiosyncratic temperament – 'the appearance of a lamb but the heart of a lion' is the usual description – and was at one time more popular than it is today. 'Dog people', of whom Craigie is undoubtedly one, tend to be either highly enthusiastic about the breed or thoroughly hostile to it. Certainly Bedlingtons take looking after; for many years, unable to find anyone in London able to clip them satisfactorily, Craigie would drive to Sheffield to visit Mrs Hall the expert.

Craigie has always used his pets in his paintings in one form or another; the beagle Somerset, his constant companion in his student days, had earlier sat for her 'portrait' [6], and in *Dog in Red Painting* [54] the Bedlington provides

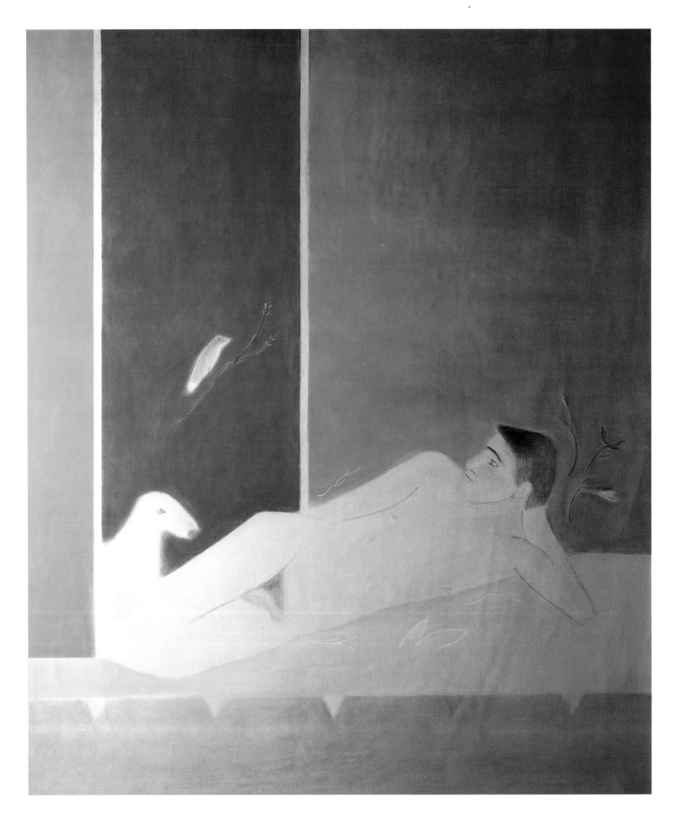

69 Bird, Boy and Dog, 1981

the only relief in what amounts to a 'colour field' of red, while in *Model and Dog* [**53**] Wayney, again seen in profile, seems to have some cryptic symbolic function relating both to the nude and to the Crucifixion. At the beginning of the 1980s, however, Craigie began to incorporate his Bedlingtons into his pictures in a more personal way; now they become personalities in their own right, as worthy of our attention as the human presences they frequently accompany.

In *Bird, Boy and Dog* [**69**], one of the few large-scale reclining male nudes Craigie has painted, the Bedlington enters the picture space as if surprising the boy, the dog's characteristic profile wittily forming a visual echo of the boy's penis as well as of the shape made by the elbow on which he reclines. In *Portrait of Patrick Kinmonth with Sugarbush* [**70**], the one-eyed Bedlington appears to sit on the subject's lap.

But it was the deaths of Craigie's first two Bedlingtons – Sugarbush in 1982 and Wayney four years later – that triggered off a completely new kind of painting. The series of 'laments' for Sugarbush and Wayney was a cathartic exercise for the artist – 'After Wayney died I couldn't do the pictures. I didn't know what I was doing,' Craigie once told a journalist. But the pictures were never originally intended for exhibition, and it was a great surprise for Craigie when they became immensely popular. Yet these small works introduce an entirely fresh and moving melancholy into Craigie's painting.

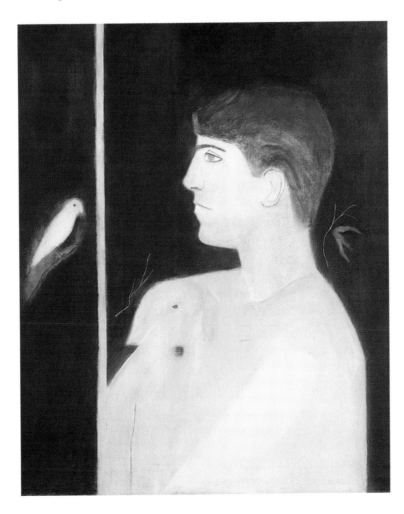

70 Portrait of Patrick Kinmonth with Sugarbush, 1984

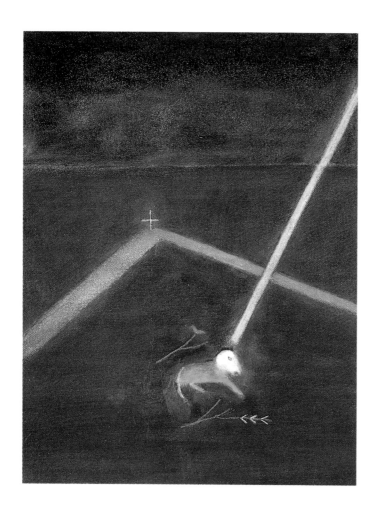

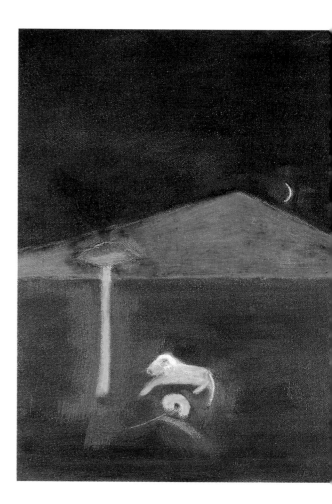

71 Wayney Dead I, 1986

72 Wayney Dead II, 1986

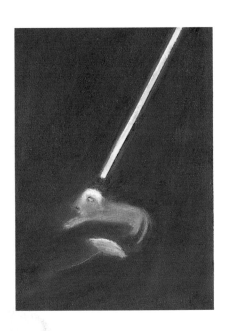

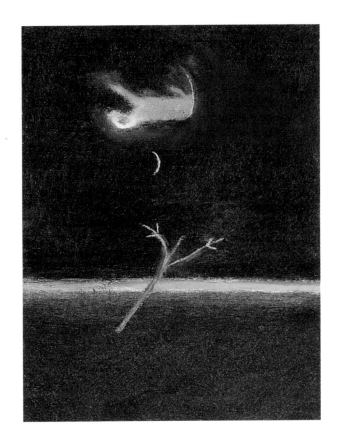

73 Wayney Dead III, 1986

74 Wayney Going to Heaven, 1986

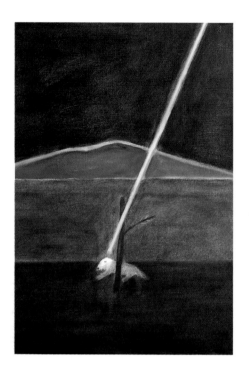

There are three major elegies on Wayney's death and all are imbued with a heavily religious flavour; were they not painted with such obvious compassion they might be considered sacrilegious.

In *Wayney Dead I* [**71**] the dog is depicted at rest on a sombre hillside, the hill itself picked out by a mauve halo and against a grey-black funereal sky. The Crucifix which seems to float above the hill immediately suggests that this scene is of religious significance, a suggestion amplified by the shaft of light descending from the top right-hand corner of the picture that, in some medieval altarpiece, would deliver the stigmata to a saint. Wayney is blessed and sanctified, his martyr's palm beside him. In the second version of the subject [**72**] Wayney, bathed in soft moonlight, is accompanied by a solitary tree reminiscent of an umbrella pine, and a flower, while in the third [**73**] he floats against a translucent sea of ultramarine blue, again sanctified by heavenly light. Craigie also painted a number of follow-ups in which Wayney's after-life experience mirrored Christ's more closely; in *Wayney Going to Heaven* [**74**] the canine saint ascends, paws first, towards, as one critic put it, 'that doggy place in the sky'.

The earlier Sugarbush sequence lacks the imaginative scope of the Wayney pictures, although one [**75**] seems prophetic in that in it the dead Sugarbush is stranded in a desert landscape over which rises the unmistakable silhouette of Holy Island, Arran, a motif that was to come to dominate much of Craigie's landscape painting over the next ten years.

The way in which Craigie has integrated his love of his pets into the fabric of his feelings about the pivotal story of Christian faith, the Crucifixion, is extremely clever; it has allowed him to exploit the religious theme to express his emotions about his Bedlingtons and their passing, while at the same time he has been able to endow the universal image of the suffering Christ with a personalised iconographic imprimatur. Extraordinarily, Craigie's juxtaposing of the Bedlington and the crucified Christ manages to augment the spiritual significance of the subject rather than

75 Sugarbush Dead, 1982

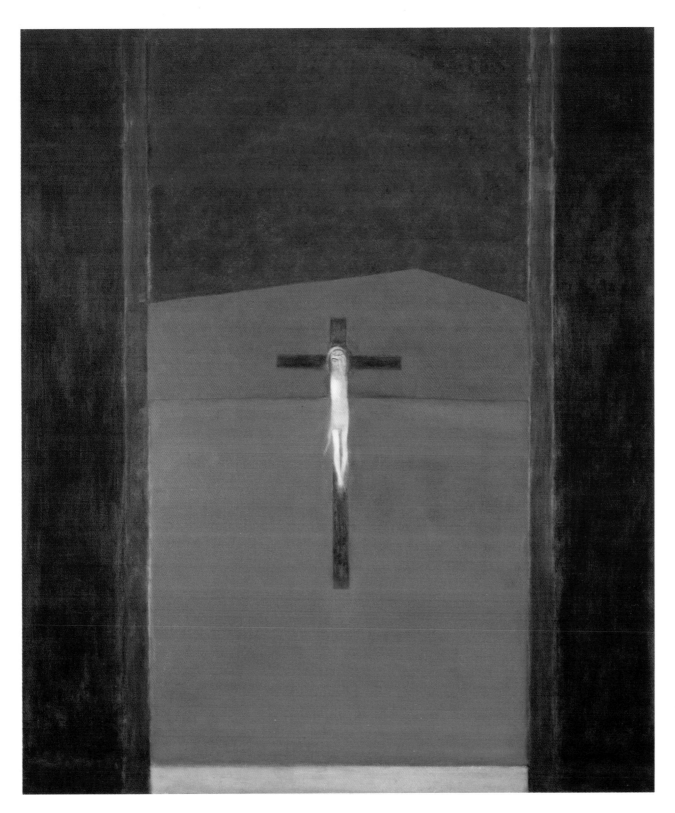

76 Crucifixion, 1970–75

diminish it; after all it is not as if Craigie is or ever could be a painter of animals in the Landseer mould – the dogs in these paintings always appear more symbol than furry friend. And the central way in which he has managed this is by playing on the iconographic assonances of animals in the New Testament story. The similarity of a Bedlington to a lamb is naturally a great help – there may have been no ruminants present on Golgotha but they were certainly around at the beginning of the saviour's life – and so there seems nothing at all unusual about the presence of a lamb-like creature. The Paschal lamb is the other obvious reference. Yet the idea of amalgamating his obsession with his pets with the Crucifixion subject did not at first occur to the artist.

In his initial treatments of the Crucifixion theme in the early 1960s Craigie always had the rich imagery of the Early Renaissance at the back of his mind; and even, at the beginning of the 1980s, when animals do begin to enter the religious fray, they are either ram-like creatures sport-

ing the horns of Jacob's sheep, or birds – doves of peace sweeping down towards the execution, or colourful crows perched on the cross awaiting Christ's last breath. In the most important of Craigie's early large-scale 'Crucifixions', there are no fauna whatsoever.

The Crucifixion painted between 1970 and 1975 [**76**] was Craigie's most ambitious treatment of the theme to date. It is notable for its severity and its altar-like appearance: symmetrical panels escort the scene; the diminutive event is set within a jigsaw of simple shapes which give it an assertively abstract quality. The depiction of the Crucifixion itself is of the Gothic kind; the elongated figure is almost at one with the cross to which it is pinned; its very smallness somehow emphasising its intrinsic poignancy. It is a picture in which Craigie's full command of scale is brought to bear; distance adds pathos to the event and yet the thrill of the picture lies in the fact that the artist makes one aware that, above all, he is concerned with 'getting the picture right'.

Craigie was never to fall out of love with the starkness of the effect he could achieve from refraining from cluttering large canvases. A large Crucifixion dating from the late 1970s [**77**] gains its authority from a wonderfully simple arrangement of colour – plangent orange through purple to a throbbing red. When animals join in the mourning, however, there is an added charm, an extra dimension of mystery.

Crucifixion 1984 [**78**], although painted on the same-size canvas as the important 1970s Crucifixion, appears a much more imposing work because of the interior scale. Here the Crucifixion itself has been brought to the front of the picture plane, the contours of the figure and cross have been delineated with the utmost subtlety, and the questioning eye of the animal performs much the same function as that of saints in medieval interpretations of the subject: he silently comments on the pitiful horror of the event and mutely invites our pity. The animal is humanised and sets the pensive mood of the entire picture; the stillness is palpable, the birds show no sign of fleeing. In

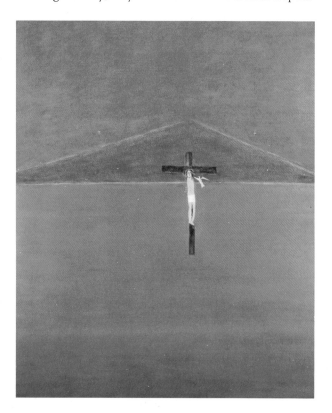

77 Crucifixion, 1979

78 Crucifixion, 1984

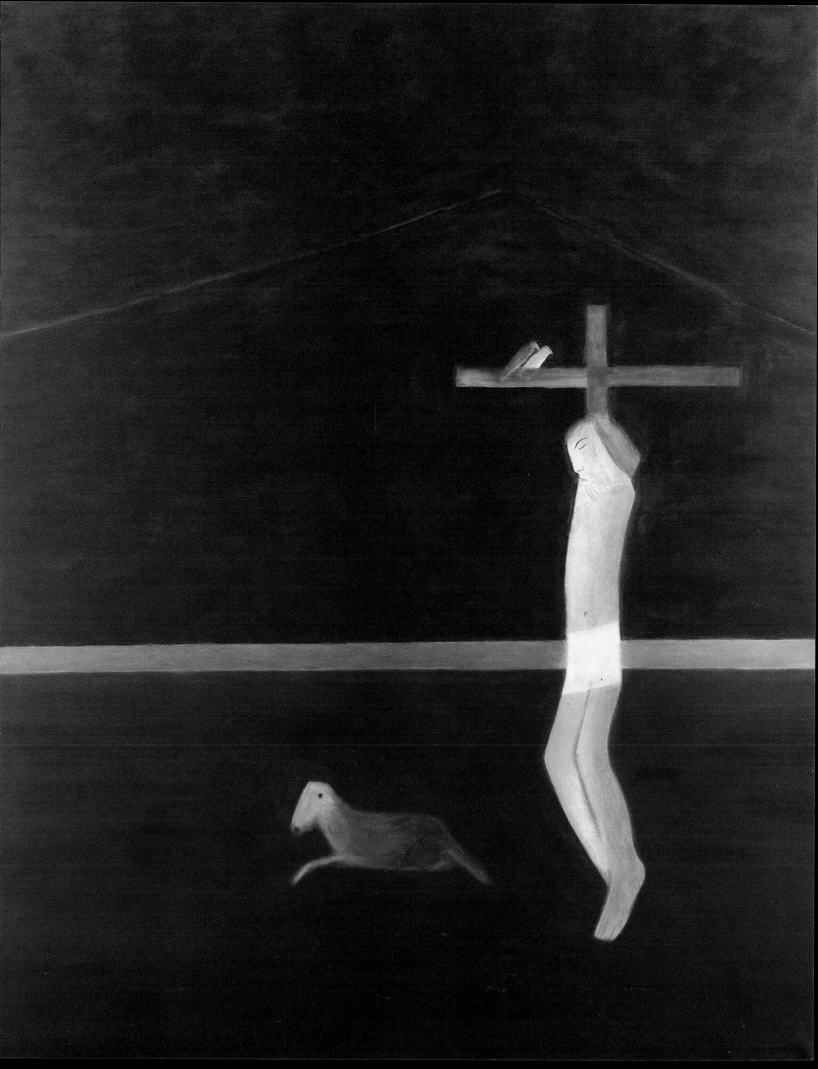

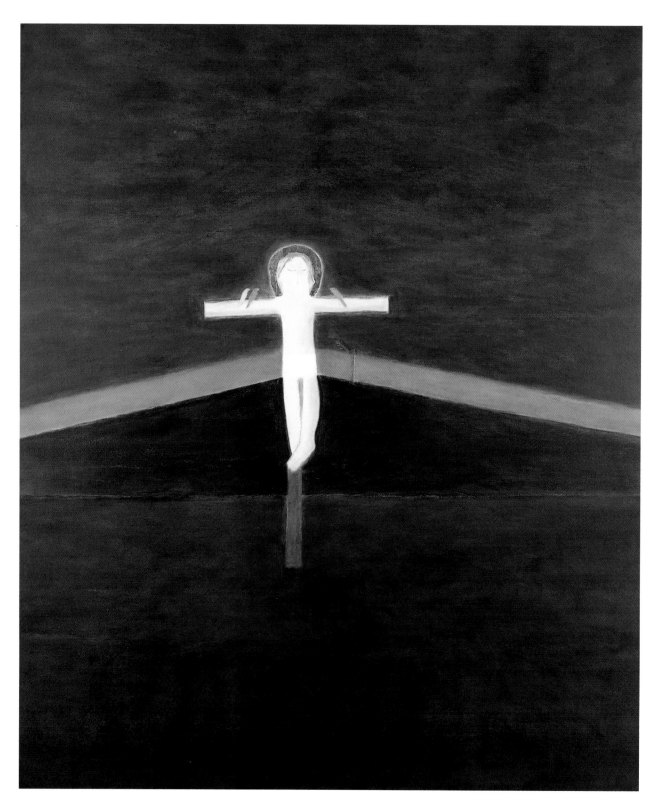

79 Crucifixion, 1985–86

the slightly later work gifted by the Chantrey Bequest to the Tate Gallery [**68**] the architecture of the composition is even more overwhelming. The chimera bays noiselessly at the limp, lifeless Christ, the picture's sense of mystery engendered as much by the strange tonal balance of the eerie nocturnal scene as by the meaning of the relationship between crucified Christ and animal.

Craigie's interpretations of the Crucifixion certainly strike a chord with the general public; postcard reproductions of them are among the bestsellers at various art galleries. But the Church, at least on one occasion has objected. When in the 1980s the Dean of St Paul's installed two 'Crucifixions' in the crypt of the cathedral he found his taste vetoed at the last moment by a minority of reactionaries on the Chapter. The Dean himself, however, Alan Webster, is steadfast in his admiration for Craigie's interpretations of this sacred subject. At the time of the controversy he wrote of the Crucifixion now in the Tate Gallery: 'Here, the divine is vulnerable and disturbing, not almighty or ecclesiastical. As in some Eastern religious thinking, the divine is seen to be at one with nature, the birds and the beasts, suffering with suffering humanity.' The Dean's colleague, Canon Eric Turnbull, commented that Aitchison's 'Crucifixions' 'reflect what is stirring in the hidden subconscious of his generation'.

The débâcle over the acquisition of his pictures by St Paul's Cathedral revived in Craigie early memories of an-

The communion table donated by Craigie's father in 1937 to the Erskine Church, Falkirk, in memory of his parents

other church's narrow-minded intolerance towards art. When, in 1937, his father donated a commemorative communion table to the church where his own father had preached for 55 years, the gift looked set to bring latter-day iconoclasts out onto the streets of Falkirk. Even as recently as the 1930s, it would seem, the gilded cross and polite tracery designed by the Edinburgh firm Whytock & Reid to embellish the oak table looked too 'Popish' for the burghers of the United Free Church. The donation was however eventually accepted, albeit with bad grace; but the incident of the 'gaudy' communion table sparked off in Craigie a love of opulent church decoration and a fascination with the symbolism of the cross which have had far reaching consequences for his art.

Two large-scale Crucifixions of a more sombre and threatening nature (in these Craigie abandoned the earth colours that also led the Dean to suggest, somewhat implausibly, that the artist has some kind of ecological game-plan) are very much in tune with the spirit of a still nuclear-threatened world in the aftermath of the Cold War. In them [**79** & **80**], as St Paul would have it, the whole of creation is groaning in one great act of giving birth. The smaller of the two is more ominous; over a highly placed horizon a fiery pink penumbra glows; apart from the tiny moon there is nothing to detract from the Crucifixion itself. This is a world as airless as Mars, alien to bird and beast. In the larger canvas, although the general tonality and colour key is the same, the crucified Christ has, unusually for Craigie, a childlike appearance – he is the beardless, boy-Christ of the catacombs rather than the hirsute Byzantine-looking character usually favoured by the artist. He is wholly unnaturalistic, an impression made more emphatic by the solid-looking two-dimensional gold halo and the way in which his body seems actually to be part of the substance of the cross rather than pinioned to it. It is a feature of both these austere pictures that, were the subject to be removed, an entirely abstract design would remain.

This sense of clear design, as calculated as any abstract

by Mondrian (Craigie is a great admirer of the Dutch pioneer of Abstraction) informs the series of large 'Crucifixions' begun in the early 1980s more pervasively than any other group of works. It is this that allows Craigie to 'get away with' working variation after variation on such a loaded theme; even though he is treading on territory stamped by any number of Old Masters from Grünewald to Rembrandt, one never feels as if Craigie is in competition. The 'classics' are all motivated by religious purpose in one form or another; Craigie's motive is always overwhelmingly formal. Above all, his paramount concern is to preserve the integrity of the picture surface and not to indulge in bogus illusionism, not to pretend that he could possibly be recreating the event. In this way he asserts the series' independence of tradition.

If one were forced to pinpoint prototypes of course, Craigie's revered Piero della Francesca would head the short-list, even though Craigie's Saviour is nearly always closer to the Bosch-ian type than anything to come out of Renaissance Italy; and, in two further 'Crucifixions', it would seem that, at least subconsciously, Craigie is thinking back to Piero's *Story of the True Cross* cycle at Arezzo. In the artist's Diploma work for the Royal Academy of Arts and, more dramatically, in a larger picture of the same design now in the collection of the Glasgow Museums & Art Galleries [**81**], the trunk of a tree descends diagonally – like a thunderbolt – across the surface of the picture. It is both substance and symbol of the cross – the tree on which Christ was hanged; and with it Craigie plays, as he is wont to do, with the iconographic logic of the scene. That he 'means' more than the abstract force of the composition is signalled, succinctly enough, in a comment the artist made on this picture: 'The picture I hope clearly tells a story; which is what paintings at the beginning were intended to do.' Though the story is one of the oldest and best known in the world, Craigie tells it afresh in a new way.

Craigie has always worked on more than one canvas at a time, often over a very extended period. He may well have a *Crucifixion* or a major still-life painting under way,

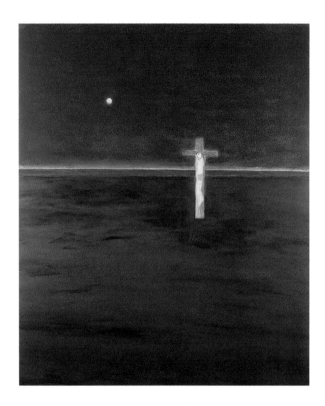

80 Crucifixion, 1987–89

81 Crucifixion, 1988–89

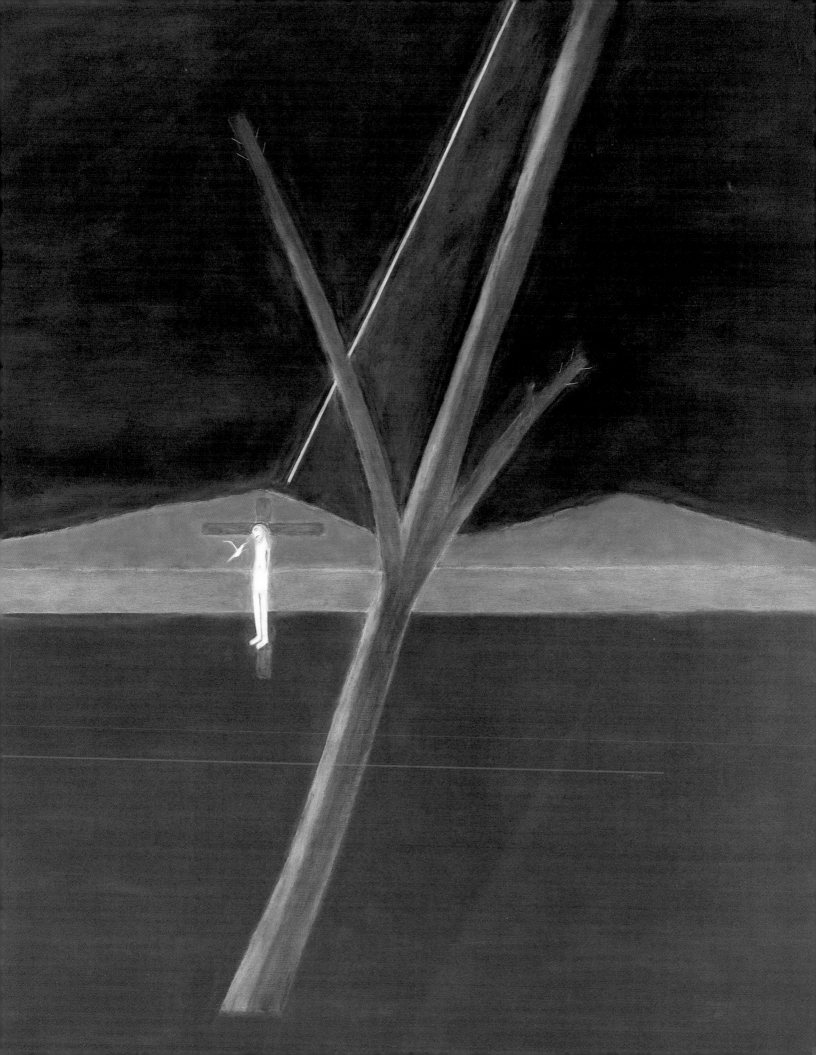

while working on one or two portraits contemporaneously. So, during the 1980s, while the artist's most 'serious' attentions were being devoted to the large 'Crucifixions', he was also extending his range in portraiture. In the portrait of *Leroy Golding* [**82**] a dove alights on the sitter's arm, a device with universal connotations of peace that elevates the image beyond the particular while, at the same time, Craigie is at pains to stress the individuality of the sitter. In a number of portraits of the model *Patrice Felix Tchicaya* [**83**], there is an even more intense focusing on the specific nature of the sitter's appearance and, as usual, the strange and exotic hairstyles of the model make the

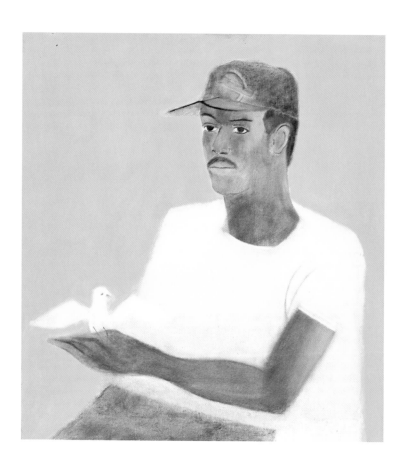

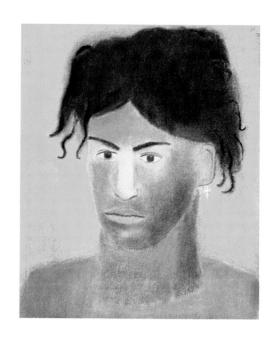

82 Portrait of Leroy Golding, 1981

83 Portrait of Patrice Felix Tchicaya, 1985

most unusual shapes on the canvas. Craigie was helped, as always, by Tchicaya's habit of regularly changing his hairstyle.

In the later of these two Tchicaya portraits [84] the severe high-standing 'flat-top' is locked into a wonderfully tight jigsaw of simple shapes against which the almond-shaped eyes register with dazzling intensity. And it is this same ultra-sensitive delineation of idiosyncratic shape allied to a highly personal range of colour that distinguishes what many consider Craigie's finest series of portraits of black models.

Craigie first met the Ghanaian writer, Naaotwa Swayne

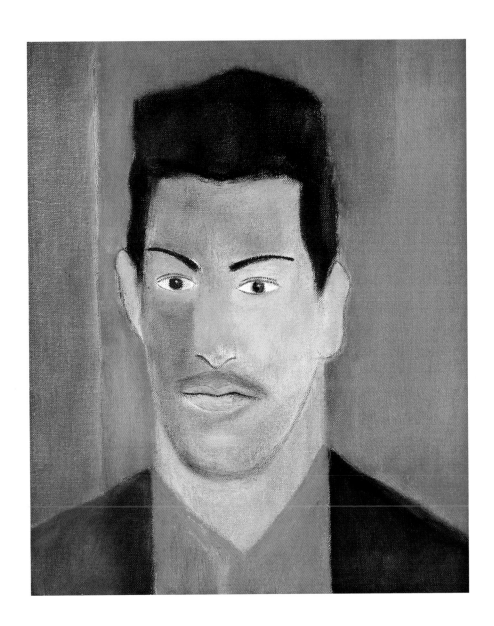

84 Portrait of Patrice Felix Tchicaya, 1989

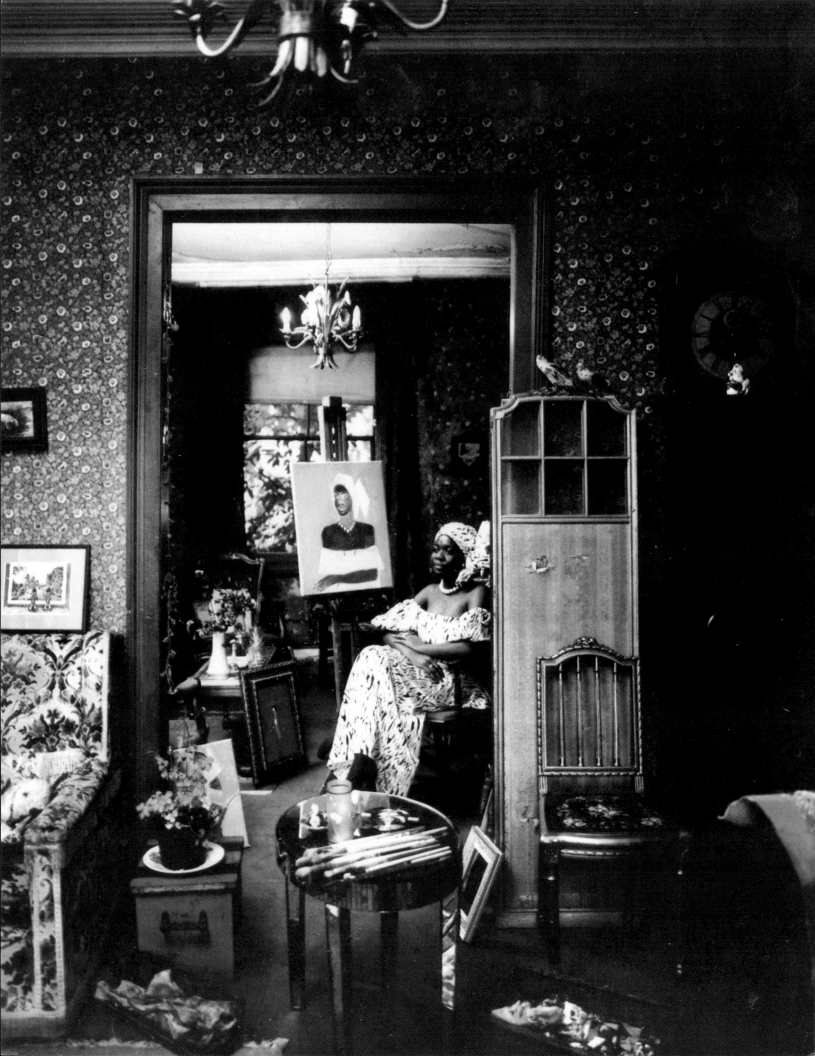

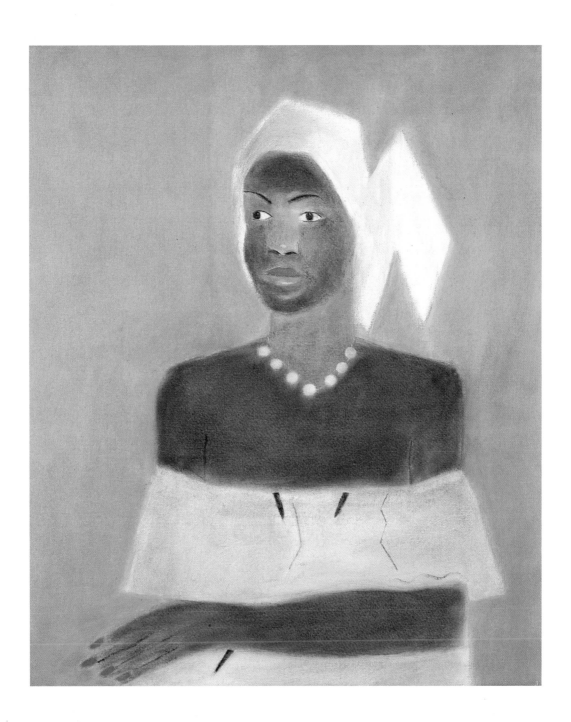

85 Portrait of Naaotwa Swayne, 1987

Left: The portrait in progress at 32 St Mary's Gardens

in the early 1980s when she married his friend, the composer Giles Swayne. She is a seductive personality with a marvellous sense of humour and an acute intelligence: her novel, *The Dancing Tortoise* (1995), in which she draws on her experience growing up in West Africa is an informative and entertaining introduction to the mores of that part of the world. As a model, Naaotwa offered everything and more that Craigie could have wished: she has beautiful dark yet translucent skin tones, an aristocratic bearing, a refined voluptuousness, and a wonderful way of combining her gorgeous native costume with Western dress. In contrast to the female models Craigie painted in the 1970s, Daphne and Lendel, the artist has preferred to take advantage of Naaotwa's flamboyant clothes, and, unusually, has frequently painted her three-quarters view.

In the portrait of Naaotwa Swayne [85], painted in 1987, the unbroken pink background and her pure white garments provide the perfect foil for her lustrous dark skin.

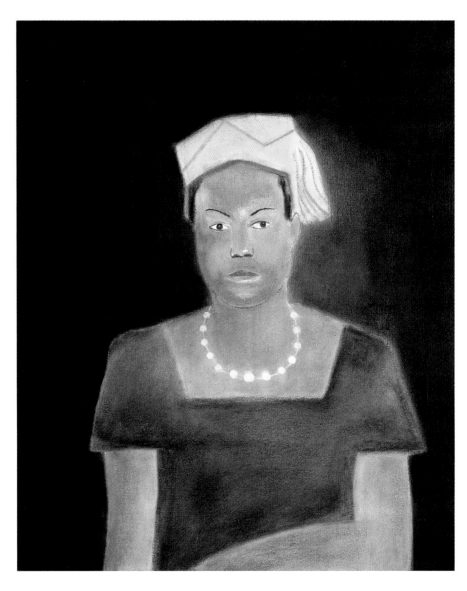

86 Portrait of Naaotwa Swayne, 1989

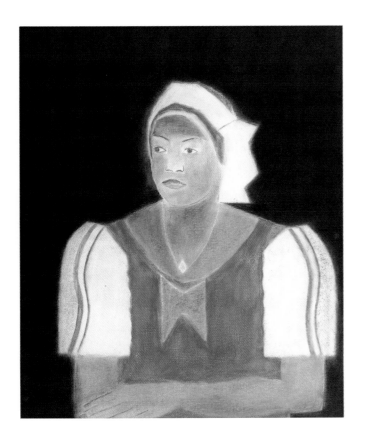

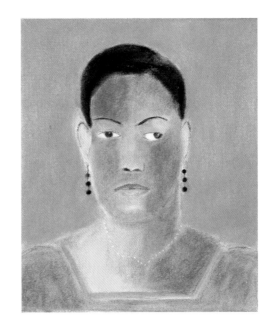

123

The use of the white beads is reminiscent of Craigie's earlier depiction of Daphne. The abstract potential of headdress and off-shoulder costume is exploited cleverly and to the full but without infringing the practical logic of the dress. Apart from the delicate use of line in some of the sitter's features and in the pattern of her dress the structure of the picture depends wholly on the precisely organised relationships between flat areas of colour.

Much the same applies to the portrait of Naaotwa Swayne [86], painted the following year. Here, however, the boldly designed costume is used in a far more architectonic way and there is a symmetry about the work that brings to mind the portraiture of the sixteenth-century Italian Mannerist painter Bronzino, although the sultriness finds its nearest parallel in Gauguin's studies of Tahitian beauties. There is a mood of quiet expectancy about Naaotwa here, as if she is prepared in her finery to receive a lover.

In this series of portraits there is plentiful evidence that Craigie was paying attention in a more deliberate way to the character of his sitter. Naaotwa's strong sense of her own identity seems encapsulated in Craigie's images of her; but there is a forceful side to her personality that also comes across. It is especially striking in another beautiful half-length portrait [87] which amounts to a set of nocturnal variations on Naaotwa's darkness: the model's skin is 'black', her simple shift black, but the background blacker than both. There is a determined expression on Naaotwa's face, as if, beneath the calmness, simmers anger. And in a number of smaller studies of Naaotwa, head and shoulders only [88], a similar quality is apparent.

Over the several years during which Craigie has been

87 Portrait of Naaotwa Swayne, 1988

88 Portrait of Naaotwa Swayne, 1989

painting Naaotwa, artist and writer have established a rapport, both equally amused by one another's occasionally peculiar ways. Naaotwa is constantly amazed by the elaborate coded system Craigie has devised to defend himself from a stream of bothersome telephone inquiries. For her, the hours she spends modelling for Craigie constitute one of the great pleasures of living in London.

One of the salient qualities – perhaps the salient quality – of Craigie's mature style is that the finished product looks effortless; there is never anything 'tired' about the canvas, the impression is, as he wishes it to be, that the picture has been created as it is conceived '*à premier coup*'. That this is very far from being the case, even after nearly fifty years of practice, is illustrated by a fascinating account of Craigie painting a portrait in the summer of 1992. In that year Craigie's much-valued friend Susan Campbell, a distinguished writer on cookery and gardens, asked Craigie to paint a picture of her dog, a whippet named D'Arcy. Understanding that this would almost certainly be a 'one off' Susan Campbell decided to keep a diary charting the progress of the commission.

Considering the artist's attitude towards taking commissions in any form, it was a brave request; but Craigie – perhaps because the subject was to be the author's pet rather than herself – consented. In July 1992 therefore Craigie found himself ensconced in Susan's country house, Pitts Deep, overlooking the Isle of Wight. Things were not to go entirely smoothly; but the end result of Craigie's labours and Susan's supervision is a fine portrait of D'Arcy [**89**], unique in its scale, ambition and character. Its quality suggests that the artist responds better than he thinks to the seemingly unconducive demands of others.

Susan Campbell's diary of Craigie's efforts to 'make something' of D'Arcy provides a fascinating insight into the artist's method.

JULY 6TH

Craigie has come to paint D'Arcy's portrait. At first taken by the sight of the sea, white sails, blue sky, grey-green hedge, bright green lawn and pink poppies in a clump by a dying apple tree, he started an upright canvas with D'Arcy a solitary, small dog in the centre. I somewhat complained about this, so today he has started indoors, on a horizontal canvas with D'Arcy more or less filling it standing profile.

D'Arcy is the most patient model. He is posing on top of the old Habitat desk, which I've covered in a rug to stop him slipping. He stands quite stock-still for up to fifteen minutes at a time ... Craigie has put his easel by the south window. He starts with the palest of oil paint, washed thin with turps. A lot of grunting goes on, and rubbing out with a rag. He says it's got to go wrong before it goes right, and that Claude Rogers told him at the Slade that you can always start pale then go dark, but not to start dark because you can't get darker. He is also glad to have photos to work from. There is a fair bit of rough measuring (holding up a paint brush), but he clearly paints as much by what he knows as by what he can see. For example, there is more light falling into the room behind D'Arcy than there is on the side Craigie's painting. He's virtually in silhouette for Craigie. But this doesn't worry him, he paints him in the pale faun colour that he knows he is, spreading tiny dabs of paint onto a newspaper beside him on the floor, and thinning it with turps. The newspaper is his palette.

JULY 7TH

The dog is roughly painted in now on a white canvas. First thing this morning Craigie moved both easel and chair nearer to D'Arcy, so that he could do the eye. I'm totally amazed that he could choose to put the dog in the part of the room least well lit, but there you are. (He asked me what colour D'Arcy's eyes are and I said 'amber' and he gave a little grunt and said 'yellow ochre'.) He carefully mixes yellow ochre for the eye and out comes his precious palette knife in the silver box that belonged to his mother. He says if he ever lost it he would never be able to paint another picture, and has had it donkey's years. Needless to say both knife and box have been lost, stolen, found, given back again and again. He uses the knife to 'itch' in the lines that will finally delineate the forms, scraping the paint

on either side of a line until he has precisely what he wants. He's having trouble with the feet, partly because he's never done dog's feet before (having always painted Bedlingtons whose feet are covered in curly grey fluff). Another trouble with the feet is that D'Arcy stands with his hind legs far apart and feet turned out, and his front legs close together and feet straight. As the figure of the dog is almost purely two-dimensional, the two legs furthest from him can't be put in. He 'never does' all four legs. The result is the back foot looks about two inches lower than the front. Which looks odd. He gets out the tape measure to see how far from the bottom edge of the canvas the feet are.

There's another debate in his mind – the background, some blue sky is very lightly washed in at the top, and after much thought, grass at the bottom. It might have been the grey wood of the belvedere. He thinks the Isle of Wight and yachts will come into the picture too.

JULY 8TH

I stayed away from the painting all day as D'Arcy wasn't needed. The problem was now entirely to do with the background. C. had spent the previous evening sketching (in pencil) yachts from the belvedere, and obviously thinking about the view from there.

By lunchtime D'Arcy was standing on a green foreground, the top of it level with the base of his feet, and a little step about one inch high provided for the front feet. An elegant solution. A yacht had appeared (with one red and one white sail) directly above D'Arcy's back leg. No horizon as yet, but I could see one, or rather where one ought to be, and suggested it went in just behind the top of the sails. After lunch this is where it appeared, with a grey smudge for the Isle of Wight. I said I'd rather like to see the Needles just above D'Arcy's head, but the weather had got dreadful again and, peer as we might, C. couldn't make them out from the house.

JULY 13TH

Craigie returned on Wednesday at lunch time, bearing two haggises and a very expensive box of five chocolatised morello cherries in brandy costing £8.75, from Fortnums.

A beautiful day. The Needles showing very clearly from the house, but Craigie seemed to find it impossible to incorporate them into the painting. They didn't fit in at the far left – he tried them in the centre, to the right of the boat, with the lighthouse looking like a rocket on the launch-pad.

LATER

The inclusion of the lighthouse was clearly a mistake.

The yacht remains, both sails now red; they and the boat drawn as by a schoolboy, very carefully. On Thursday he returned to painting the dog, peering closely at his nose, though saying that from where he was it was all one colour with his muzzle. I pointed out that there was white on D'Arcy's chin, and his underside was very pale, and his chest deeper. This caused a lot of huffing and grunting. In the end C. said 'How could he define the underside without a line?' I said 'Easily'; either by tone or colour. This seemed not to satisfy him. The fact is, Craigie's reasons for whatever he paints are unique to him, reasonably done from his point of view but totally unreasonable from mine.

The newspaper palette is now covered with thin spreads of paint, forming a radius from his right foot, which from time to time strays on to the paint. There's a lot of rubbing out with the rag, and thinning with turps before applying the paint. The painting still looks like a watercolour, but the animal is alive, his pointed willy, pointed feet and pointed nose all at exactly the same angle, like arrows running to the right of the canvas. Does he know he's done this? (Craigie decides to take a break)

He will have to return to finish the portrait. He says thank goodness 'it's wrong' – when they go wrong he thinks it's better, that is, it's not natural for things to go right all the time, he also says he knows what's wrong, 'it's not focused – you don't know where to look', but he's no idea how he's going to get it right.

JULY 18TH

C. has come back to finish/go on with the painting. I'm strictly leaving him alone to do it. Not saying anything. The whole thing, he says, may yet prove to be hopelessly

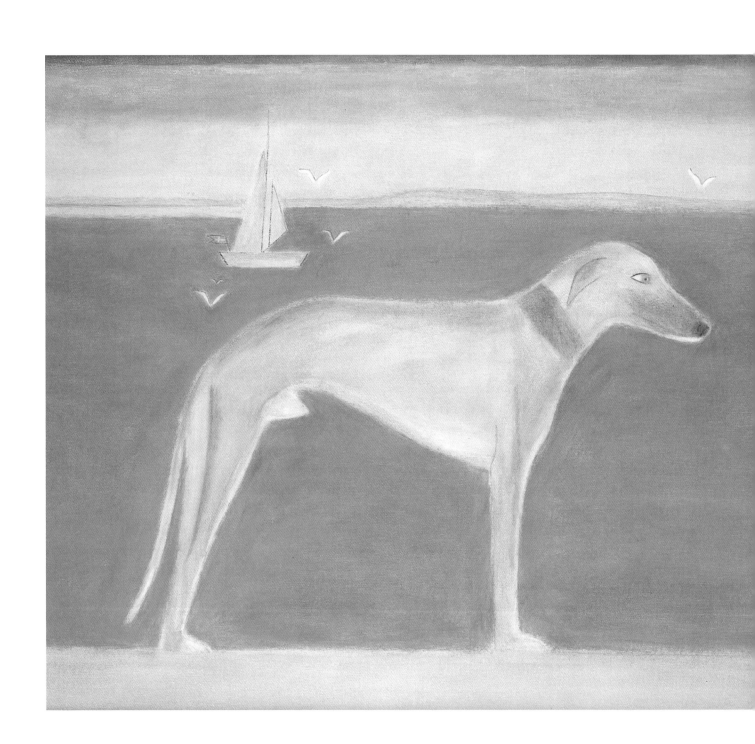

89 D'Arcy at Pitts Deep, 1992

wrong. In which case that's it. But by mid-afternoon he's delightedly painted out all of the Isle of Wight, partly because he never wanted it and partly because at that moment it was truly invisible behind a bank of sea-mist.

After tea the Isle of Wight has reappeared again (in life but not in the painting) and I'm holding D'Arcy still so that he can do the markings. Only this time C. says don't bother to put him on the table as he only wants to see which bits are which colour. After a while he remarks that Picasso ('PiccARSO') was right about doing things from so many different angles, as that way you could see things that otherwise you wouldn't. A little later he wonders if the picture isn't becoming frightfully 'academic'.

JULY 21ST
C. packed up yesterday before lunch, ready to go back. He'd had a good day on Friday, and all Saturday morning, mostly without D'Arcy.

The foreground is now grey and three of four seagulls are now flitting about in the sky and the island is now back again and green – a continuous wavy strip across the horizon. As it very rarely looks green I'm bemused by this, but I'm saying nothing, having wrought such havoc with the Needles. Then I saw a yacht going by with an ensign flying, and thought C. might quite like that, and he did. Vehemently, painting a flag onto the yacht in the painting, but alas on the bows rather than the stern. I said no one would notice if they knew nothing about boats, but if they did it would look very odd. So he said rather petulantly 'find a postcard of a boat with a flag then'; which I knew we hadn't got though I did find some ads for yachts in a sailing magazine, showing flags (all sorts, Royal Ensign, British Ensign, French, Irish, Danish ... Canadian ...). The one he really loved was the Danish (white cross on red background, with a 'V' cut out of the side). We ripped all the best pages out of the magazines, and he's taken them and photos of D'Arcy back to London, to finish it there.

JULY 25TH
Called on C. at St Mary's Gardens, where I found he and Alex at their first drinks of the evening. Builders have been

in the house, and all his furniture was put in store. They've gone but he's not restored the furniture, saying he wants to leave the house anyway, and putting it back will mean he's not moving out.

The front room is very dark, a tree of heaven in front and three chestnut saplings in the back. Light came from a green revolving cylinder with fish painted on it and a flicker arrangement on top. The electronic fire also glowed red, with its false coals removed and another flicker effect installed. the usual Craigie nick-nacks – Christmas decorations and souvenirs were still about, plus a great number of framed posters advertising his exhibitions of or containing his paintings, and a sugar lamb on a rock-hard kugelhopf from Poland which had been the inspiration for the Tate's new T-shirt saying 'Bedlingtons are Best'. Lamb into Bedlington.

On the easel in the front room was D'Arcy, now with the flag on the yacht amidships (a green version of the Danish ensign), and the sea painted a much darker blue. A thin white outline all around the dog, where the sea and the dog would meet, and not yet put in with any certainty (this 'itching' towards the line as it were, still going on). I asked him how on earth he could paint with so little light coming in and he said, 'Oh I can paint better in the dark you know,' and then he said, 'I know what I'm doing you know,' and he does.

JULY 29TH
A card came saying the picture was finished. I am nervous now that I won't like the picture, but I can't look at it until next week when I go up to London.

AUGUST 8TH
The picture is wonderful! The blue has stayed a little way away from D'Arcy's outline, the boat links the sea, the island and the sky, it is now possible to talk about it purely in pictorial, almost geometric terms – it is a picture more than a portrait and yet whenever I look at the eager glint in that yellow-ochre eye I laugh with pleasure, it's so like D'Arcy! I'm off to France tomorrow and can hardly bear to leave the picture behind ...

The fastidiousness of Craigie's procedure is the best possible retort to the frequently made charge that he is a 'primitive' artist. And Susan Campbell's account also gives a vivid insight into the way Craigie balances the information he observes with the demands the picture itself begins to make after the initial stages. Craigie is autocratic in 'editing out' what might be considered key elements in the composition – the island in this case – if he feels they contribute nothing to the composition. When it comes to colour his attitude is similar. Although he usually bases the colour scheme of a picture on the local colour he observes, he thinks nothing of changing it if the picture begins to demand that it be changed. In the case of the *D'Arcy* portrait, for example, he took the picture back to London and instantly 'beefed up' the colours he had indicated when painting on the spot. If a green ensign works better than a red one so be it.

A portrait, of course, is more 'dictatorial' in essence than a still-life or a landscape; the need for a 'likeness' inevitably restricts the artist to some extent. In *Lemon and Jar Still-life* [**90**], a work that caused controversy when at the 1982 Royal Academy Summer Exhibition it scooped the £5000 Johnson Wax Award for the most outstanding exhibit ('Joy, Perplexity and Disgust at Art Rummage' ran the *Daily Telegraph*'s headline), Craigie seems to have been especially imaginative in fixing the contours, particularly when it came to the lemon; but his aim in this picture, as in the charming *Liquorice Allsorts Still-life* [**92**], was to evoke an atmosphere of calmness, of sanctity, and in this the picture succeeds. Amidst the controversy, the actual award of the prize elicited from Craigie one of his better *bons mots*: 'I suppose I will just have to go home and polish all my furniture,' replied Craigie when asked by a journalist what he intended to do with the prize money.

Other still-lifes painted later in the 1980s [**91** & **96**] evince a less contemplative spirit than these quiet works. *New York Still-life* and *Reindeer Jug-Still-life* both appear more trenchantly figurative than the earlier works and this could relate to the new-found respectability figuration was

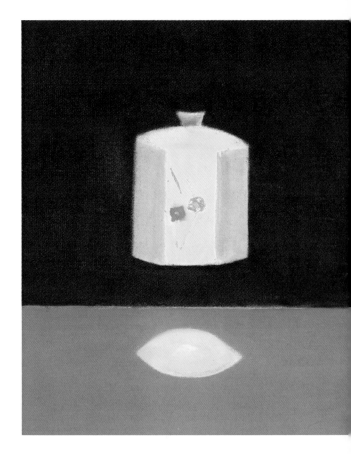

90 Lemon and Jar Still-life, 1981

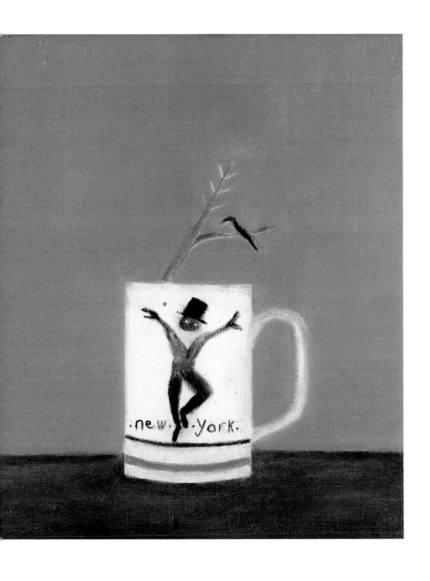

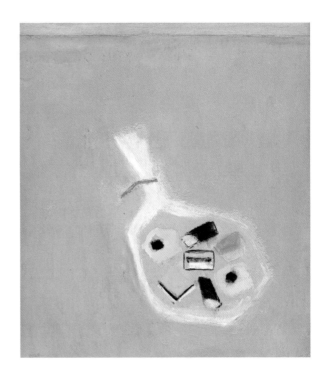

91 New York Still-life, 1989

92 Liquorice Allsorts Still-life, 1980

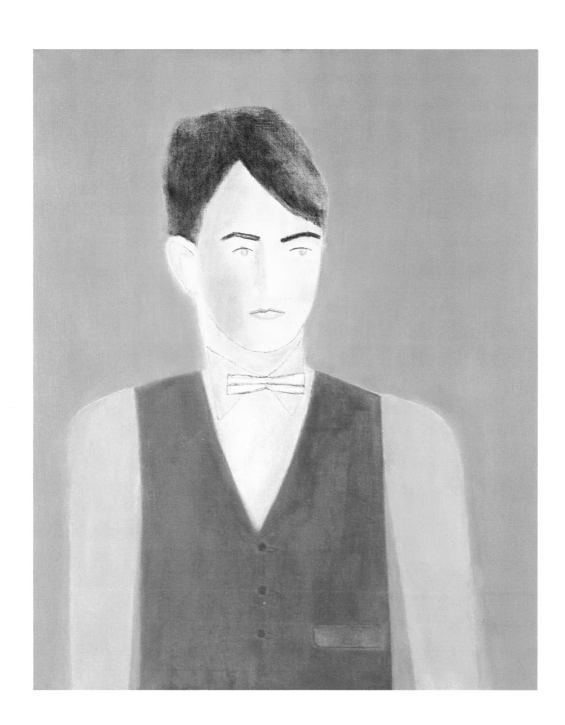

93 Portrait of Simon de Wrongal, 1984

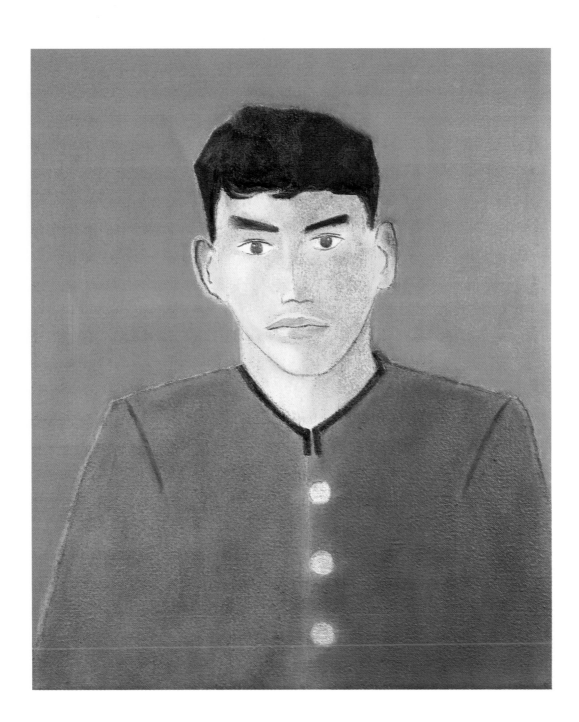

94 Portrait of Kunwar Singh Bagri, New Delhi, 1984

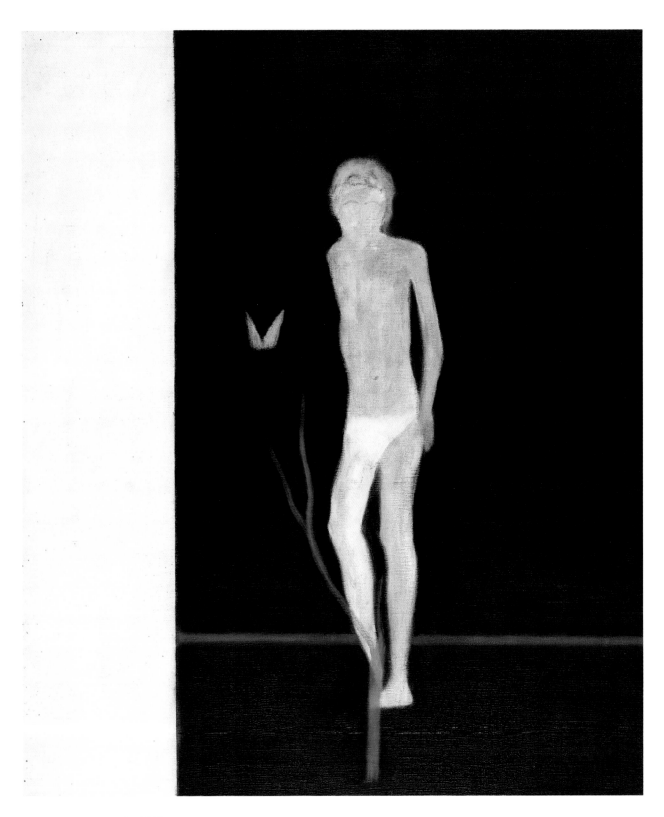

95 Boy with Butterfly, 1988

assuming at the time they were being painted; Craigie could never be accused of being a follower of fashion but he is nevertheless keenly aware of what is going on in the art world. Whereas a work such as *Lemon and Jar Still-life* seems a natural development from the cool, undemonstrative works of this genre made in the early 1960s – those bearing affinities to the work of Giorgio Morandi – these more colourful later examples have a studied brashness about them, an almost devil-may-care *joie de vivre*.

In this they are, in a way, atypical of the artist inasmuch as he is never likely to forsake his intrinsic nature and begin painting for the sake of impact, and it is in what, at first sight, appear oddball pictures that the more meaningful developments in Craigie's painting may be perceived. A portrait painted during a trip to India in 1984 of a staff member of the hotel where Craigie was staying is a case in point [**94**]. It has a less tentative air about it than the contemporaneous portraits of black sitters, as if the

painterly solutions presented themselves more readily, and the same may be said of a portrait Craigie admits to disliking but which, on its own terms, is pleasing enough [**93**]. Both these portraits portend the manner in which Craigie was to paint non-black subjects in the following years, even if an entirely imaginative picture such as the superbly lyrical *Boy with Butterfly* [**95**] stresses the fact that Craigie has never shown any signs of allowing his imagination to be fettered by the 'real' world.

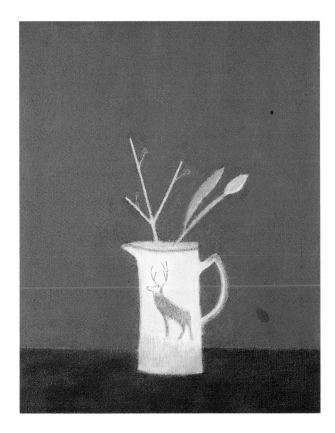

96 Reindeer-Jug Still-life, 1986

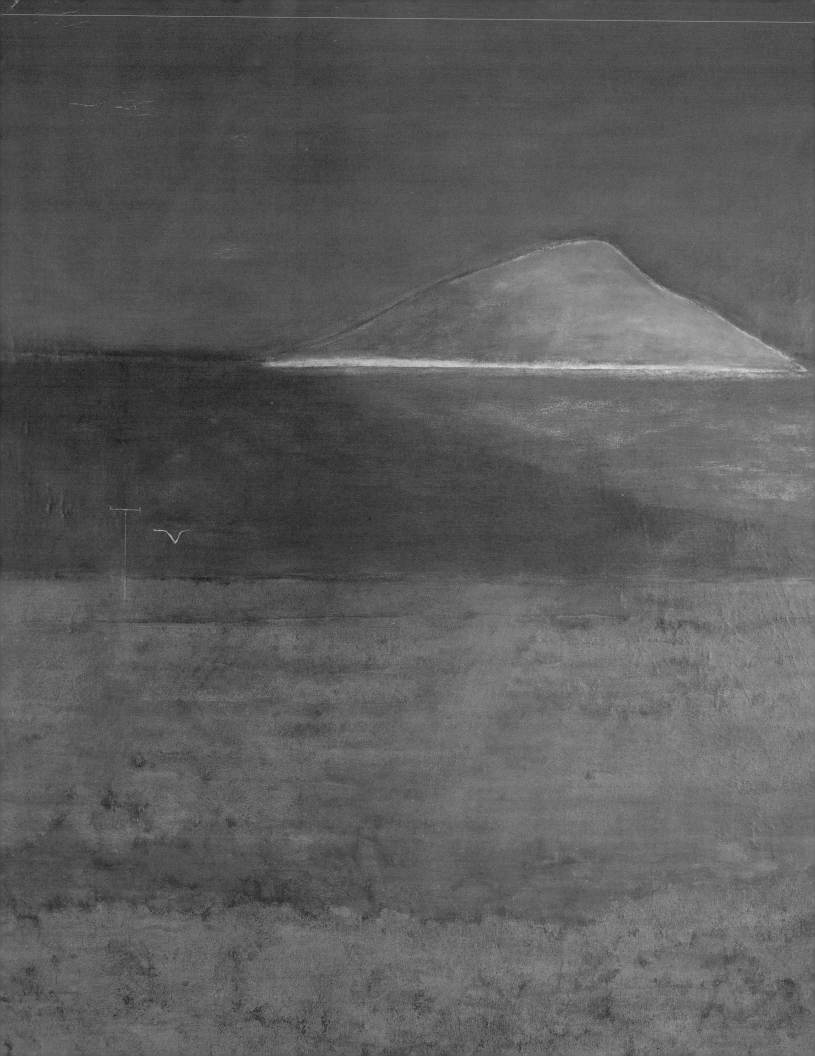

6 Return to the Island

the centre of one of the world's most densely populated conurbations. He was born in a great – if somewhat smaller – city, and he never appears more at ease than when indulging in the social delights of urban life. But no matter how citified his habits, there remains something gentle and pastoral about Craigie. Nothing of the harshness of the 'concrete jungle' seems to have rubbed off on him. He has a confidence in the world he has created which brings to mind the immutable pattern of rural life conveyed in so many nineteenth-century novels. Others find this quality in him immensely attractive; those who do not know him respond to it in his paintings.

Guidebooks to Scotland published in the 1920s and 1930s lamented the fact that the Isle of Arran in the Firth of Clyde was becoming little more than a suburb of the 'great Clydeside cities', by which they meant, principally, Glasgow. Yet children, fresh to every experience, are immune to such depressing perspective views, and to Craigie and his brother Raymund, holidaying with their parents on Arran in the years between the wars, this 'suburb' seemed overwhelmingly rural. One of the great strengths of Scotland's landscape is its diversity – relatively short journeys can transport one 'to another planet'; and Arran must have seemed positively exotic compared with the soot-stained sandstone Georgian home in Auld Reekie.

In Lamlash where the Aitchison family first stayed, and later in the town of Brodick, the sense of being on an island is potent, and it certainly made its mark on the mind of the young Craigie. At Lamlash the presence of Holy Island across the bay augmented the insular nature of the experience, and the history of Holy Island itself, visited as early as 680AD by one of the missionary Irish saints, compounded the romance of the place. Like the exiled Tibetan monks who inhabit Holy Island today, Craigie loved the place, responded to its spirituality; and such was the intensity of this youthful impact that Holy Island and the equally dramatic silhouette of Goatfell, Arran's highest peak, became touchstones of his imaginative life. It is no

97 The Island, 1971

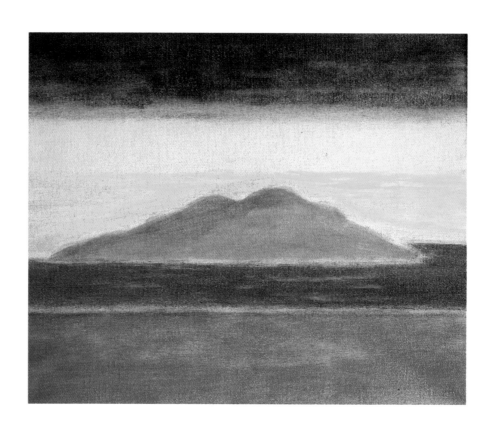

98 Holy Island from Lamlash, 1993

exaggeration to say that the constellation which is Craigie's art has orbited these twin stars ever since. Whether the artist is rendering a Crucifixion, portraying a somnolent saint, composing a still-life with a single lily, or sending Wayney up to heaven, the backdrop is often Arran, or rather, the world which Arran represented to a sensitive boy.

In 1970 Craigie returned to Arran for the first time since his childhood to scatter the ashes of his mother on the same site where his father's had been scattered nearly thirty years before. A year later he painted what must be counted one of his finest and most haunting pictures.

The Island [97], clearly an image distilled from his memory of Holy Island, acquires its mesmerising quality largely through the stark simplicity of the composition; apart from a lone seagull circling a telegraph pole, the featureless pyramid of the island is undisturbed by local association. It is both symbol and place, a poignant symbol of the individual's ultimate physical and spiritual isolation, a place where tragic events have occurred. While the saturated colours are Expressionist, the emotional impact of the composition is calculated with the precision of Mondrian. The gull and telegraph pole playfully dare the spectator to link the picture with a real place; an ironic

aside typical of Craigie, as apparently out of tune with the key of the picture as the idea of a Bedlington might seem to the climax of the Passion.

The re-acquaintance with the magical isle of his childhood Craigie made in the early 1970s triggered much more than one single great picture; it reawakened in the artist an interest in Holy Island and Goatfell as vehicles for expressing his innate melancholy on a grander scale. While the Arran of his childhood had influenced in an oblique way pictures such as the superb *Crucifixion in a Landscape* [44], the Arran he encountered in later life suggested a whole new range of compositional and emotional possibilities. In 1990 Craigie's brother Raymund retired to Lamlash and, until his tragic death in a house fire there in 1995, this provided a tangible link. A rich range of pictures inspired by Arran resulted. Most are imbued with a bitter-sweet nostalgia.

The series is heralded by a small and apparently slight picture of Holy Island [98] in which the silhouette of the island is set within bands of colour; it is as if the artist were limbering up for more ambitious things – a curiously low-key exercise, a template for greater variations. Here Craigie is reminding himself that the importance of the surface of the picture must remain paramount no matter how daringly he might investigate the emotional dimension of the subject.

View of Holy Island from Lamlash, Isle of Arran, 1930s

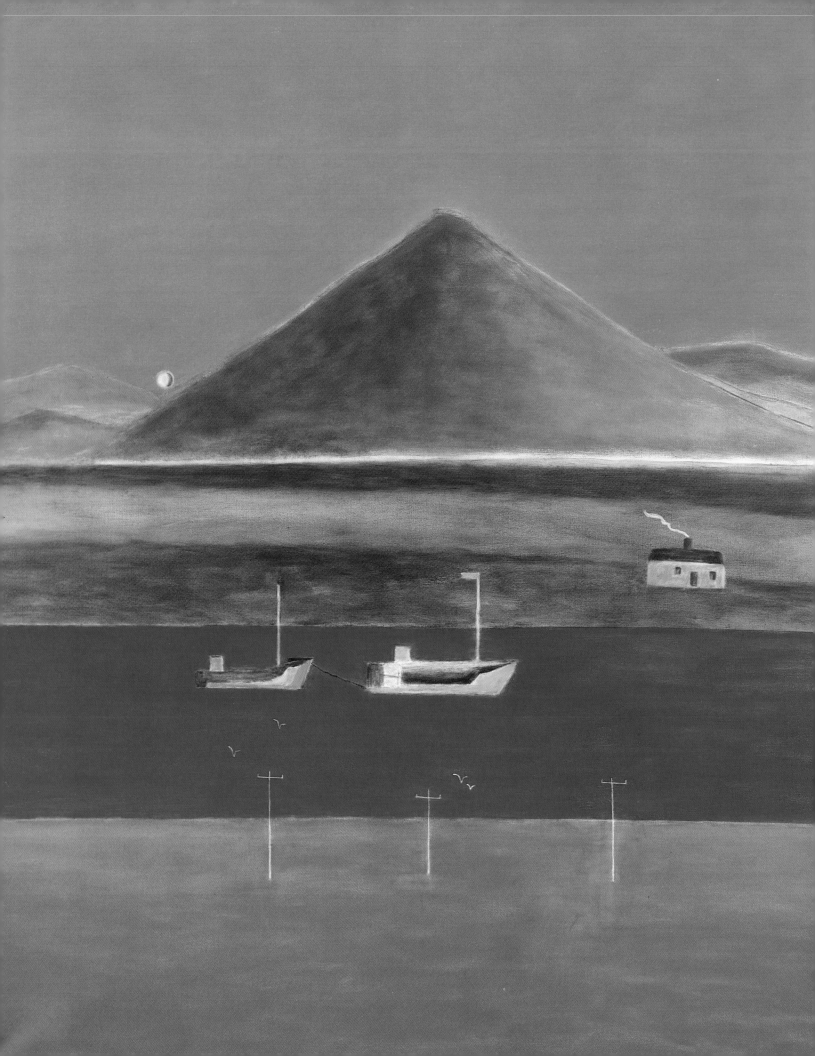

Craigie with his canary at Brodick, Isle of Arran, 1937

View of Goatfell, Isle of Arran (photograph)

99 Goatfell, Isle of Arran, 1993

Two large and intensely atmospheric pictures followed in the wake of this small one. *Goatfell, Isle of Arran* [**99**] and *Holy Island from Lamlash* [**100**] are two of the profoundest landscapes Craigie has painted. In both compositions ships trawl through the channel between the land mass, indicated by its umber coloration, and the distant peaks. One imagines them on their way to distant, mysterious destinations, like the emigrant vessels that disembarked from Lamlash Bay for Canada at the time of the Highland Clear-ances. They are unmanned *Marie Célèstes*, symbols of man's journey through the uncertain terrain of life. In the busier of the two pictures smoke issues from the chimney of the solitary house on the far shore, but apart from that there is not a sign of habitation.

What make this series of Arran landscapes especially remarkable, however, is the skill with which Craigie has balanced atmosphere and emotion in the subjects with the formal demands made by the pictures themselves.

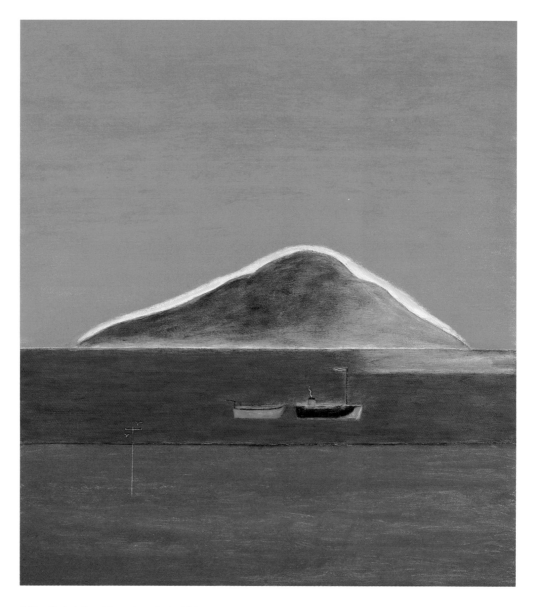

100 Holy Island from Lamlash, 1994

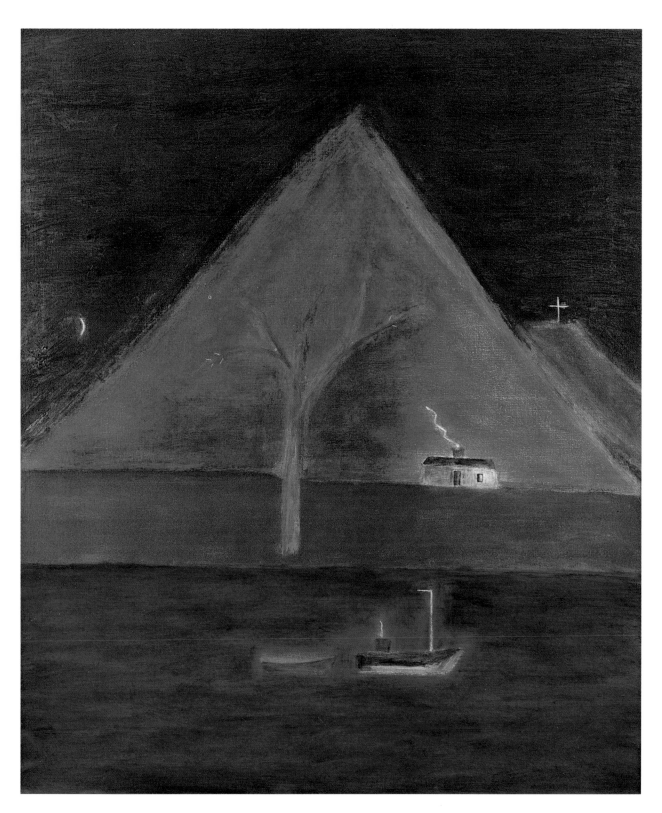

101 Goatfell, Isle of Arran, 1993

142

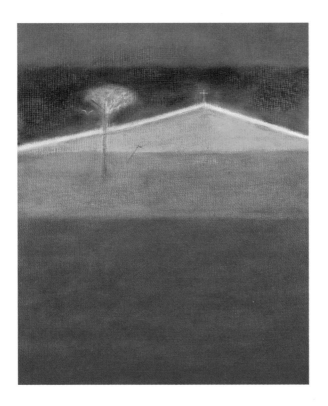

While they are undeniably pictures 'about something' — Craigie's narrative bent has rarely been more marked — each brushstroke, each tone, each colour has been chosen with an acute concern for pictorial effect; the boats are as 'unrealistic' as the yachts in the portrait of the dog D'Arcy, the land as fictitious-looking as the desert in the most austere of the Crucifixions. And in a third picture of Goatfell [101] this synthesising of subject and appearance of subject is, if anything, even more accomplished. Here, in a beautiful nocturnal scene, scale is added with striking results to the artist's emotional repertoire; a tree, typical of Craigie in its resemblance to a hieroglyph, looms up on the far shore dwarfing the house, the ship and its tender, and competing for prominence with the rich magenta mass of the mountain itself. Against the night sky a crescent moon and a crucifix atop a sibling peak punctuate the composition with two references of multiple and universal meaning. While any number of interpretations of the work are possible, the form of the picture, from its tightly planned composition to its subtle coloration, eschews all alteration.

Craigie's predilection for crepuscular, nocturnal effects, especially in pictures with spiritual overtones, has increased as the years have passed. At an early date he perceived the possibilities of night settings for depicting the Crucifixion and in several pictures the night itself seems to usurp the main subject itself; *Landscape and Tree* [102] and *Crucifixion, Montecastelli* [103], both pictures dating from the early 1980s, are examples of this. In the latter Craigie refers, unusually, to the topography of the landscape near his own house in Italy. Yet, more frequently, Craigie seems happier not to specify precise location. In *Orange Tree* [104] a low peak reminiscent of Holy Island rises above a plain and the effect suggests an imagined amalgam of Arran and Tuscany.

Until the early 1990s Craigie had restricted his religious subject matter almost exclusively to the Crucifixion, but from this time various hermit saints creep onto the stage of his imagination. One of the most curious of the

102 Landscape and Tree, 1981

103 Crucifixion, Montecastelli, 1980

104 Orange Tree, 1986

religious pictures where no depiction of or allusion to the Crucifixion occurs is called simply *Religious Painting* [**105**]. The body of the saint lies in a desert that glows vermilion against the night sky. A large crow perched in a Tuscan tree seems to await the holy man's last breath before swooping down and pecking at his pale flesh. It is a kind of Agony in the Garden, or at least an improvisation on that theme, and the atmosphere summoned up by the unusual colours

and the spare composition could not be more quattrocento.

In 1994 paintings by Craigie were used to illustrate a Christmas book written by Jeffrey Archer called *The First Miracle*. The book itself had been written many years before, but the addition of the artist's illustrations resulted in a jewel-like publication that offers a chance to contrast Craigie's recent works on religious themes (some made specifically for the book) with much earlier paintings. The

105 Religious Painting, 1990–2

conclusion suggested by a juxtaposition, a Crucifixion painted as long ago as 1959 near to a new picture called simply *Donkey* [**106**], was that over the past thirty years the artist has evolved a distinct, idiosyncratic religious iconography which, while retaining the mystical impact of that originally derived from Early Renaissance pictures seen in Italy, has become increasingly sympathetic to the contemporary audience. True, there is not a little *faux-naïveté*

about the tiny new pictures Craigie painted with the book in mind; but the best of Craigie's pictures of the early 1990s depicting religious subjects succeed in bridging the gap that has persisted since the advent of the modern movement between art and, in Western culture at least, its original *raison d'être*, Christian belief.

In spite of extending his range of religious subjects, however, there seems no prospect of Craigie forsaking

106 Donkey, 1993

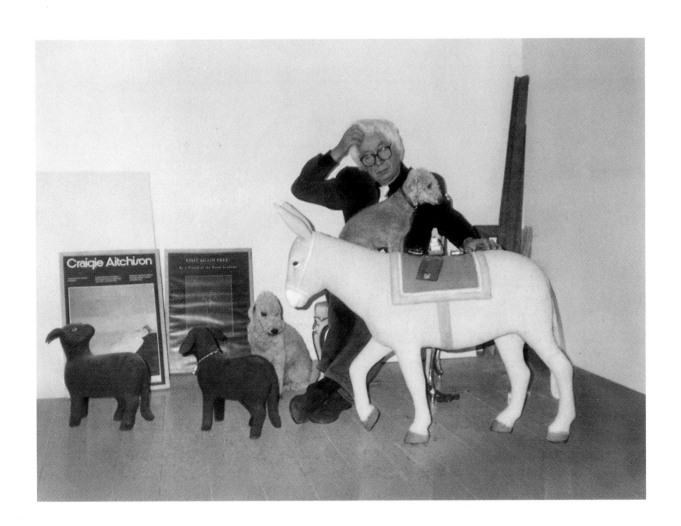

Craigie with the Tate Gallery Christmas tree decorations and pets in 1993

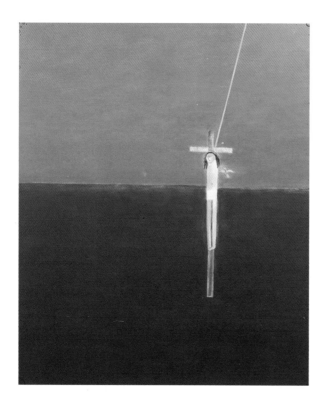

what remain for him the most moving ones. A slow but continuous stream of new compositional solutions seems to emerge from the artist's 'painting room'. In 1991 came a further large-scale *Crucifixion* [**107**] which is as stark as any he has painted, and there have been a number in which the artist has imagined Christ literally hanging from the cross, his one arm contorted into a hook-like shape. It was one of these [**108**] that most impressed the panel who awarded Craigie the Jerwood Prize in 1994; the work now belongs to the foundation. In others however, the artist seems to be developing the iconic potential of the Crucifixion by setting a withered, limp, medieval-looking saviour against luminously brilliant backgrounds [**117**]. The effect is highly unnaturalistic, although no more so than that of the ancient icons that adorn so many orthodox churches. Set in the gold-embossed archaic-looking frames the artist favours, these depictions of the Crucifixion betray a nostalgia for a time when pictures themselves became objects of veneration.

In the most recent still-lifes Craigie has painted it would appear that these subjects too are being shorn of extraneous detail and allowed to assert their independence as decorative and decorated objects devoid of competition. These, too, have acquired an iconic quality. The large *Bethlehem Vase Still-life* [**109**] is a particularly fine example. No illusionistic attempt has been made to define the form of the vase or the flower; that it is a picture wholly dependent on refinement of contour for its effectiveness is further stressed by the decorative use of gold pigment on the vase itself. It is as concise and articulate a visual statement as something by Piero della Francesca or as a piece of elegant Japanese calligraphy.

Craigie's still-lifes, especially the most recent, have been criticised for being repetitive. This is largely due to the central positioning of the main subject and the symmetrical nature of most of his compositions. But it is easy to overlook their subtlety. The artist still remembers vividly a criticism made of a picture he was working on while at the Slade School. Andrew Forge, the artist and chief

107 Crucifixion, 1991

108 Crucifixion, 1994

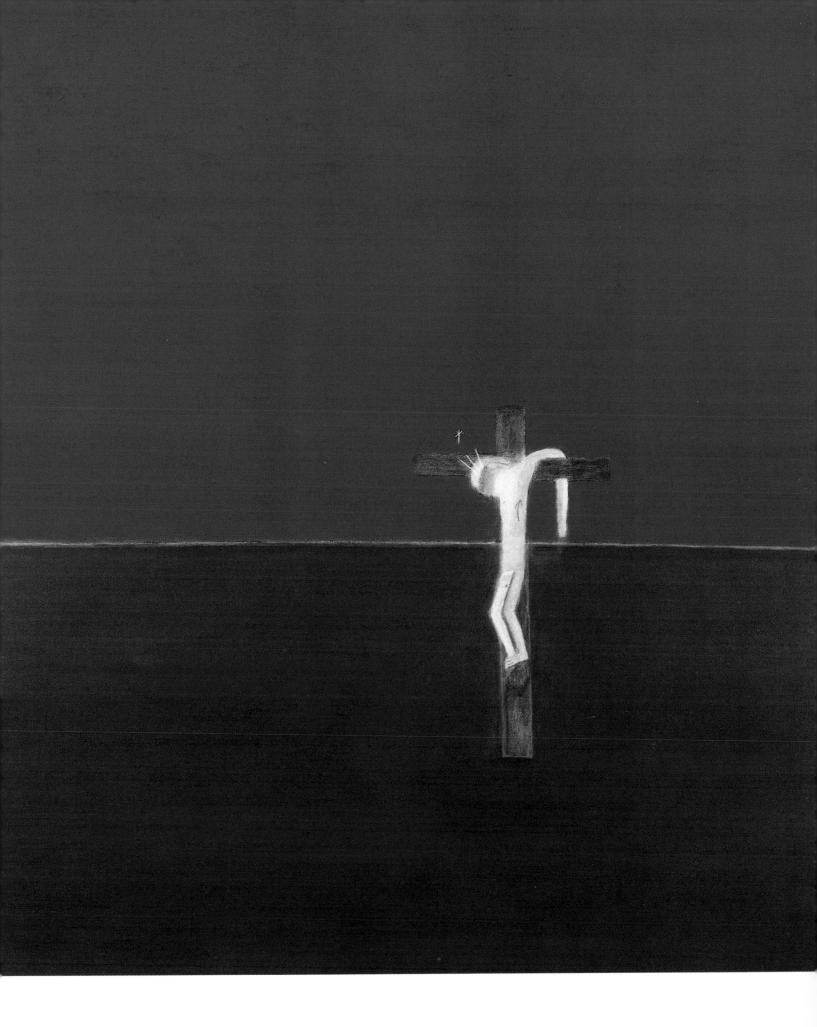

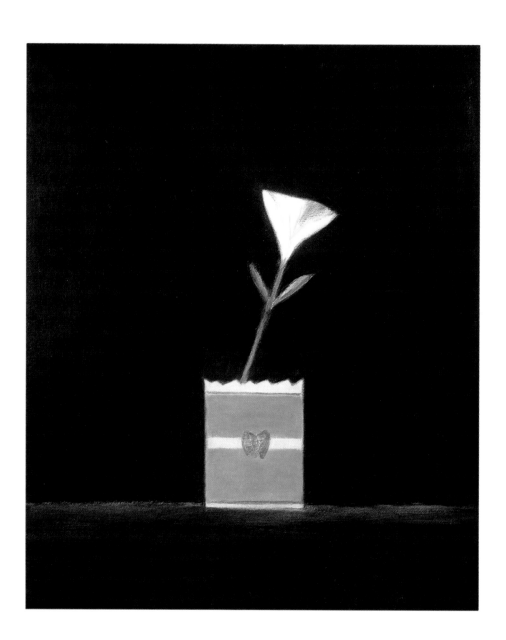

109 Bethlehem Vase Still-life, 1993

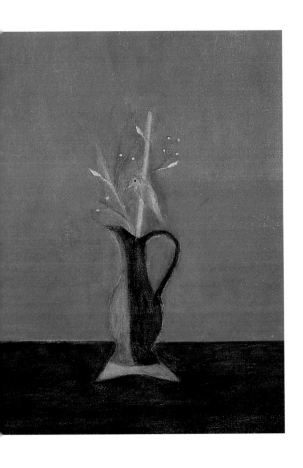

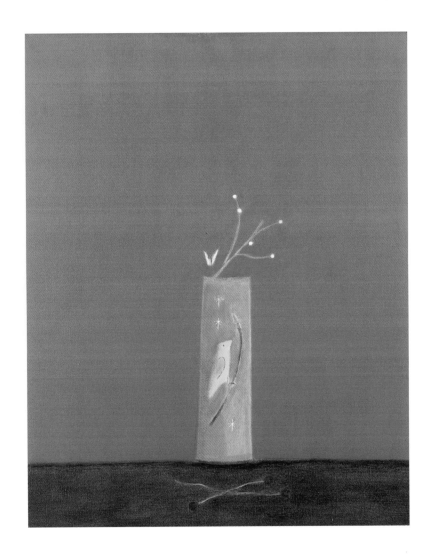

110 Black Vase Still-life, 1990

111 Pink Vase Still-life, 1992

chronicler of the school, examined the picture the artist was working on and suddenly observed that a certain shape in the composition was 'not very expensive'. Craigie thought this was odd at first, but quickly began to understand what was meant. There are 'expensive' or 'valuable' shapes and there are 'inexpensive ones'. In the still-lifes, in particular, this is a constant preoccupation: how to make all the shapes in a composition 'expensive'.

About this Craigie remains fastidious to a degree, and it is acutely relevant to his paintings of still-life subjects where the point of the picture resides exclusively in its formal qualities. In *Black Vase Still-life* [**110**] and *Pink Vase Still-life* [**111**] the areas of colour between the motifs on the vases and the edges of the vessel are carefully judged so as to give each space optimum value; no less does this apply to the areas of 'background' that 'infiltrate' the stalks of the delicate flowers in the vases. When, in 1993, the latter picture was enlarged dramatically to provide the backdrop to a ballet called *Extenzion* for the Northern Ballet Theatre, the expensive shapes registered just as well, so perfectly had they been crafted.

Although Craigie has not exhaustively explored the potential of a single model since the series of portraits of Naaotwa Swayne came to an end in the late 1980s, he has continued to take advantage of the pictorial potential of black models whenever the opportunity presented itself. On a number of occasions he has painted a model called Comfort [**113**] introduced to him by the artist John Hoyland. Comfort is a fine-featured voluptuous woman, and Craigie has tended to emphasise her sexuality in a way that is reminiscent of Gauguin. Strangely, it is not until the *Comfort* portraits that one senses the natural tensions between artist and model which, traditionally, have informed depictions of the female nude by Western artists. In Craigie's portraits of males [**112**] such tensions are absent largely on account of his primary fascination with their hairstyles or apparel.

Most artists map out their pictorial territory at an early stage in their careers and Craigie is no exception to this

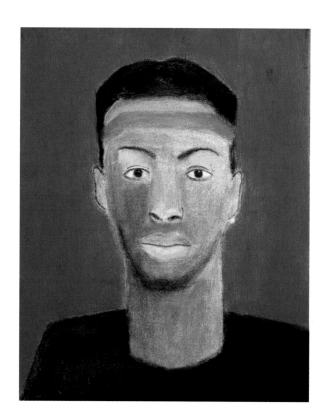

112 Portrait of Kelvin O'Mard, 1992

113 Portrait of Comfort, 1993

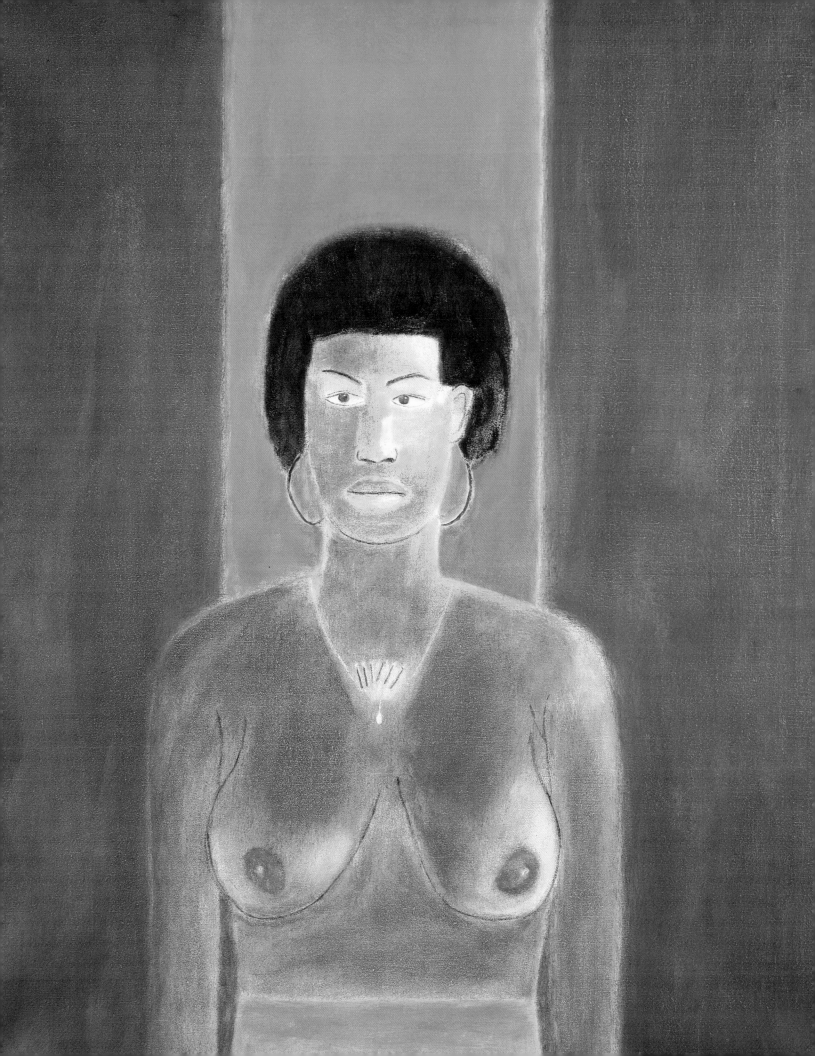

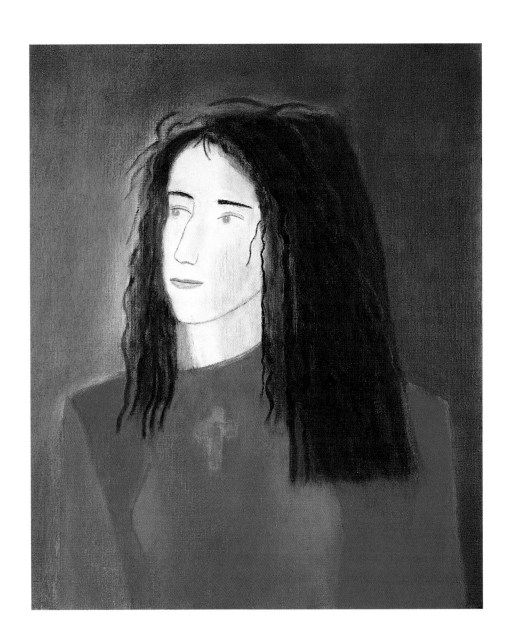

114 Portrait of Pilar, 1989

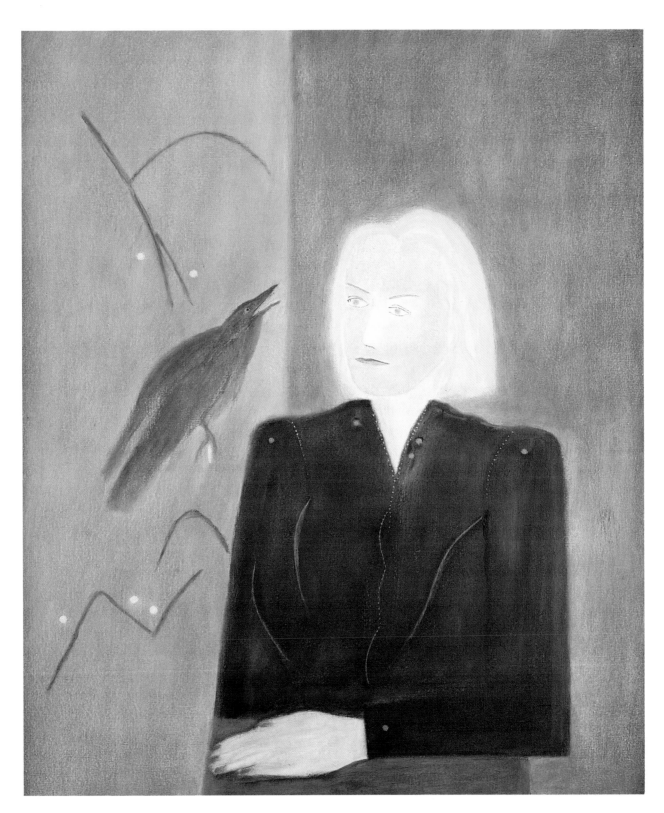

115 Portrait of Sheelagh Cluney, 1990

general rule. The qualities he perceived in the landscape that surrounded him at Tulliallan in the 1950s, the clarity he first discovered in Italy and Italian art, the quality of the variations of colour and tone presented by black models, have all conspired to make his personal territory unmis-

Tombstone of Sir Lees Mayall designed in 1995 by Craigie, at Corsley, near Warminster, Wiltshire

takable, unique in British painting. Of course, there are new departures. Contrary to the artist's disinclination to accept commissions or to paint white models, Craigie has scored notable successes in recent years when he has gone against his better judgement. In *Portrait of Pilar* [**114**], the sitter's wavy mass of jet-black hair clearly inspired him to original invention, while in an intriguing portrait of his most dedicated collector Sheelagh Cluney [**115**], there is an indication that he might develop a more formal kind of portraiture. In 1995 he even accepted a commission from a close friend to design a tombstone.

But, while one of Craigie's greatest charms both as an artist and as a personality remains his open-mindedness, his faith in the continuum of nature and man's dialogue with it will always set the tone for his own art. Once, berated by a journalist for the 'too conventional' nature of the subjects he chose to paint, Craigie responded as he so often does, with a disarming piece of common-sense: 'Ever since the world began there have been trees and there have been birds sitting on them and artists have painted them.' In any age other than our own such an innocent thought would have sounded commonplace.

116 Chinese Dish Still·life, 1989

117 Crucifixion, 1993

Chronology

1926 Born 13 January at 12 India Street, Edinburgh. Younger son of Craigie Mason Aitchison KC and Charlotte Forbes Aitchison née Jones. Baptised by his grandfather, the Revd James Aitchison, a minister in Falkirk.

1929 Father appointed Lord Advocate for Scotland, first Labour politician to hold the post; elected MP for Kilmarnock and made Privy Counsellor.

1930s Holidays with family on the Isle of Arran.

1933 Father raised to bench and appointed Lord Justice-Clerk of Scotland.

1936 Attends Loretto School, Musselburgh, as a boarding pupil along with elder brother Raymund.

1939–40 Family moves temporarily to manse near the 'Dunmore Pineapple' on mother's family estate near Stirling.

1941 Father, Lord Aitchison PC KC, dies. Leaves Loretto School. Attends Basil Paterson & Ainslie, Tutors, Edinburgh.

1943 Leaves Basil Paterson with average grades in English Language, English Literature, French, History and Religious Knowledge; achieves credits in Latin enabling future study of law.

Conscripted but immediately discharged on medical grounds.

1944 Enrols at University of Edinburgh to study law. Studies British History and Jurisprudence until 1946.

1948 Moves to London and takes lodgings in Montpelier Walk. Enrols at Middle Temple, City of London, to study law. Sits examinations in British History, Public International Law and Roman law.

1950 Converts mews house in Church Lane, Edinburgh, behind family home in India Street into studio. Paints mostly still-lifes. Shows very first pictures at Elizabeth Bell Flower Shop next-door to studio.

1951 In London takes private tuition from artist Adrian Daintrey. Copies Augustus John portrait in Tate Gallery.

1951–2 Moves into lodgings at 19 Adam's Row, Mayfair. Copies painting of a view of Dieppe by Fauvist master Albert Marquet.

1952 Takes private tuition from artist Gerald Frankl. Applies to Slade School of Art to study as part-time fee-paying student in August. Accepted at Slade School and begins attending classes three days per week in October. Frequents Orange Street pub along with Euan Uglow, Myles Murphy and friends.

1953 Moves from Gloucester Place, Marlyebone, first to Portobello Road and from there to Gower Street. Increases study at Slade School to six days per week. Moves to Slade Hostel, Cartwright Gardens, near Euston. Eighteen months later moves with fellow student Myles Murphy to 22A Lower Marsh, near Waterloo Station, London.

Wins Slade School prize (the book *Artists on Art*, compiled by Robert Goldwater and Maria Treves) for still-life painting, *Scissors and Pink String*. Subsequently destroys painting.

1954 Shows for first time in group show at Gimpel Fils, London.

1955 Wins Italian Government scholarship to travel in Italy. Spends two-and-a-half months travelling first to Rome, and then through Tuscany and Umbria to Venice, returning home via Munich, Amsterdam and Brussels.

1956 Shows in Gallery One, London, in exhibition entitled Three Romantic Painters. Leaves Lower Marsh and returns to Scotland.

1958–63 Paints series of landscapes at Tulliallan, near Kincardine-on-Forth, Fife. Paints first *Crucifixion*, the beginning of an ongoing series of works on this theme.

1959 On recommendation of painter Michael Andrews, taken up by dealer Helen Lessore and shows for first time at Beaux Arts Gallery, Bruton Place, London.

1960 Shows for second time at Beaux Arts Gallery.

1962 Meets professional model Georgeous Macaulay while teaching part-time at Regent Street Polytechnic. Begins extended series of nudes and portraits lasting until 1976.

1963 Returns from Scotland with mother, Lady Aitchison, to live full-time in London. Moves to 32 St Mary's Gardens, Kennington.

1964 Shows for third and final time at Beaux Arts Gallery. Gallery closes down a year later.

1965 Lawrence Gowing, Principal of Chelsea School of Art, allows Craigie to use large studio in school during the summer. Paints large-scale nudes. First work, *Nude against a Blue Background*, purchased by Arts Council of Great Britain.

1968 Begins teaching part-time at Chelsea School of Art. Meets model Daphne Charlton and begins series of nudes and portraits.

1970 Mother dies in London. Awarded Edwin Austin Abbey Premier Scholarship for Painting.

1971 Sees first Bedlington terrier at Crufts and buys Wayney.

1975 With help from writer John McEwen, acquires SPACE studio on fifth floor of building overlooking Cambridge Circus. Introduced to American writer and journalist Lendel Scott-Ellis by friend Ann Barr. Begins series of nude studies and portraits of her.

Acquires house at Montecastelli near Siena. Spends eighteen months working in Italy.

1977 Meets eighty-five-year-old retired boxer, David Smith, known as Chicago, and begins series of portraits.

1978 Elected Associate Member of the Royal Academy of Arts.

1981–2 Arts Council of Great Britain holds retrospective exhibition of work at the Serpentine Gallery, London. Subsequently tours.

1982 *Painting Chicago*, a film about Craigie Aitchison produced to coincide with retrospective at Serpentine Gallery.

1986 Designs neckties and ceramics for the Royal Academy of Arts.

1987 Meets Naaotwa Swayne, wife of friend, composer Giles Swayne, and begins extended series of portraits.

1987–9 Exhibits at the Albemarle Gallery, London.

1988 Elected Member of Royal Academy of Arts.

1993 Returns for first time since childhood to Isle of Arran and begins series of large landscapes.

1996 *Craigie: The Art of Craigie Aitchison* held at Gallery of Modern Art, Glasgow. Commissioned by National Portrait Gallery, London, to paint portrait, possibly of athlete Linford Christie.

Awards

1953 The Slade School annual prize for best still-life

1955 British Council Italian Government Scholarship

1965 Arts Council of Great Britain purchase award

1970 Edwin Austin Abbey Premier Scholarship

1974 Prizewinner John Moores Liverpool Exhibition

1974–5 Lorne Scholarship

1976 Arts Council of Great Britain bursary

1984 First Johnson Wax Prize, Royal Academy of Arts

1989 Korn Ferry International Award, Royal Academy of Arts

1991 Korn Ferry International Award, Royal Academy of Arts

1994 The Jerwood Prize

118 Dead Bird, 1984

One-Man Exhibitions

1959 Beaux Arts Gallery, London

1960 Beaux Arts Gallery, London

1964 Beaux Arts Gallery, London

1968 Marlborough Fine Arts Ltd, London

1970 Compass Gallery, Glasgow
Catalogue introduction by Cyril Gerber

1971 Basil Jacobs Gallery, London

1975 Rutland Gallery, London
Catalogue introduction by Helen Lessore

Craigie Aitchison: Recent Paintings
Scottish Arts Council, Edinburgh
Catalogue introduction by Helen Lessore

1977 M. Knoedler & Co. Ltd, London

1979 Kettle's Yard Gallery, Cambridge
Catalogue introduction by John McEwen

1981 David Grob Fine Art, London

1981–92 Arts Council Retrospective Exhibition,
Serpentine Gallery, London; Midland Group,
Nottingham; City Museum and Art Gallery, Old
Portsmouth; Central Library Exhibition Gallery,
Milton Keynes; Museums & Art Gallery, Bolton.
Catalogue introduction by Helen Lessore; essay by
John McEwen

1985 Artis Monte Carlo, Monaco

1987 Albemarle Gallery, London
Catalogue introduction by Patrick Kinmonth

1989 *Craigie Aitchison: Recent Paintings*
Albemarle Gallery, London
Interview by Andrew Lambirth

1993 *Craigie Aitchison, New Paintings*
Thomas Gibson Fine Art, London
Catalogue introduction by John McEwen

1994 *Spirit of Lamlash: The Paintings of Craigie Aitchison*
1954–1994
Terrace Gallery, Harewood House, Leeds
Catalogue essay by Mary Sara

1996 *Craigie: The Art of Craigie Aitchison*
Gallery of Modern Art, Glasgow

Selected Group Exhibitions

1954 *Six Young Contemporaries*
Gimpel Fils, London

1956 *Three Romantic Painters*
Gallery One, London

1958–61 *New Paintings*
Arts Council Touring Exhibition

1964 Gulbenkian Foundation
Tate Gallery, London

1967 *Il Tempo dell'Imagine*
Second International Biennale, Bologna

1969 *Modern British Painters*
Tokyo

1969–70 Cunard Marlborough London Gallery
(on board QE2)

1974 *British Painting '74*
Hayward Gallery, London

1975 Contemporary Art Society Art Fair
Mall Galleries, London

23rd Salon Actualité de l'Esprit
Centre d'Accueil de l'Université de Paris

1979 Artists' Market, London

1982 *Prophecy and Vision*
Arnolfini Gallery, Bristol

1984 *The Proper Study*
British Council Exhibition
Lalit Kala Akademi, Dehli

1984–5 *The Singular Vision*
Royal Albert Memorial Museum, Exeter

1985 *The Hard-Won Image*
Tate Gallery, London

1987 *The Glass of Vision: Seven Artists in a Christian Context:*
Craigie Aitchison, Jane Dowling, Donald Johnson, John
Piper, Michael Renton, John Skelton, Richard Webb
Foreword by The Very Revd Robert Holtby,
Dean of Chichester
Chichester Cathedral

119 Tree at Oppedette, 1973

1988 *Graven Images: Art, Religion and Politics*
Harris Museum & Art Gallery, Preston

Jeffrey Camp: A Personal Choice
Nigel Greenwood Gallery, London

1989 *Faces of Britain: An Exhibition of Figurative Painting*
1949–89 for China
British Council

New Ikons
Mead Gallery, University of Warwick touring
exhibition

A Spiritual Dimension
Peterborough Museum & Art Gallery touring
exhibition

1991 Castlefield Gallery, Manchester

Art in Worship
Catalogue essay, *Seen and Unseen*, by Don Cupitt;
Commentaries by Sister Wendy Beckett
Tewkesbury Abbey, Worcester Cathedral

1992 *British Figurative Painting of the 20th Century*
The Israel Museum, Jerusalem
British Council

1993 *Images of Christ*
Arts Council touring exhibition
Northampton Museum & Art Gallery; St Paul's
Cathedral, London

1994 *Five Protagonists: Craigie Aitchison, Anthony Eyton,*
Patrick George, Myles Murphy, Euan Uglow
Browse & Darby, London
Catalogue essay, *A Common Pursuit*, by Andrew
Lambirth

Public and Corporate Collections

Aberdeen Art Gallery and Museum

The Arts Council of Great Britain

The Contemporary Art Society

The Central Selling Organisation (De Beers)

Robert Fleming Holdings Limited

The Glasgow Museums and Art Galleries

Grundy Art Gallery, Blackpool

Harewood House, Leeds

The Jerwood Foundation

The National Art Collections Fund

Newcastle Region Art Gallery, New South Wales, Australia

Newport Art Gallery

Nottingham Castle Museum and Art Gallery

The Royal Academy of Arts

Rugby Borough Council

The Scottish Arts Council

The Scottish National Gallery of Modern Art

The South African National Gallery

The Tate Gallery

University College, London

University of Liverpool Art Gallery and Collections

120 Dusty in the Sun, 1989

List of Plates

Dimensions are given in centimetres, height precedes width; all works are oil on canvas unless specified otherwise

Illustrated on page 1
Chinese Whistle
1986, 12.5 × 18
Kenneth Lambert and Martin Sherry

Illustrated on page 10, left
Pogy Inez
1978, 29 × 25.5
Inez Murphy

Illustrated on page 10, right
Donkey Sian
1980, 22 × 16.5
Sian Murphy

1 Crocuses
1959, 27.5 × 23
Susan Campbell

2 Landscape at Tulliallan
1950, oil on board, 36 × 47
Francis Fry

3 Still-life with Jug and Check Cloth
1952, 31 × 26
Sally Aitchison

4 Dovecot Tapestry Still-life
1951, oil on board, 12.5 × 14.5
Charlie Behrens

5 Jug and Horseshoe Still-life
1952, 142 × 123
University College London

6 Somerset – Little Head
1965, oil on board, 12 × 15
Susan Campbell

7 Nude – Jackie Seated
1953, 77 × 60
Private Collection

8 Girl in Field with River
1953, 142 × 112
Juliet Lygon

9 Portrait of Mary Newbolt
1953, 24 × 18.5
Private Collection

10 Landscape from inside a Cathedral
1957, 91.5 × 76
Anthony Fry

11 Pope Walking in the Garden
1957, 76 × 63.5
Private Collection

12 'Swan Vestas' Still-life
1956, 26.5 × 23
Private Collection

13 Purple Landscape
1956, 76 × 61
Private Collection

14 Butterflies in a Landscape
1956, 76 × 61
Private Collection

15 Yellow Painting
1957, 76 × 61
Private Collection

16 Self Portrait
1957–8, 30.5 × 25.5
Private Collection

17 Small Crucifixion
1958, Oil on board, 13 × 9
Susan Campbell

18 Poppies in Tulliallan Garden
1963, 35.5 × 29.5
Mark Glazebrook

19 Tree and Wall Landscape
1958, 26 × 22.5
Karen Heath

20 Garden at Tulliallan
 1963, 61 × 51
 Private Collection

21 The Pigeon House at Tulliallan
 1958, 40.5 × 30.5
 Private Collection

22 Wall and Fields at Tulliallan
 1960-1, 239 × 213.5
 Private Collection

23 Triptych
 1959, 115 × 110.5
 South African National Gallery
 Permanent Collection. Presented by
 the Contemporary Art Society,
 London, 1962

24 St Sebastian
 1964, 51 × 41
 Euan Uglow

25 Crucifixion
 1964, 51 × 41
 Mark Glazebrook

26 Crucifixion and Angels
 1960, 112 × 86.5
 Private Collection

27 Crucifixion in a Landscape
 1967–70, 129.5 × 96.5
 Susannah York

28 Japanese Tin Still-life
 1964, 25.4 × 20
 Barney Cordell

29 Candlestick Still-life
 1963, 30.5 × 25.5
 Private Collection

30 Model Standing against Blue
 Wall with Crucifix
 1963, 91.5 × 80
 Private Collection

31 Georgeous Macaulay in Red
 against a Yellow Background
 1970, 76 × 63.5
 Dr John O'Driscoll

32 Georgeous Macaulay in Blue
 against a Red Background
 1965, 76 × 63.5
 Jeremy Fry

33 Georgeous Macaulay in
 Uniform
 1969, 46 × 40.5
 Private Collection

34 Model Standing in front of a
 Black Background
 1966, 167.5 × 145
 Jeremy Fry

35 Ivan Standing in front of a
 Yellow Background
 1968, 167.5 × 145
 Jeremy Fry

36 Chinese Cup Still-life
 1963, 21.5 × 12.5
 Michael Palmer

37 Black Glove and Tangerine
 Still-life
 1968, 45 × 35
 Private Collection

38 Blue Bird Still-life
 1970, 42 × 51
 Private Collection

39 African Boy with Rose, Flowers
 and Budgies
 1969–70, 30 × 23
 Barry Miller

40 Japan
 1970, Collage, 74 × 40.5
 Miles Donnelly

41 Strawberry
 1966, 19.5 × 14
 Arthur Campbell

42 Butterfly in a Purple
 Landscape
 1968, Oil on paper, 62 × 49.5
 Gryphon Ltd

43 Portrait of Michael de Courcey
 1968, 61 × 51
 Georgia Georgallas

44 Crucifixion in a Landscape
 1988, 61 × 51
 Private Collection

45 Daphne with Black Necklace
 1968, 101.5 × 91.5
 Nancy Lazrus Istel

46 Portrait of Georgeous
 Macaulay
 1973, 28 × 23
 Private Collection

47 Carl with Black Hat
 1969, 45.5 × 35.5
 Shirley Rush

48 Georgeous Macaulay in a
 Sou'wester
 1976, 76 × 63.5
 Private Collection

49 Daphne with her Arm on a
 Table
 1971, 76 × 63.5
 Franco Leo

50 Daphne with her Eyes Closed
 1969–70, 173 × 145
 Kenneth Lambert & Martin Sherry

51 Girl against a Pink Background
 1974–5, 76 × 63.5
 Shirley Rush

52 Model in a Black Hat
1977, 75 × 62
William Darby

53 Model and Dog
1974–5, 221 × 188
The Tate Gallery

54 Dog in Red Painting
1975, 221 × 188
Francis Fry

55 Bedlingtons are Best
1977, 87.5 × 119.5
Private Collection

56 Portrait of Carl Campbell
1973, 61 × 51
Graham Snow

57 Girl in Red Blazer
1974, 63.5 × 61
William Sumpton

58 Carl with Blue Watch
1971, 61 × 51
Private Collection

59 Portrait of Vida
1973, 61 × 51
Private Collection

60 Portrait of Gerald Incandela
1977, 61 × 51
Baron Thilo von Watzdorf,
New York

61 Portrait of Francis Fry
1978, 61 × 51
Sheelagh Cluney

62 Butterflies and Lemon Still-life
1974, 40.5 × 45.5
Gryphon Ltd

63 Lily Still-life
1974, 76 × 63.5
Scottish National Gallery
of Modern Art

64 Mr Golly on any Planet
1977, 61 × 51
Francis Fry

65 Uncle Tom Still-life
1973, 76 × 63.5
Gryphon Ltd

66 Sacré Coeur
1978, 73 × 60.5
Private Collection

67 Portrait of Chicago
1981, 28 × 25.5
Gryphon Ltd

68 Crucifixion
1986–7, 214.7 × 183
The Tate Gallery

69 Bird, Boy and Dog
1981, 173 × 145
Francis Fry

70 Portrait of Patrick Kinmonth
with Sugarbush
1984, 61 × 51
Private Collection

71 Wayney Dead I
1986, 35 × 27
Lindsay Wilcox

72 Wayney Dead II
1986, 35 × 27
The Glasgow Museums & Art
Galleries

73 Wayney Dead III
1986, 18 × 12.5
Private Collection

74 Wayney Going to Heaven
1986, 20.5 × 15
Private Collection

75 Sugarbush Dead
1982, 18 × 12.5
Sheelagh Cluney

76 Crucifixion
1970–5, 221 × 188
Newcastle Region Art Gallery, NSW,
Australia

77 Crucifixion
1979, 203 × 143
Private Collection

78 Crucifixion
1984–5, 221 × 188
Private Collection

79 Crucifixion
1985–6, 221 × 188
Courtesy of David Grob

80 Crucifixion
1987–9, 172.5 × 145
Private Collection

81 Crucifixion
1988–9, 213 × 177.8
The Glasgow Museums & Art
Galleries

82 Portrait of Leroy Golding
1981, 65.5 × 58.5
Kenneth Lambert & Martin Sherry

83 Portrait of Patrice Felix
Tchicaya
1985, 30.5 × 25.5
Kenneth Lambert & Martin Sherry

84 Portrait of Patrice Felix
Tchicaya
1989, 30.5 × 25.5
Sheelagh Cluney

85 Portrait of Naaotwa Swayne
1987, 61 × 51
Private Collection

86 Portrait of Naaotwa Swayne
1989, 61 × 51
Private Collection

87 Portrait of Naaotwa Swayne
1988, 61 × 51
Private Collection

88 Portrait of Naaotwa Swayne
1989, 30.5 × 25.5
Mark Glazebrook

89 D'Arcy at Pitts Deep
1992, 62 × 76
Susan Campbell

90 Lemon and Jar Still-life
1981, Oil on board, 22 × 30.5
Private Collection

91 New York Still-life
1989, 30.5 × 25.5
Susan Campbell

92 Liquorice Allsorts Still-life
1980, 18 × 15
Sheelagh Cluney

93 Portrait of Simon de Wrongal
1984, 61 × 51
Brian Knox

94 Portrait of Kunwar Singh Bagri
1984, 51 × 40.5
Francis Fry

95 Boy with Butterfly
1988, 60 × 50
Gryphon Ltd

96 Reindeer–Jug Still-life
1986, 51 × 40.5
Private Collection

97 The Island
1971, 170 × 145
Private Collection

98 Holy Island from Lamlash
1993, 25.1 × 30.5
Private Collection

99 Goatfell, Isle of Arran
1993, 172.7 × 144.8
Private Collection

100 Holy Island from Lamlash
1994, 106.5 × 96.5
Private Collection

101 Goatfell, Isle of Arran
1993, 172.5 × 144.8
Private Collection

102 Landscape and Tree
1981, 61 × 51
Gryphon Ltd

103 Crucifixion Montecastelli
1980, 129.5 × 96.5
Gryphon Ltd

104 Orange Tree
1986, 61 × 51
The Central Selling Organisation
(De Beers)

105 Religious Painting
1990–2, 45.4 × 35.6
Robert Carsen

106 Donkey
1993, 76.2 × 63.2
Private Collection

107 Crucifixion
1991, 200 × 188
Galerie Claude Bernard, Paris

108 Crucifixion
1994, 107 × 96.5
The Jerwood Foundation

109 Bethlehem Vase Still-life
1993, 61 × 51
Private Collection

110 Black Vase Still-life
1990, 40.5 × 30.5
Mark Glazebrook

111 Pink Vase Still-life
1992, 55.8 × 45.7
Robert Carsen

112 Portrait of Kelvin O' Mard
1992, 30.5 × 25.4
Private Collection

113 Portrait of Comfort
1993, 73.7 × 63.5
Simon Keswick

114 Portrait of Pilar
1989, 50 × 40
Private Collection

115 Portrait of Sheelagh Cluney
1990, 101.5 × 76
Sheelagh Cluney

116 Chinese Dish Still-life
1989, 10.5 × 13
Private Collection

117 Crucifixion
1993, 106.5 × 35.5
Private Collection

118 Dead Bird
1984, 12.5 × 10
Sheelagh Cluney

119 Tree at Oppedette
1973, 49.5 × 40
Sally Aitchison

120 Dusty in the Sun
1989, 12.5 × 10
Private Collection

Bibliography

General

Forge, Andrew. 'The Slade', Motif – An Art Quarterly, Nos 4, 5 & 6, London, 1960

Hassell, Geoff. Camberwell School of Arts & Crafts: Its Students & Teachers 1943–1960, Antique Collectors' Club, 1995

Lessore, Helen. A Partial Testament: Essays on Some Moderns in the Great Tradition, Tate Gallery Publications, London, 1986

Roboz, Zsuzi, Edward Lucie-Smith and Max Wykes-Joyce. British Art: A Personal View, Art Books International, London, 1993

Spalding, Frances. British Art Since 1900, Thames & Hudson, London, 1986

Unpublished Material

Aitchison, The Revd James. 4 Volumes of Diaries/Memoirs 1846–1929. Begun 1915

Periodicals & Newspaper Articles

Anonymous. 'Young Contemporaries', The Scotsman, 8th September 1954

Anonymous. 'Romantic Painters: Triple Exhibition at Gallery One', The Times, 14th September 1956

Anonymous. 'London Letter: Scottish Artist', The Scotsman, 15th September 1956

Berryman, Larry. 'Craigie Aitchison (Albemarle Exhibition)', Arts Review, 15th December 1989

Blakeston, Oswell. 'Craigie Aitchison (Serpentine Exhibition)', Arts Review, 19th December 1981

Brett, Guy. 'Craigie Aitchison Exhibition (Beaux Arts Exhibition)', Manchester Guardian, 11th January 1964

Burr, James. 'Craigie Aitchison at the Beaux Arts Gallery', Apollo, January 1964

Bumpus, Judith. 'Getting It Right (Albemarle Exhibition)', The Royal Academy Magazine, Winter 1989

Farson, Daniel. 'Dog Day Heaven: New Paintings at Thomas Gibson Fine Art', The Mail on Sunday, 10th October 1993

Feaver, William. 'Acts of Devotion (Serpentine Exhibition)', Observer Review/ Arts, 13th December 1981

Feaver, William. 'Suppressed Cunning and Passion in Craigie Aitchison', Vogue, December 1989

Ford, Anna. 'Portrait of Comfort by Craigie Aitchison RA', The Royal Academy Magazine, Summer 1994

Gibbon Williams, Andrew. 'Real Art Fights Back', The Sunday Times, 7th August 1994

Januszcak, Waldemar. 'Craigie Aitchison (Serpentine Exhibition)', The Guardian, 3rd December 1981

Kinmonth, Patrick. 'Spotlight on Craigie Aitchison', Vogue, November 1981

Lambirth, Andrew. 'Craigie Aitchison (Jerwood Prize Exhibition)', Modern Painters, Winter 1994

Lee, David. 'In Profile: Craigie Aitchison', Art Review, March 1994

McEwen, John. 'Eclectic (Knoedler Exhibition)', The Spectator, 2nd July 1977

McEwen, John. 'Human Spirit (Serpentine Exhibition)', The Spectator, 12th September 1981

McEwen, John. 'The Brighter Side of Life (Thomas Gibson Exhibition)', The Independent Magazine, 25th September 1993

McEwen, John. 'An Itch to say "Cobblers" (Thomas Gibson Exhibition)', The Sunday Telegraph, 3rd October 1993

Melville, Robert. 'A Mersey Pound (John Moores Liverpool Exhibition)', New Statesman, 21st June 1974

Mullally, Terence. 'Young Artist Unswayed by Fashion (Beaux Arts Exhibition)', Daily Telegraph and Morning Post, 6th January 1964

Newton, Eric. 'A Symposium of Youth (Gimpel Fils Exhibition)', Time and Tide, 28th August 1954

Penrose, Stuart. 'Craigie Aitchison: Beaux Arts Gallery', Arts Review, 11th–25th January 1964

Russell, John. 'The World of Art (Beaux Arts Exhibition)', The Sunday Times, 5th January 1964

Richardson, Sally. 'Animal Passions: Craigie Aitchison's Bedlington Terriers', The Telegraph Weekend Magazine, 18th November 1989

Robertson, Bryan. 'With or Without Politics (Beaux Arts Exhibition)', New Statesman, 10th December 1960

Rosenthal, T. G. 'The Roses Next Month (Beaux Arts Exhibition)', The Listener, 16th January 1964

Russell Taylor, John. 'Craigie Aitchison (Albemarle Exhibition)', The Times, 14th April 1987

Rykwert, Joseph. 'Three Exhibitions (Young Contemporaries)', Time and Tide, 30th January 1954

Sara, Mary. 'Colourful Character, Colourful Canvases (Harewood House Exhibition)', 29th August 1994

Sylvester, David. 'Students and Others (Gimpel Fils Exhibition)', The Listener, 2nd September 1954

Vaizey, Marina. '(Serpentine Exhibition)', The Sunday Times, 6th December 1981

Weideger, Paula. 'A Painter of Innocence and Experience', The Correspondent Magazine, 12th November 1989

Interviews

Judd, Leslie. 'Artbeat with Leslie Judd', L.B.C. Radio, 2nd December 1989

Lambirth, Andrew. 'Craigie Aitchison: Portrait of the Artist', The Artist's and Illustrator's Magazine, December 1988

Eds. David Wright and Patrick Swift. 'X' vol 1, 1960–61, Barrie and Rockliff, London, 1961

Films

Painting Chicago, a film directed by Judy Marle for the Arts Council of Great Britain, 1982

Publications featuring Craigie Aitchison's Work

Archer, Jeffrey. The First Miracle, HarperCollins, 1994. Cover and illustrations throughout by Craigie Aitchison

Chaplin, Patrice. Having it Away, Duckworth & Co Ltd., 1977. Cover features A Tree, 1970 (Private Collection)

Dunn, Douglas. Oxford Book of Scottish Short Stories, Oxford University Press, 1995. Cover features detail of Goatfell, Isle of Arran, 1993 (Private Collection)

McWilliam, Candia. Debatable Land, Bloomsbury, 1994. Cover features Holy Island, Isle of Arran, 1993 (Sheelagh Cluney)

Norman, Andrew. Silence is God, SPCK, 1990. Cover features Crucifixion 1987–9 (Private Collection)

Index

Page references in **bold type** refer
to illustrations. Entries in *italics*
refer to works of art.